THE EDITORS OF
OUTSIDE MAGAZINE

FOREWORD BY
JIMMY CHIN

the edge of the world

of the

world

A Visual Adventure to the
Most Extraordinary Places on Earth

FALCON®

AN IMPRINT OF GLOBE PEQUOT
Falcon and FalconGuides are registered trademarks
and Make Adventure Your Story is a trademark of
Rowman & Littlefield.

Distributed by NATIONAL BOOK NETWORK

British Library Cataloguing-in-Publication Information available

Library of Congress Cataloging-in-Publication Data
Names: Chin, Jimmy, writer of foreword.
Title: The edge of the world : a visual adventure to the most
 extraordinary places on Earth / the editors of Outside magazine ; foreword
 by Jimmy Chin.
Other titles: Outside (Chicago, Ill.)
Description: Guilford, Connecticut : Falcon, [2017] | Description based on
 print version record and CIP data provided by publisher; resource not viewed.

Identifiers: LCCN 2017012005 (print) | LCCN 2017013647 (ebook)
ISBN 9781493029969 (hardcover) | ISBN 9781493031603 (ebook)

Subjects: LCSH: Landscape photography. | Outdoor photography. | Outdoor
 recreation—Pictorial works.
Classification: LCC TR660.5 (ebook) | LCC TR660.5 .V485 2017 (print) | DDC
 778.7/1—c23
LC record available at https://lccn.loc.gov/2017012005

♾™ The paper used in this publication meets the minimum requirements of American National Standard
for Information Sciences—Permanence of Paper for Printed Library Materials, ANSI/NISO Z39.48-1992.

The author and Rowman & Littlefield assume no liability for accidents happening to, or injuries sustained
by, readers who engage in the activities described in this book.

contents

Chin's celebrated 2006 shot of Kit DesLauriers at 28,500 feet, just above the Hillary Step on Mount Everest. DesLauriers, her husband, Rob, and Chin were the first Americans to ski down from the summit.

foreword

Before you start flipping through the pages of this book, there's something important you should understand about adventure photography: Most of the best images aren't captured—they're created. Sometimes professional photographers like me are lucky enough to be in the right place at the right time and snap an amazing shot. Serendipity happens—but it's rare. When you look at truly remarkable images like the ones collected here, you're often seeing the result of deliberate and extremely calculated collaboration between an athlete and an artist.

Working in the mountains or other extreme environments presents numerous challenges, which is why the relationship between photographer and subject is so important. In dangerous conditions, athletes need to know we're not going to be a liability. Developing that trust forges a really strong bond. Years of effort and coordination can go into the making of a single image. In 2006, I skied from the summit of Mount Everest with Kit DesLauriers and her husband, Rob.

We were the first Americans to do it. Kit asked me to come because I'd been a photographer on two previous Everest expeditions. She and I spent a couple seasons climbing and skiing together beforehand and planned extensively for the expedition and the kind of shots we wanted to get. For me all that culminated in a shot of Kit skiing above the Hillary step at 28,500 feet that I look at now and think, Wow, we made it happen.

It helps that many top athletes like Kit tend to enjoy the choreography required for producing spectacular imagery. The late Dean Potter was one of the most inventive people I worked with and always had these outrageous ideas for climbing and slacklining photos. We'd rig ropes at just the right angle or set up highlines in ridiculous places and then work together to get the wildest shot we could come up with. I've been taking photos of alpinist Conrad Anker for sixteen years, and we've built a deep relationship that's allowed us to try things in situations where the stakes are really high. Ultimately, the intersection point for athletes and photographers is passion—for a sport and for telling a story. That's what holds us together and fuels our mutual admiration and respect.

When I look at another photographer's shot, I see the moment they're sharing. But when I look at a number of their images, I learn something about the photographer—their vision, the hard work they've put in, even their personal evolution. This collection offers that same perspective on *Outside*. For forty years, the magazine has been at the vanguard of adventure photography. In their curation of images, the editors have chronicled the people, events, and trends at the heart of the genre. Like other storytellers who operate behind the scenes, they don't get a lot of credit. But the photographers lucky enough to work with them are constantly amazed at the precision and thoughtfulness of their choices. From its founding, *Outside* has sought to define the state of adventure. Look through the photos on the pages that follow, and I'm certain you'll agree with me that they've done a hell of a job.

—*Jimmy Chin*

Uli Wiesmeier accompanied two well-known German climbers, Stefan Glowacz and Kurt Albert, on a climbing trip to Vietnam's Ha Long Bay, where three thousand dolomite formations rise up to five hundred feet from the sea. While Glowacz scaled The Dragon Lady, Wiesmeier soloed up the neighboring pinnacle and shot Glowacz and Albert, who was waiting below, from the top of it. "My climb was easy, but the rock was razor sharp," recalls the Murnau, Germany–based photographer. "The fog was so thick that I had to wait for about forty-five minutes until I could see Stefan. Not only did I have to protect my lens from the rain, but also from the blood dripping from the cuts on my arms."

introduction

One morning early on in my tenure as editor of *Outside* magazine, I boarded a flight for New York and eased into my aisle seat. As we settled in for takeoff, the man seated next to me reached into his backpack and pulled out a copy of our latest issue. I froze. My neighbor's chosen leisure activity might seem mundane, but for me it offered something of a job fantasy. As *Outside's* editor, I spend weeks reading multiple drafts of five-thousand-word stories, editing myriad headlines and captions, and constantly rebooting coverlines. Then we ship everything to the printer and move on to the next issue. We always receive a few kind—and not so kind—letters regarding an article and, if I'm lucky, I might hear from a family member who liked the new issue. But it's an unsatisfying feedback loop. Until that moment on the plane, I'd never actually witnessed a subscriber consume the magazine after pulling it out of his mailbox. In fact, I've often dreamed of what it would be like to work at some giant manufacturing conglomerate, say Kraft, where I

could watch from behind a one-way mirror as a consumer-testing panel weighs in with blunt opinions about our latest powdered-cheese recipe. The man sitting next to me was as close as I'd ever get.

I took out my computer and pretended to work. Watching from the corner of my eye, I was a relentless voyeur for the better part of an hour, though I don't recall every page the guy read. I don't even remember the specific issue he held in his hands. One detail has stuck with me, however. After reading the table of contents, he flipped to the Exposure section, where we showcase our favorite images from the world of adventure. There, he encountered a two-page spread of a scuba diver suspended in the water looking straight at a massive humpback whale sleeping some fifteen feet away. (You can find the image on pages 200–201.) I remember when

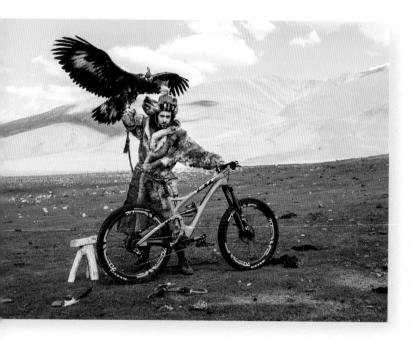

While on a mountain biking odyssey across Mongolia in 2015, photographer Joey Schusler spent time with a family that practiced the ancient art of eagle hunting. "The father insisted I wear his lynx coat and hold the eagle," says Schusler. "The family got a good chuckle out of it."

this photograph was first presented to me and that I instantly selected it for the magazine. The diver and whale mirror each other at perfectly opposing angles, making it appear as though the two are locked in conversation. No other photograph I've seen so viscerally conveys the difference in scale between a human and a whale—or how insignificant a person might feel during such an encounter. The image begs you to linger.

Which is exactly what my personal consumer test case did. I watched him stare at the photo for a few minutes before finally turning the page. He went on to read the rest of the magazine for more than an hour, but he returned to the image at least three more times. It was as if he still couldn't believe what he'd seen and needed to check again to make sure he wasn't crazy or the victim of Photoshop trickery. (He was neither.) If there had been a cartoon text bubble over his head, it would have read: Wait, how did they *do* that?

If this encounter had taken place on the other side of a one-way mirror, it would have had me high-fiving my fellow editors. That is the exact reaction we aim to evoke in Exposure, the source of the vast majority of the photos that you'll

find in this book. (A handful of others, such as Jimmy Chin's shot of climber Renan Ozturk looking over the side of a portaledge in the Indian Himalayas, came from specific feature story assignments). Each month, our photo team looks at dozens of images submitted for consideration and weeds out nearly all of them. Those that make the cut are the ones that have the power to stop you in your tracks. In this book, we've gathered the very best of these photos, and looking at our selections, I'm amazed that so many of them still have that power over me even after repeat viewings.

What is also remarkable is how well these printed photographs hold up despite the rapid expansion of digital media. Today, a sponsored athlete's every feat is captured by multiple POV GoPros and a team of videographers armed with fifty-thousand-dollar RED cameras. Some of this footage is indeed incredible, but even as HD video and filtered Instagram images clog our daily news feeds, large-format still photography remains the gold standard. As these images prove, a single, expertly composed photo, printed at a scale that allows careful investigation of the details, has the ability to convey the thrill and danger of adventure in a way that

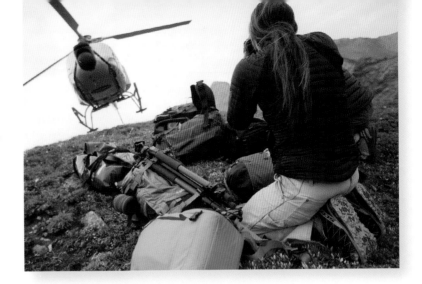

moving images and
square-cropped shots the
size of a business card
often can't. By weed-
ing out all but the most
remarkable captured
moments, we've curated a selection of images
with the unique power to give you the chills.

Jody MacDonald captures
a film crew lifting off in the
Canadian wilderness dur-
ing a 2014 expedition by
paragliders Will Gadd and
Gavin McClurg. The two men
flew some 385 miles down
the spine of the Canadian
Rockies over thirty-five days.

When that happens, your immediate reac-
tion may be to look at the subject—a skier fro-
zen just beyond a cliff face or a slackliner bal-
ancing thousands of feet above the earth—and
ask, How did they do that? It's a reasonable question, but a
better way to digest this book is to follow a different line of
inquiry. After ten years of looking at hundreds of our Expo-
sure selections and reading the narratives behind each shot,
I've found the most compelling stories are more often taking
place on the other side of the camera. So as you linger on an
incredible image, take a moment to ignore the specific action
in front of you and imagine the photographer. Where are
they? And how the hell did they get there? A good example

can be found on page 152, where you'll see a humpback whale (I have a thing for whales) in the foreground and a sea kayaker perilously close behind. Perilously close, that is, until you consider the position of the photographer, who is virtually on top of the mammoth beast. You'll want to know how someone could not only survive such an encounter but also have the presence of mind to capture it with a camera.

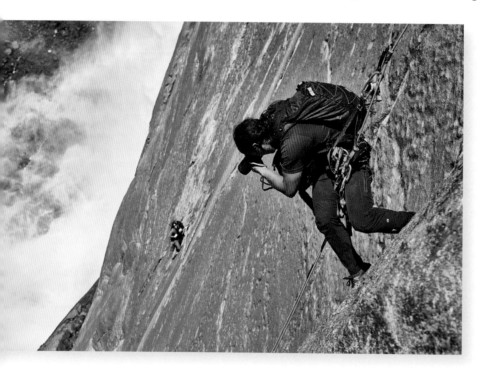

Jimmy Chin hard at work in 2010. Here, he shoots climber Madaleine Sorkin as she ascends a face near Yosemite Falls.

The good news is that you'll find the answers to these questions throughout this book. When making an issue of *Outside,* we select photos that will stop you in your tracks, but we also want to place you in the action. Each image has a story behind it that explains exactly how it was captured. These narratives are brief, but filled with surprising and

sometimes frightening details, and they're all told through the point of view of the photographer rather than the subject.

Finally, we created this book to commemorate *Outside's* fortieth anniversary. The media landscape has evolved considerably since we first began publishing in 1977, but our mission has always stayed the same: to inspire active participation in the world outside. And we've long understood that photos, often more than words, are the best way to accomplish that. It's the reason that we moved the Exposure section to the beginning of the magazine ten years ago. The photographs you're about to encounter have the power to set a mood, forcing you to recalibrate any assumptions of what is possible for humans to accomplish in the world outside. You might never get to see some of the remote places we take you with your own eyes. You'll probably never want to experience some of the harrowing action you see depicted. But I guarantee that something in here will inspire you to get out the door.

—Christopher Keyes

At peak flows, 2,425-foot Yosemite Falls could fill an Olympic-size swimming pool in a minute. But in October 2015, following several months when California saw little or no rain, the lip was so dry that Alex Manelis was able to photograph Cheyne Lempe—a climber who set a record on El Capitan's Salathé Wall in 2013—walking across it. "The average viewer is in the valley looking up at the falls and the Lost Arrow Spire nearby," says Manelis, who regularly drives to Yosemite National Park from his home in Palo Alto. "But from up there, it's a totally different perspective."

rock & earth

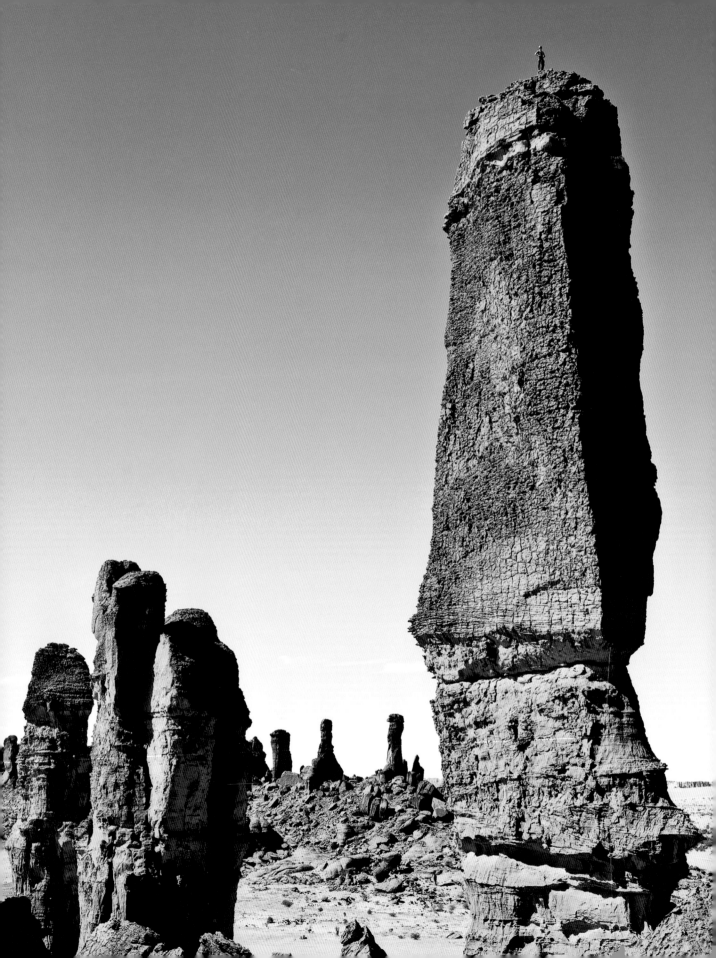

All adventures begin on the ground. From there we go, well, anywhere we can. We climb up. We rappel down. We run. We ride. We leap and land—and leap again. In their quest to document how we play and explore, *Outside's* photographers tell an evolving story about our fundamental connection to the planet. Our desire to go bigger, farther, and deeper is inspired by the landscape—from labyrinths of stone to towering forests to glittering caves—and driven by our relentless pursuit of new frontiers and experiences.

rock & earth

"We had all kinds of names for this thing," says Jimmy Chin of this spire in a remote region of Chad where he and expedition teammates Alex Honnold, Mark Synnott, and James Pearson took an exploratory expedition in 2010. Here, Pearson tops out on the very first ascent of the trip. "This was literally four days from the main road," says Chin, who lives in Jackson Hole, Wyoming. "We were all worried there wouldn't be any worthy climbing objectives. Then, we get there and there are hundreds and hundreds—we didn't know where to start."

During a three-month climbing trip in 2014, Forest Woodward made a stop in the North Cascades in Washington State to shoot photos for a guidebook. At Colchuck Balanced Rock, he caught Jenny Abegg leading a route called West Face, six hundred feet above the ground. "We'd just made it to the top when I found out she'd only been climbing for two years," says Woodward. "I was blown away."

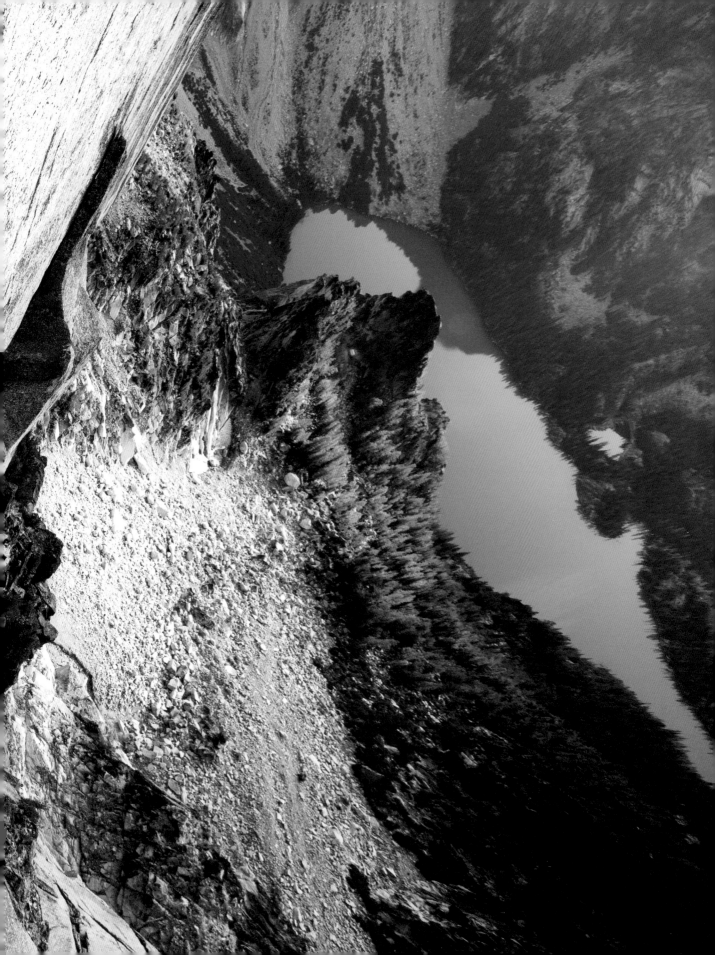

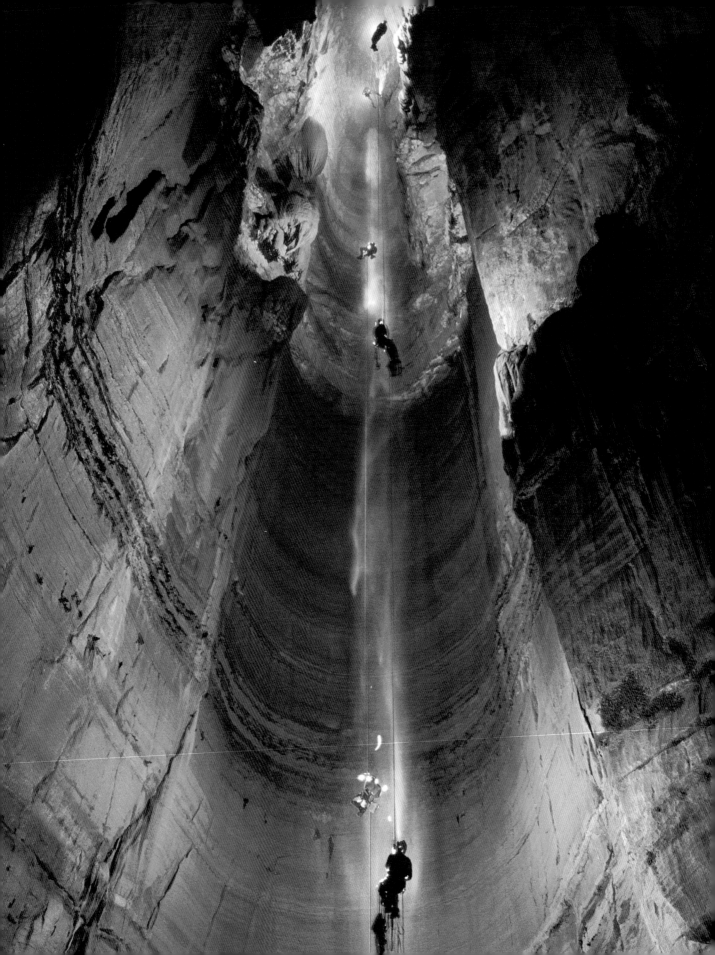

Stephen Alvarez and his friend Kent Ballew spent four days rigging a suspension line across a sixty-foot-wide upper opening of Mystery Falls, which plummets 281 feet into a limestone cavern outside Chattanooga, Tennessee. They then dropped two rappel lines down the pitch-dark shaft, next to the deafening falls, allowing Ballew and two assistants to descend and light up the pit with handheld flashes and flashguns. "It took forever for everyone to inch their way into the right position on the ropes and adjust the lights," says Alvarez, a professional photographer from nearby Monteagle, Tennessee. "In the end, after using 1,700 feet of rope and spending countless hours underground, one frame came out perfectly."

In April 2012, David Clifford had hoped to shoot Bend, Oregon, runner Max King's attempt to set a record on the 42.5-mile Grand Canyon Rim-to-Rim-to-Rim traverse—a double crossing of the 5,250-foot canyon. Unfortunately, the Park Service wouldn't let him. "For safety reasons, they were trying to keep people from running on the trails, and they were worried about publicity," says the Boulder, Colorado, photographer. King missed the record by almost an hour, but the next day Clifford talked him into a few action shots near the South Rim's Shoshone Point. "Max was pretty burned out from the day before, but there weren't any rangers around, and the backdrop was too good to pass up."

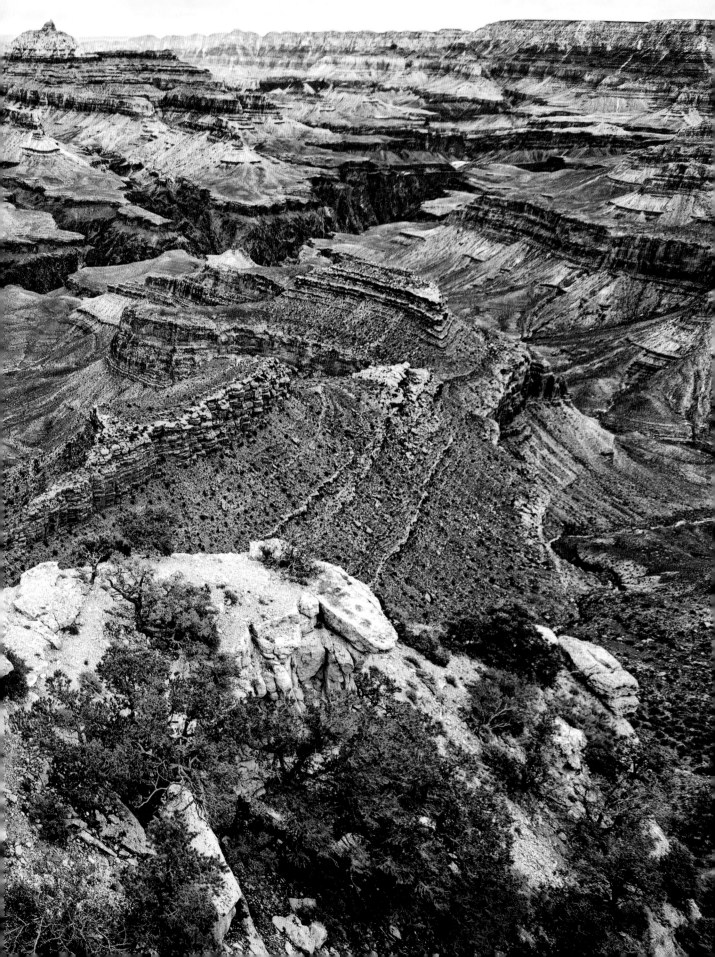

Greg Epperson went up a tree to capture his friend and fellow climber Darrell Hensel about 150 feet into a 400-foot route with the formidable name of Between Nothingness and Eternity, on Dome Rock in California's Sequoia National Park. "When you're looking up at the rock from the ground, you can't see all the extrusions and striations. So I climbed a huge Jeffrey pine to get a better view of the detail," says Epperson, who's based in the town of Joshua Tree, California. "Then I had to climb out onto the end of a branch so I wouldn't wind up with a picture of pine needles." Epperson admits the granite isn't as blue as all this: "The film just read it a little cool."

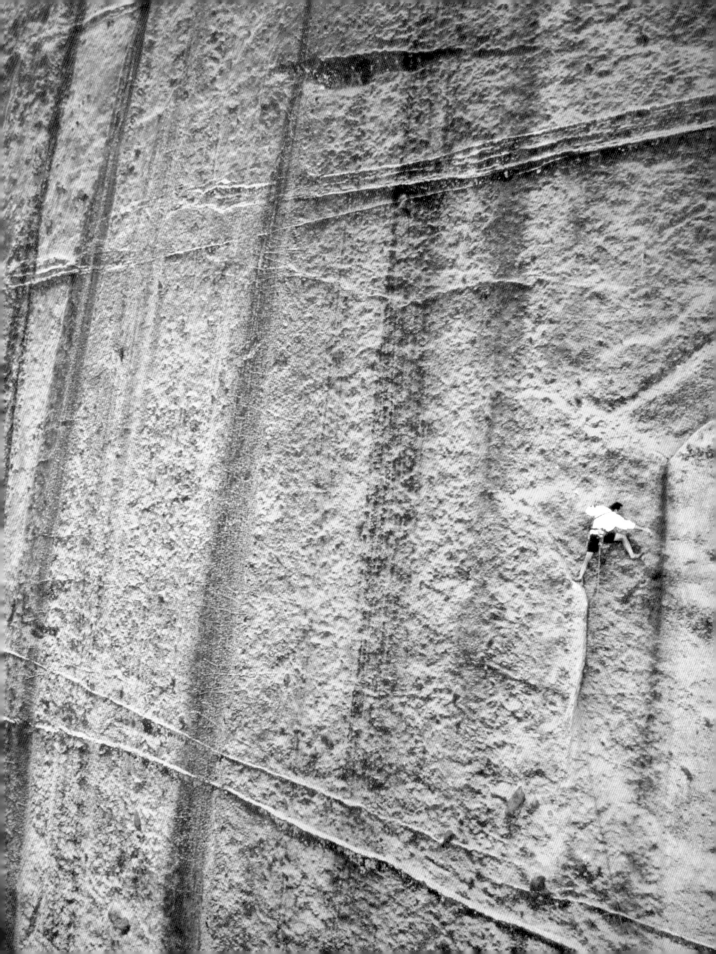

"My friends and I were headed to Yosemite to do some climbing," says Grant Ordelheide, of Denver. "We'd been on the road for about two hours when I realized I had forgotten my camera." Still, they went back and got it. After summiting the park's popular Cathedral Peak late in the afternoon, Ordelheide asked his climbing partners to traverse over to nearby Eichorn Pinnacle so he could capture them rappelling off the top as the sun set. "I wasn't sure they were going to make it in time, but they did, and this was exactly the shot I wanted," he says. "It also made for a very long hike out in the dark."

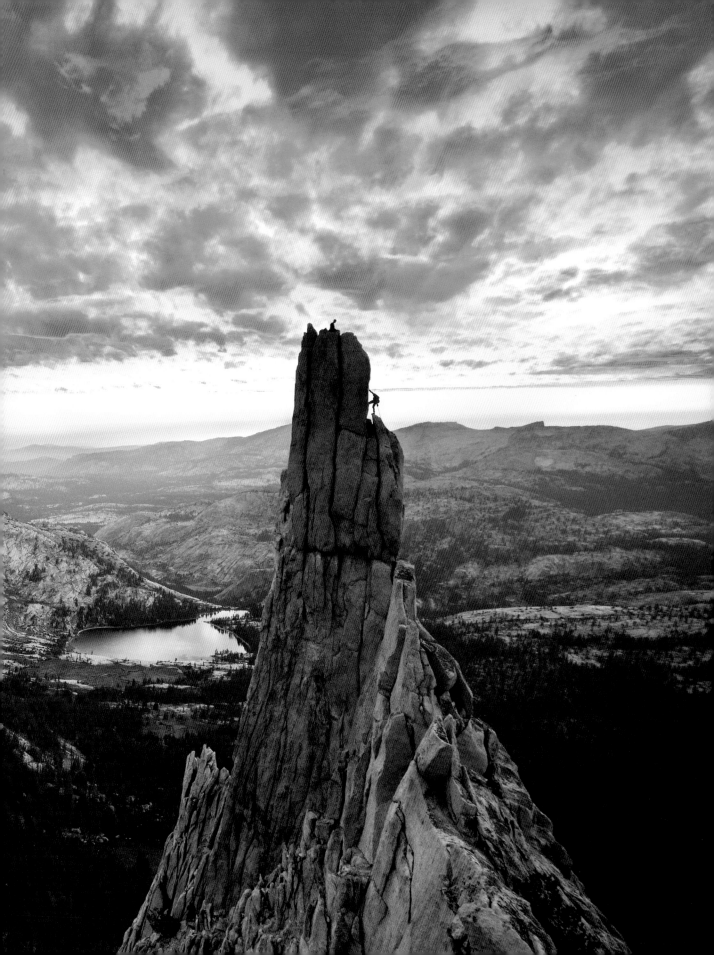

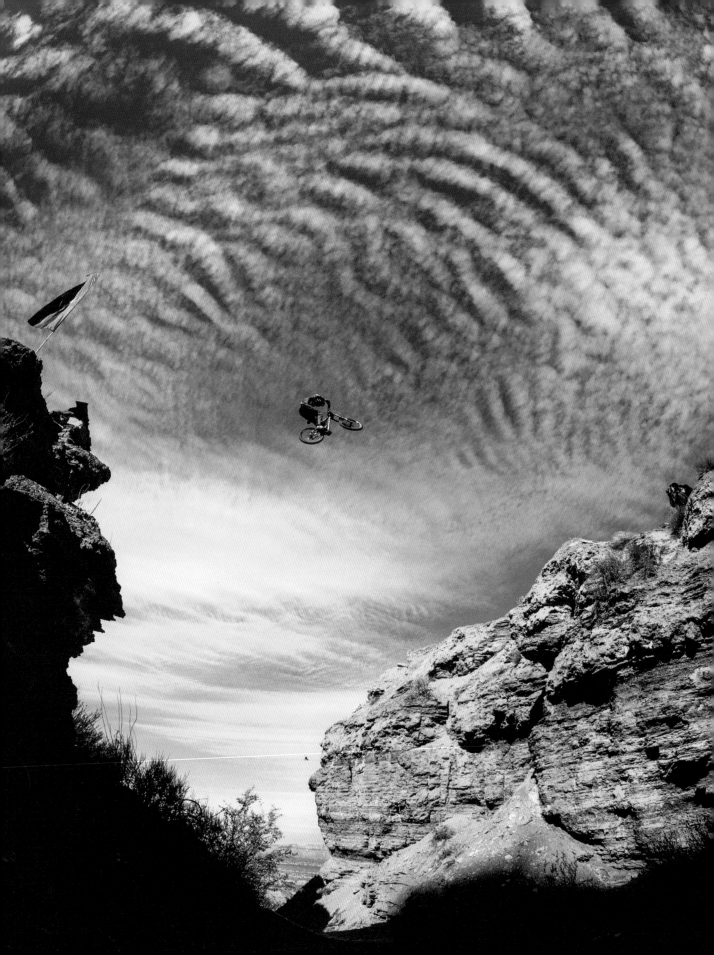

At the 2013 Red Bull Rampage mountain bike competition in Virgin, Utah, Paris Gore got this shot of Brendan Fairclough gapping a canyon by pointing his camera up from a ravine thirty feet below. "Brendan built the same feature the previous year but never attempted it because he crashed higher up," says the Bellingham, Washington, photographer. "This time there was a crash pad set up at the bottom, and we photographers were all waiting to see what happened. He got his redemption with a clean landing."

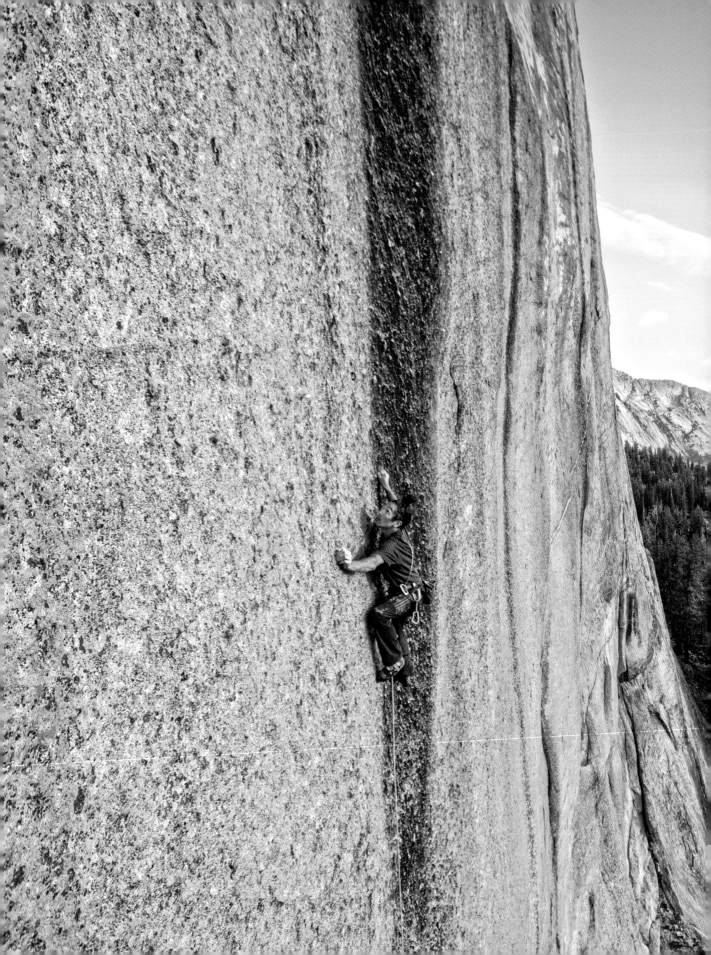

In the fall of 2014, Cody Tuttle captured Yosemite native Lonnie Kauk on the Bachar-Yerian route, halfway up 9,900-foot Medlicott Dome, a wall of granite in Tuolumne Meadows, California. "It's one of the scariest climbs in Yosemite," says Tuttle, who traveled to the park from nearby Mammoth Lakes, where he lives, and rappelled down to Kauk as he worked through the second, most daunting pitch. "There were moments when there was no room for error, and Lonnie was either going to take a hundred-foot fall or press through. But he kept his cool."

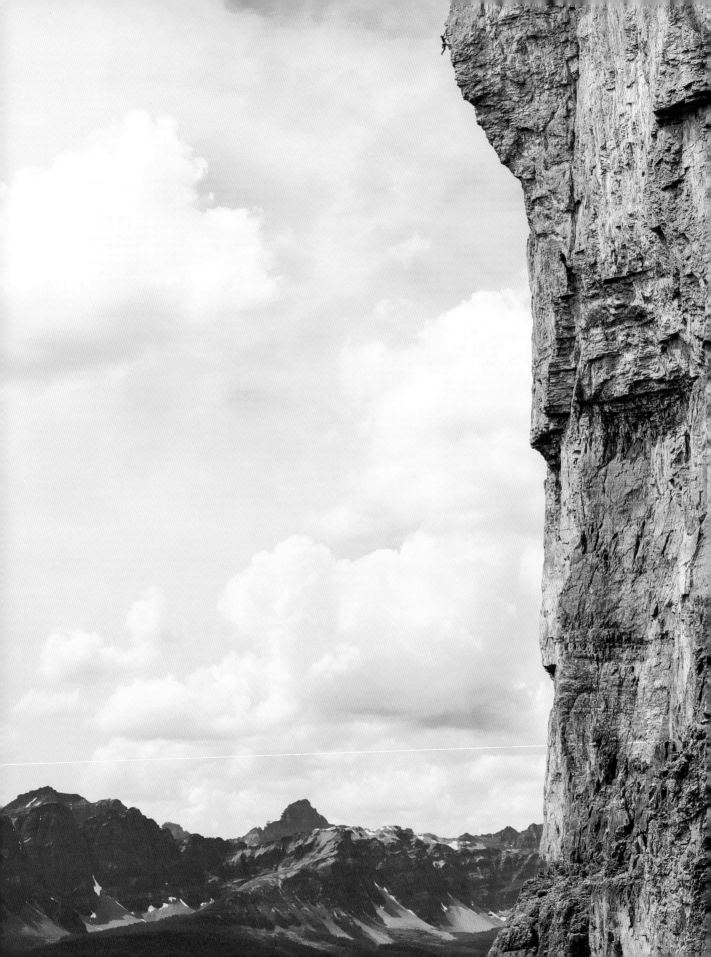

While exploring Alberta, Canada's Bow Valley last August, Ben Moon captured climber Sonnie Trotter finishing the crux arête of this five-pitch route on Castle Mountain, near Banff, Alberta. "The wind was howling, and I was trying desperately to get a shot while watching a huge thunderstorm move in over the next mountain," says Moon, of Portland, Oregon. It was worth it. "It's one of the most visually striking climbs I've ever seen."

"It was the most pressure I've ever had on a shoot," says Nicolas Teichrob, who was part of a clandestine team that gathered near the train tracks in Prince George, British Columbia, one day in 2011 to help local pro mountain biker Kyle Norbraten gap a freight train. "It would be like screwing up someone's wedding photos." British Columbia–based Teichrob had tagged along with a tight group of bikers from the area, known as the Coastal Crew, for the two weeks it took to sculpt the jump approach and landing for a scene in their film *From the Inside Out*. But, for Norbraten, it was no ordinary huck shot: "The key was getting Kyle over the engine," says Teichrob. "But he couldn't even see the train from where he was waiting, so once it was coming we called him on a radio and said 'drop.' Kyle said he could feel the engine exhaust blasting him in the air." And, yes, he stuck the landing.

2293

EF-6441

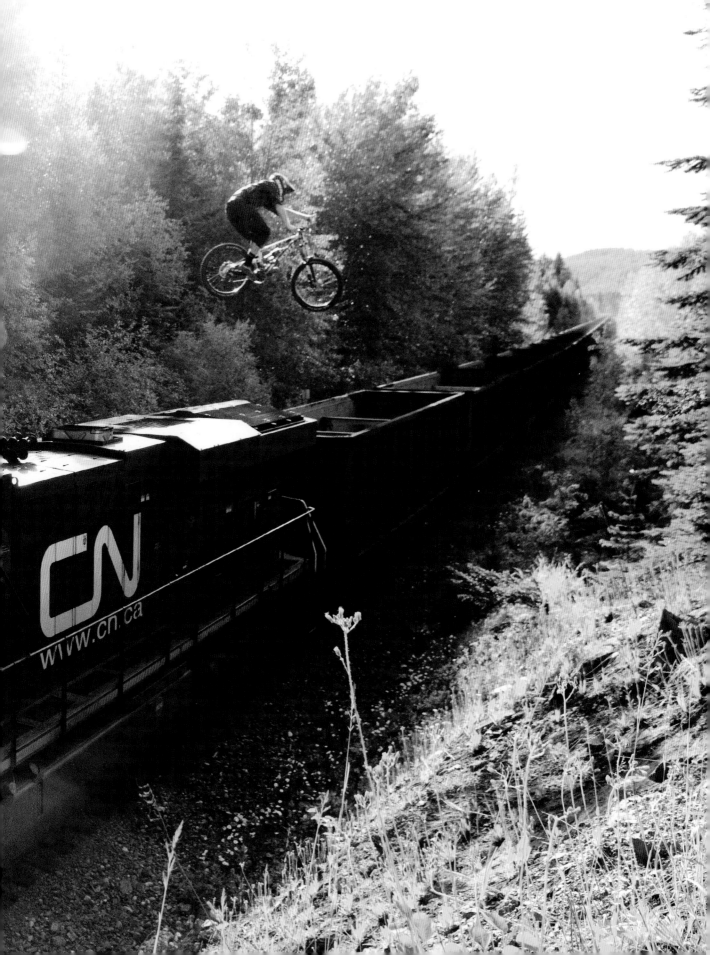

In June 2014, while traveling through Zion National Park in Utah, Jeremiah Watt captured Cincinnati's Ben Ritchey making his way up a ladder-like series of depressions in the 140-foot sandstone face of Kolob Canyon. "It's unbelievable that climbing exists like that in a natural state," Ritchey says. "Unlike most steep pitches, the holds are all there, creating a perfect line to the top."

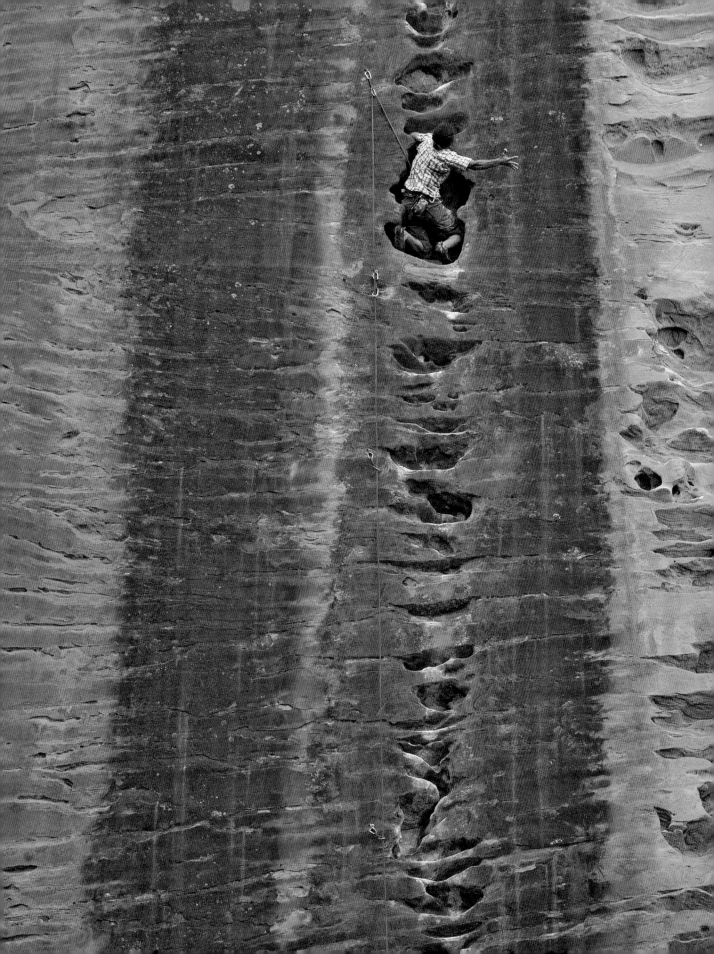

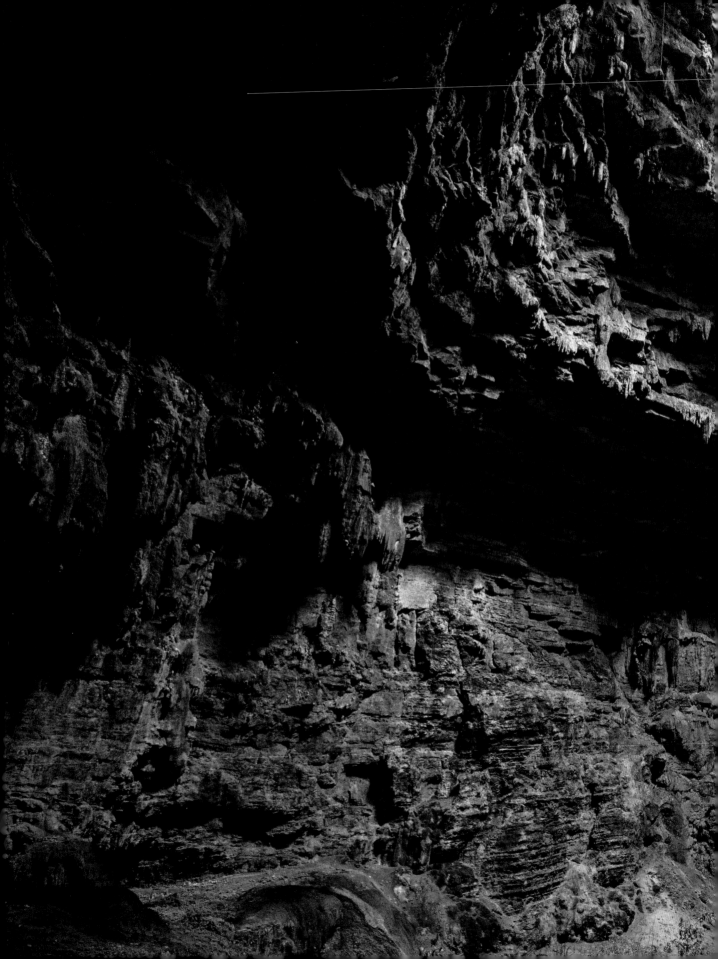

During a ten-day winter trip through San Luis Potosi, Mexico, Justin Lewis, who lives in Fairfax, California, and his friend Michael Holland rappelled into this three-hundred-foot-deep cave outside the Huastec village of La Laja. "It had been foggy all day, but it pulled back within moments of Mike unclipping from the rope," says Lewis. "That was when I could really feel the scale of the cave. From the bottom, every sight and sound seemed larger than life."

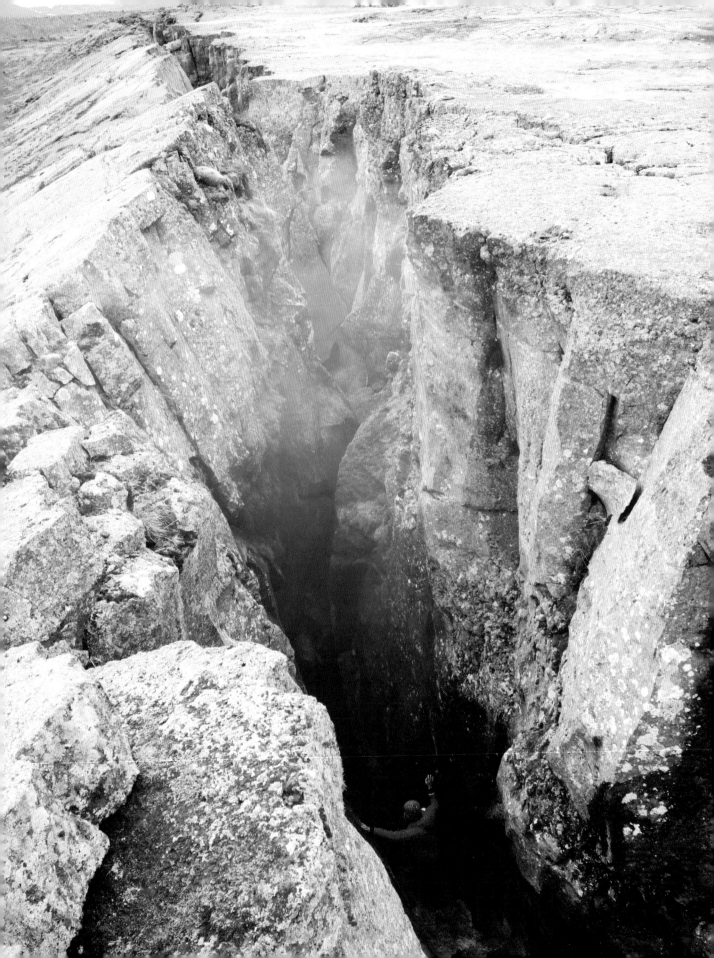

Brian Mohr and his wife had spent more than a decade searching the mountains of northern Iceland for the perfect combination of backcountry ski slopes and après hot springs before finding this fissure in the Myvatn region. Following the scrawled directions of a local guide, they stumbled upon the crack, which was said to contain a spectacular natural pool. "I was ready to give up," says the Moretown, Vermont–based photographer, "then my wife said she found it. It was in this cavern, with maybe 150 feet of space to swim and fumaroles creating a steam room inside. Without a doubt, it was the most unique hot springs we've seen."

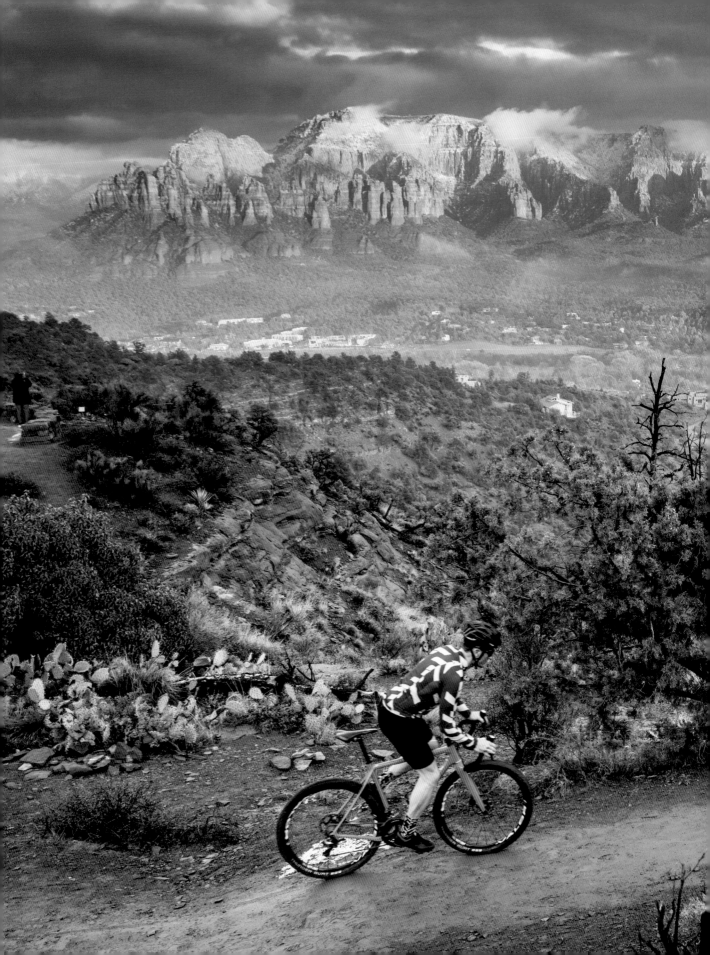

In January 2015, photographer Jen Judge spent ten days in Sedona, Arizona, with her husband, *Outside* contributing editor Aaron Gulley, who helped test dozens of mountain and road bikes for the summer *Buyer's Guide*. "Sedona sees snow only once or twice a year, and to have the light come out at the golden hour was really rare," says Judge, who lives in Santa Fe. "We started running uphill as soon as we got there. I knew it was going to be the most phenomenal shot ever, and it was."

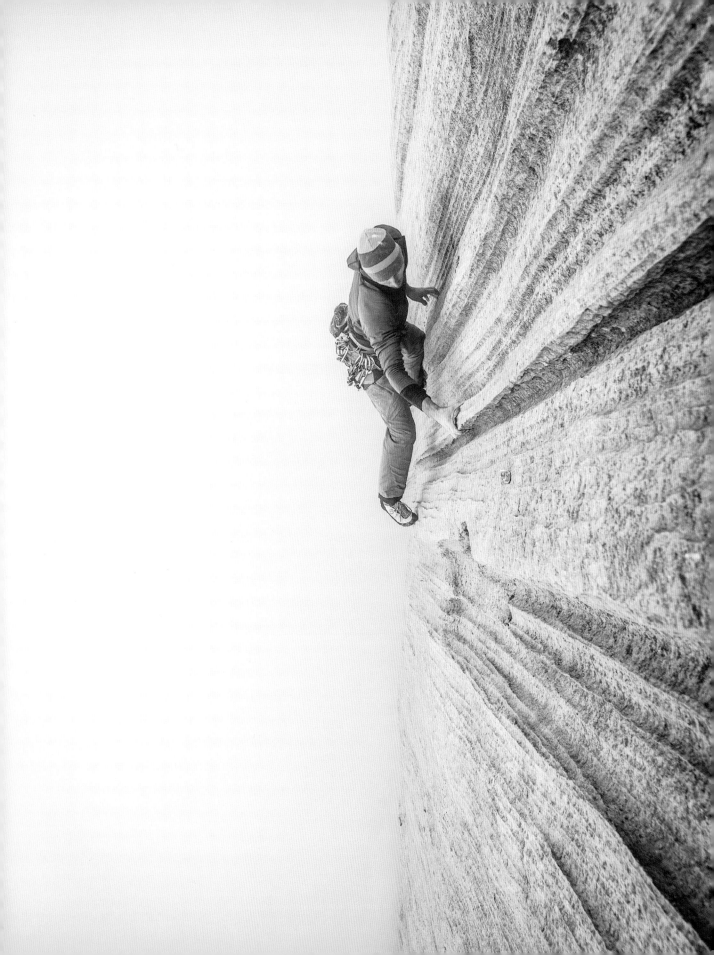

During a weeklong shoot in 2014, Michael Schaefer joined climbers Tommy Caldwell and Sonnie Trotter on a route called Coelophysis—a two-thousand-foot-high series of overhanging limestone walls on the Wendenstöcke, in Switzerland's Uri Alps. "The fog was so thick that when I looked down, I could barely see Sonnie forty feet below me," says the photographer, who lives in Redmond, Oregon. "He could be thirty feet off the ground for all you can tell, but he's really four hundred feet in the air."

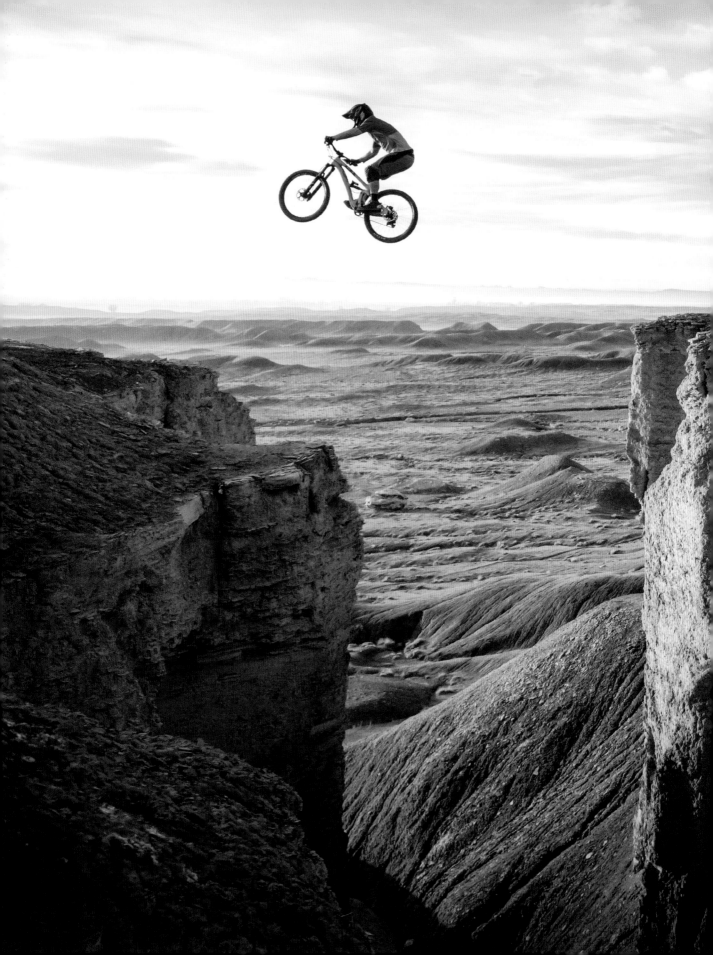

In February 2015, Joey Schusler spent a week scouting sandstone-cliff jumps around Green River, Utah, with his Yeti Cycles teammate Shawn Neer. On the morning of their last day, Neer sent the biggest jump of the trip: a forty-foot gap between the Book Cliffs, sixty feet above the ground. "It was great to hit something like that in natural terrain," says Schusler, who lives in Boulder, Colorado. "I wasn't quite in the mind-set to ride through it myself, but when I caught Shawn in the air, I knew it would be a highlight of the season."

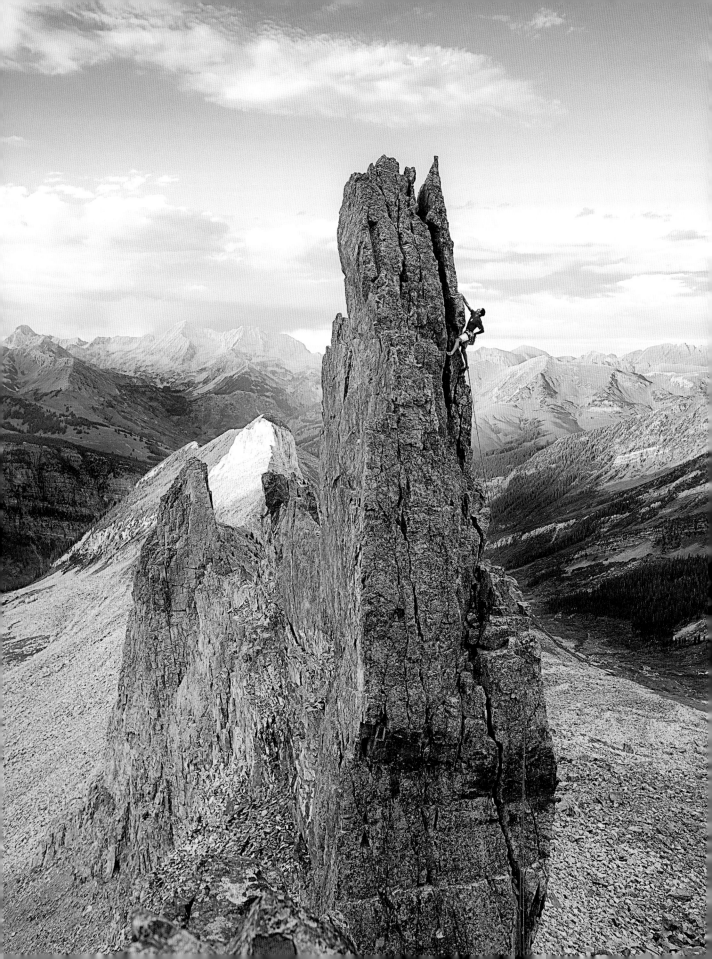

To photograph Glenwood Springs, Colorado, climber Mike Schneiter scaling Donkey Ear, an eighty-foot pinnacle west of Colorado's fourteen-thousand-foot Elk Mountains, David Clifford free-soloed a forty-foot pillar beside it during the last light of the day. "The hardest part was not getting blown off the wall by the forty-five-mile-per-hour wind," says the Carbondale, Colorado, photographer. High gusts weren't the only challenge: the climb also involved a six-hour off-trail hike from the nearest road. "It's God's country up there," says Clifford, "but you have to really work to see it."

"Sometimes the best angle for a photo is the most obvious one," says Sterling Lorence, of Vancouver, British Columbia. That was certainly the case when he photographed mountain biker Brandon Semenuk near Semenuk's home in Squamish, British Columbia. "With a rider like Brandon, you just let his moves do the talking," says Lorence. On the day of the stunt, Semenuk arrived at the jump, took three practice runs, then back-flipped over the thirty-five-foot gap. "It was ridiculous how little time it took him to prepare for something so big," says Lorence.

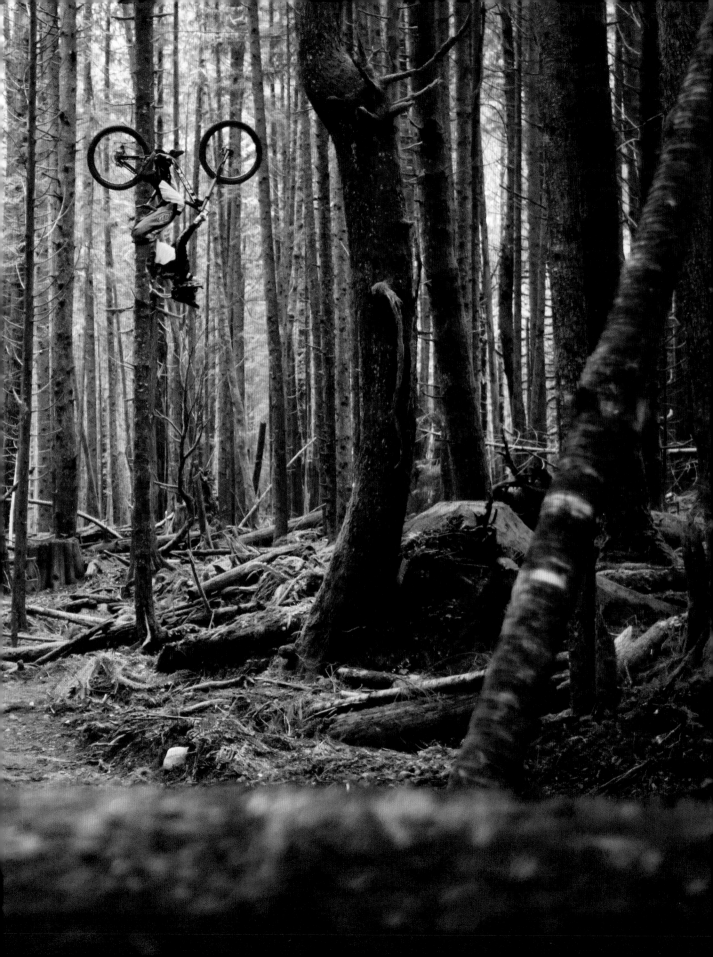

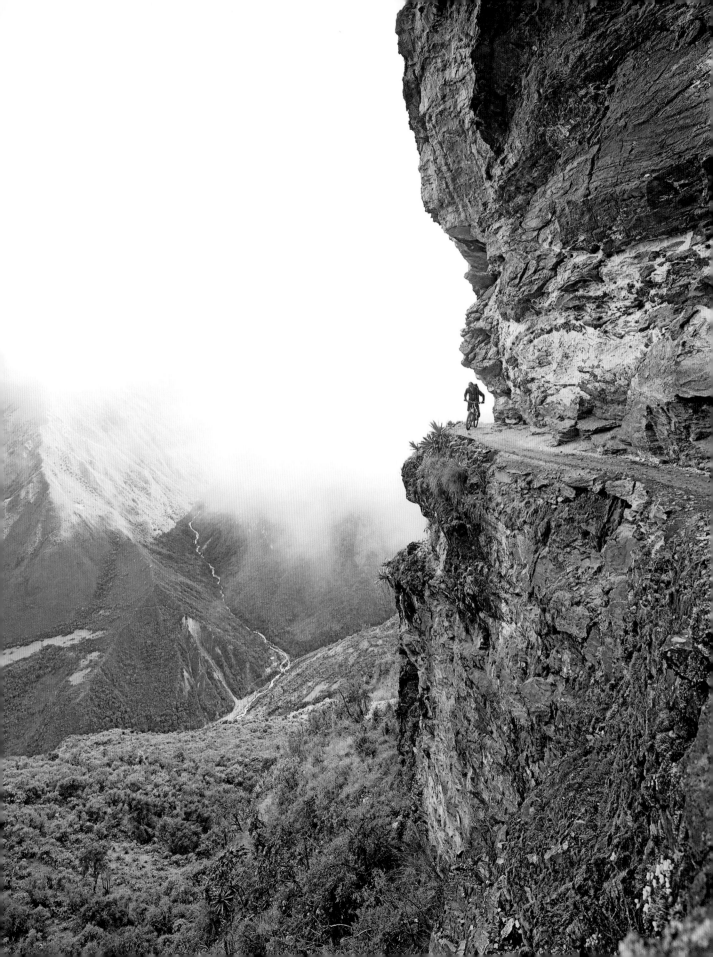

In 2014, John Wellburn, who lives in Williams Lake, British Columbia, rode miles of unmapped trails in south Peru with professional mountain biker Chris Van Dine in order to find a new route to the Inca city of Choquequirao. Twenty-one miles from the ruins, the photographer turned back to see Van Dine on an opposing ledge, a few thousand feet above the Yanama River. "It was the only time the mists cleared that day," says Wellburn. "Right away I knew this shot was unreal."

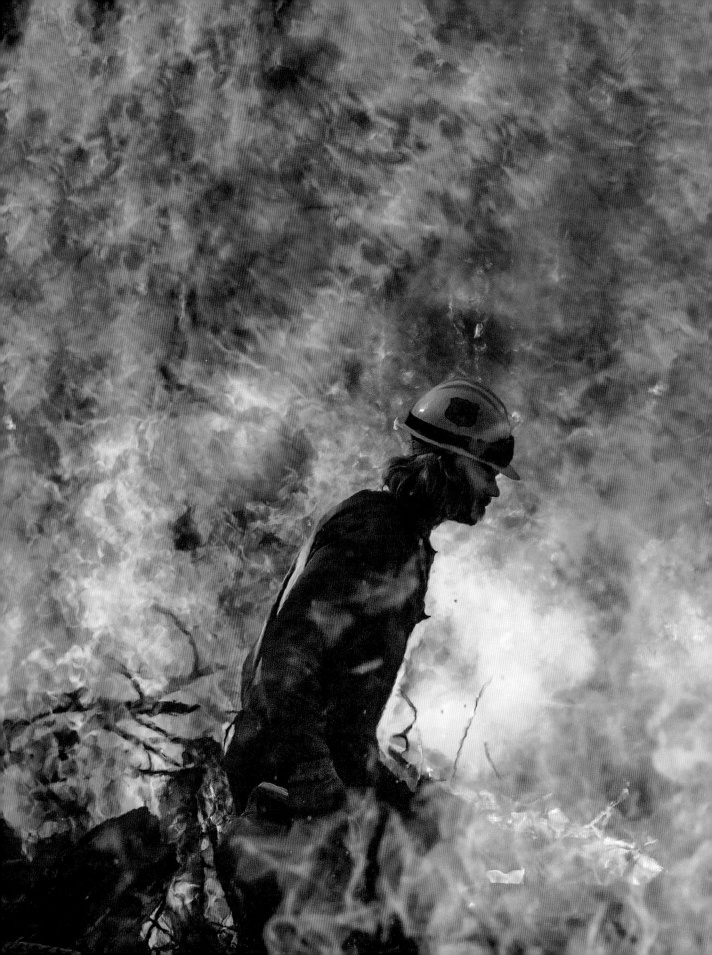

Outside contributing editor and former wild-land firefighter Kyle Dickman captured this image while reporting a story on an elite California hotshot crew for the June 2013 issue. A month after the piece ran, nineteen members of an Arizona crew just like the one he shadowed were killed in one of the worst firefighting disasters in history. The magazine ran the photo on the cover for Dickman's follow-up piece on the tragedy. It shows a firefighter working on a controlled burn of cleared brush, but the power in the image conveys an authentic intensity. As Dickman is quick to point out, all flames can be deadly. "For firefighters, work like this is usually pretty orderly," he says. "But things can quickly take a turn and people can die."

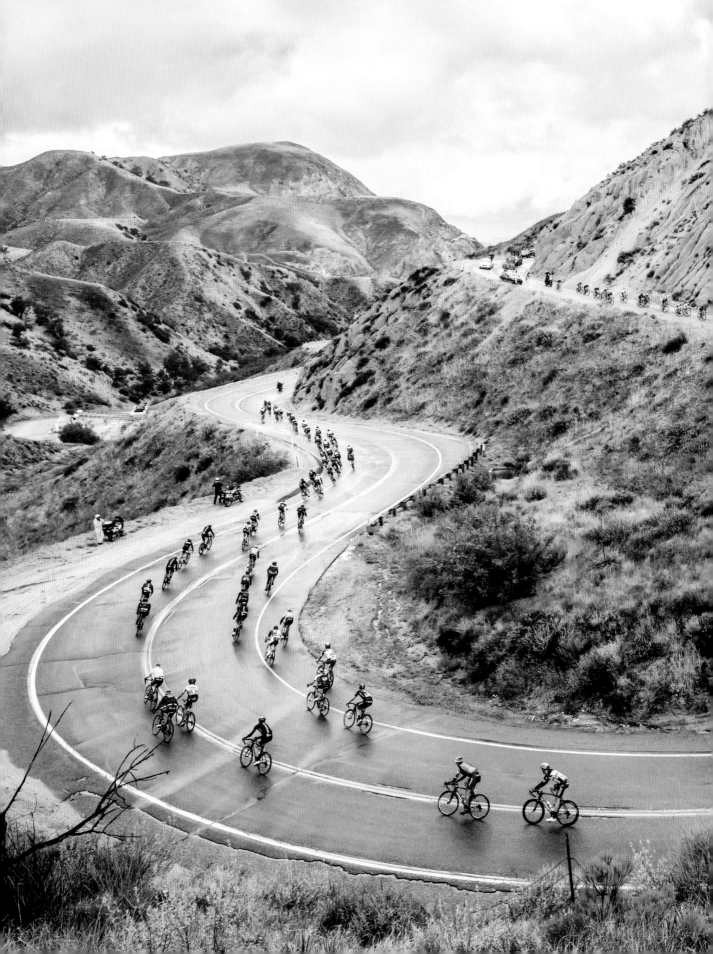

Near the end of the fifth stage of the annual Amgen Tour of California, held in May, riders fly through the orange groves of Grimes Canyon, near Fillmore, at nearly fifty miles per hour. It's a favorite spot for Virginia-based photographer Darrell Parks, who had chronicled the race for ten years before snapping this shot in 2015. To get the image, he traveled by motorcycle and then walked up a roadside deer path to this vantage point. "I'm passionate about landscapes, and the tour is full of curvy roads and wide-open spaces that I love," he says. "As soon as they came around the first corner, I was almost giggling with delight."

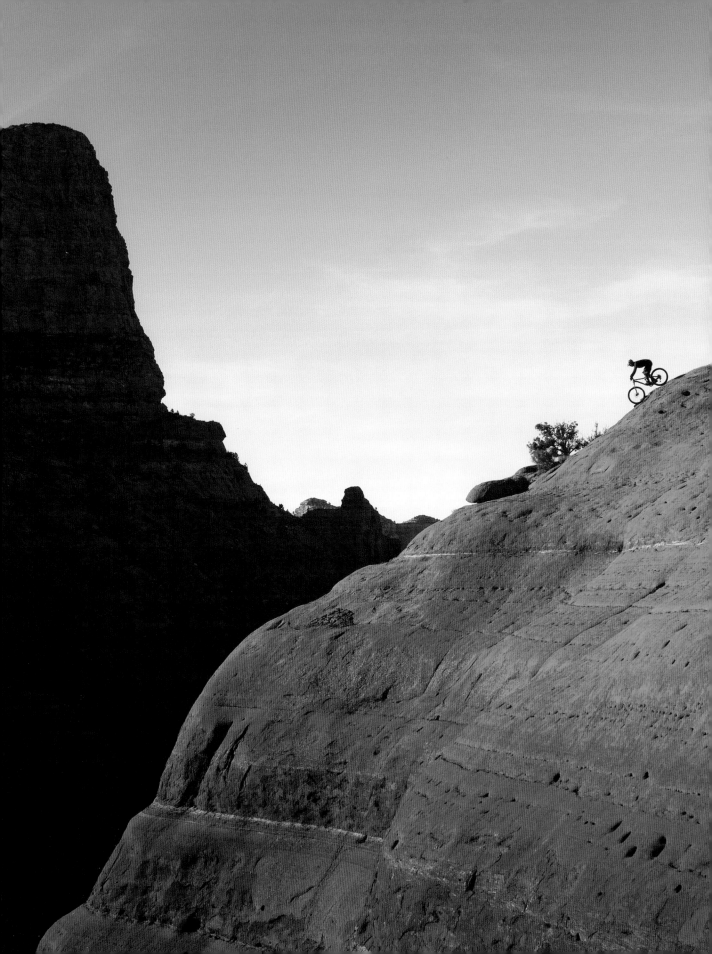

In October 2015, Jeff Diener dropped into Sedona, Arizona, to join pro mountain bikers Simon Bosman and Josh Langdon in Coconino National Forest. After an hour-long climb at sunrise, the group took turns riding a steep, two-hundred-foot downhill run off the sandstone White Line Trail. "It takes some truly precise bike handling, and any mistake would have serious consequences," says Diener, who splits his time between Boulder, Colorado, and Jackson Hole, Wyoming. "Simon was on his game. He pulled it off like it was a walk in the park."

In May 2015, Nick Kelley spent four days on the Colorado River in a forty-year-old wooden dory with photographer Ryan Heffernan, *Outside* senior editor Grayson Schaffer, and OARS crew member Blake McCord. Halfway through the third day, the group stopped at the Vishnu Basement rocks—at 1.7 billion years old, the Grand Canyon's most ancient—and McCord set to work. "I got the sense that Blake likes climbing even more than he likes guiding," says Kelley, an associate editor at Outside Online. "When climbers see rock that unique, they can't help themselves."

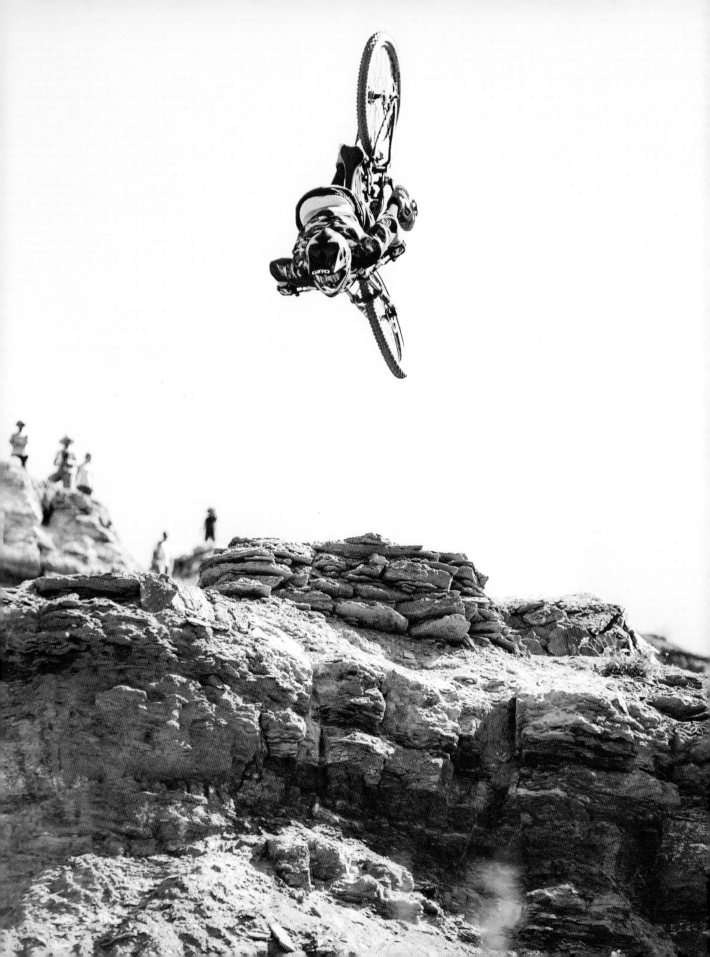

In the days leading up to the October 2012 final of Red Bull's invitation-only Rampage mountain bike competition in the Utah badlands, Greg Mionske got a sense of the course by touring it with the event's thirty-six athletes. "The mountain is essentially a blank canvas. Each rider scouts and plans his own route down from the 1,500-foot ridge," says the Brooklyn, New York, photographer. "It's amazing how fast they ride. They're 100 percent committed to their line." Like Kurt Sorge was when he backflipped off this twenty-foot cliff at the end of his winning run.

Capturing this image of a canyoneer rapelling into a massive chamber known as Grand Cathedral, in Utah's Grand Staircase-Escalante National Monument, required serious commitment from Boulder, Colorado–based lensman Joey Schusler. "To get here, you have to drop into a tight slot canyon and travel it for miles," says Shusler. "Unless you plan on doing some serious rock climbing to get out." Despite hundred-degree-plus temps the day he took this shot, Shusler says the greatest risk was hypothermia. "The water in the canyon and in this pool was freezing," he recalls. "I had to stand on my tip toes, barely holding the camera above water, to get this shot—we couldn't wait to get out and get hot again."

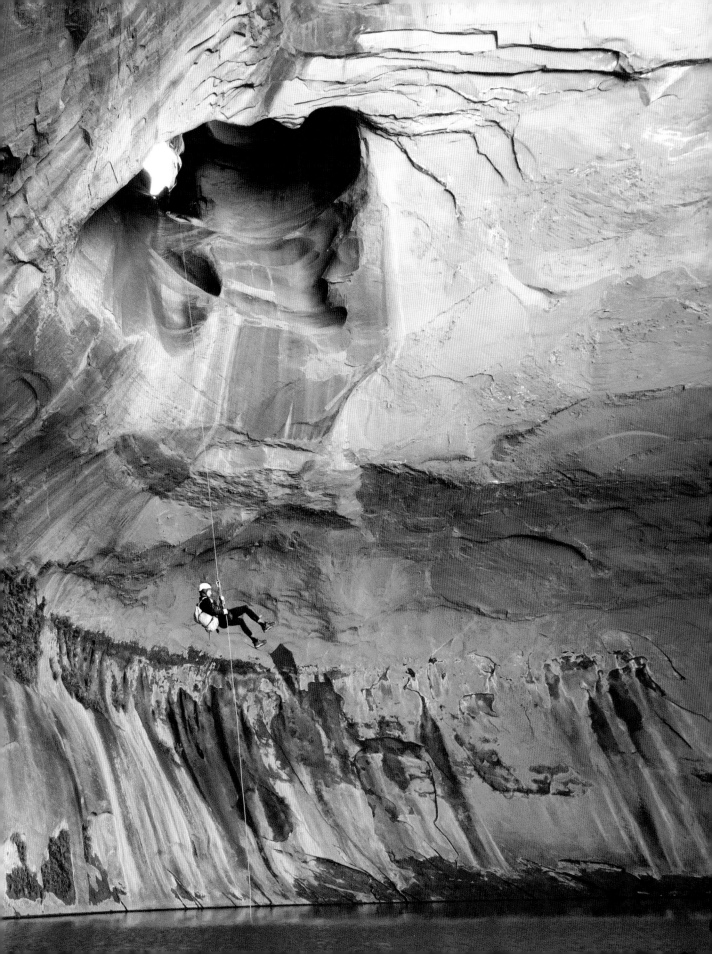

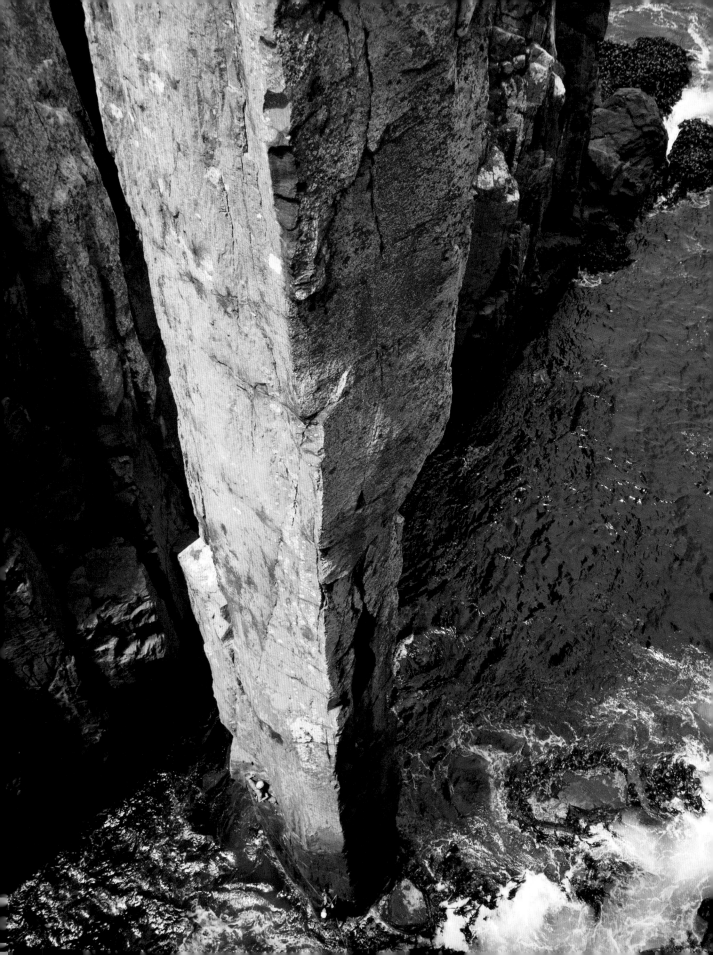

To reach the base of the two-hundred-foot Totem Pole, at Cape Hauy, Tasmania, Australia's Erik Carleberg (climbing), Brit Richard Pike (belaying), and American Dave Vuono (not pictured) had to rappel down the adjacent cliff, swing across the open water Indiana Jones style, and grab a one-inch-wide hold that was wet with seawater. "You had to time it right, because you didn't want to get washed over by a wave," says Carleberg. "You'd be fine, but you'd have to climb wet." To take the photo, Nelson, British Columbia–based Steve Ogle laid down on the opposing cliff and shot the Totem using a wide-angle lens. "The climb actually wraps onto the far side, so I had to get them at the bottom," he says. "The belayer is pinned to the wall above the ocean, holding on for dear life."

As Kelvin Trautman hovered in a helicopter above the last stage of the nine-day joBerg2c mountain bike race in South Africa in 2012, he had to be careful not to ruin the potential for a stunning image. "I was waiting for the leaders of the race," says Trautman, who splits his time between London and Cape Town. "We spotted these wildebeest grazing on the ridgeline, right where the riders would be coming through. So we hovered from a safe enough distance that we didn't spook the animals." The moment the racers came bombing down the singletrack, Trautman and the pilot were ready. "As soon as they reached the ridge, the wildebeests took off running in this long single-file line."

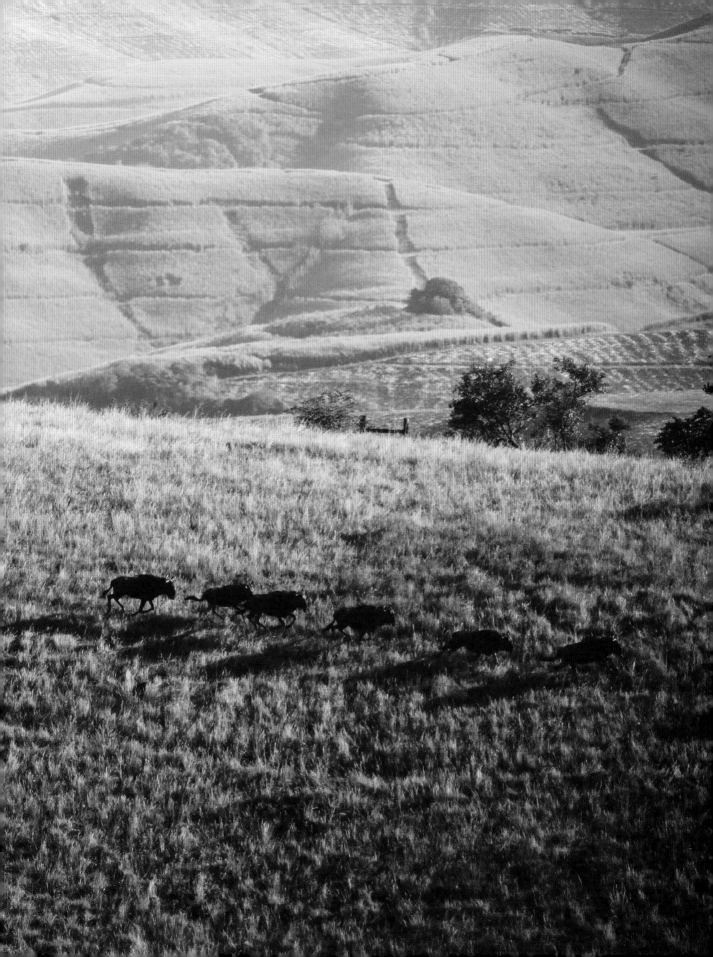

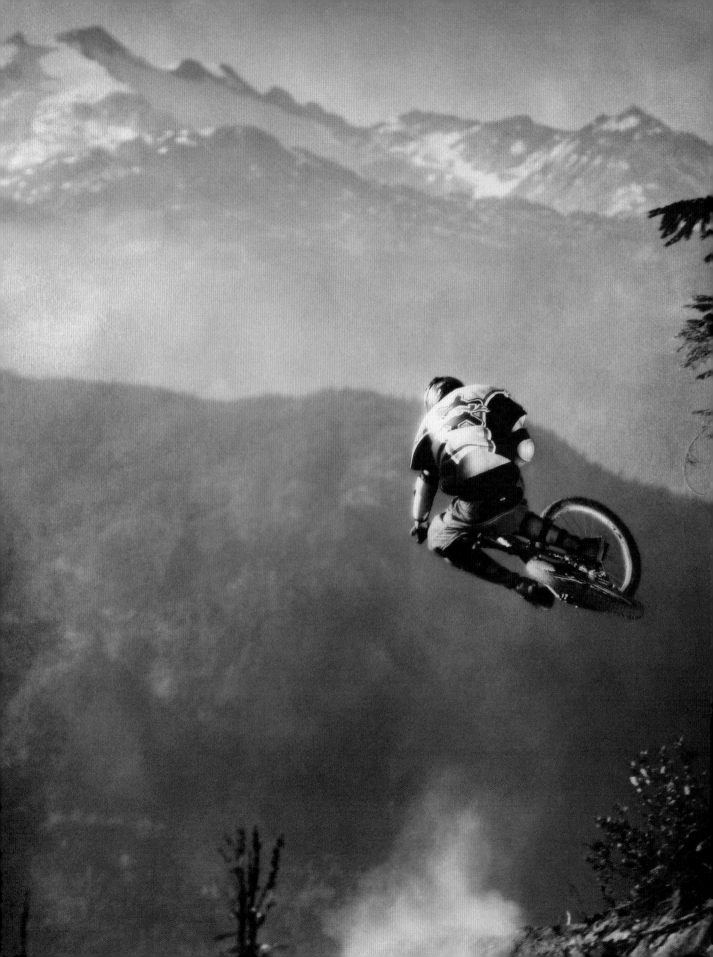

Brian Bailey schlepped his photo gear into Whistler Blackcomb's bike park and shot pro mountain biker Brent Floyd hitting this well-known jump, the Garbanzo Hip. "Free riding is this wild, super-fast, adrenalized sport," says the forty-four-year-old photographer, who lives in Carbondale, Colorado, "but I like to freeze it and reveal the style of the athlete. And what better setting than the mountains of British Columbia?"

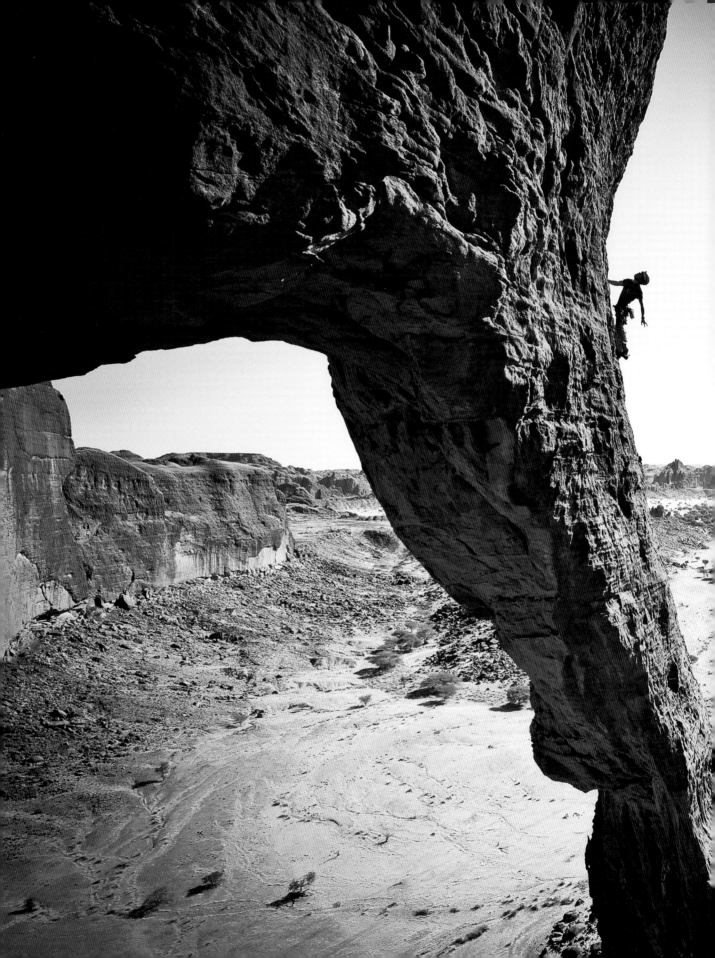

After two weeks, roughly twenty first ascents, multiple illnesses, and being robbed at knife-point, nothing was going to stop Jimmy Chin and his teammates from scaling this near-perfect arch in Chad's remote Ennedi Desert. "We were all pretty fried at this point in the expedition," says the Jackson Hole–based photographer. "But the formation was so iconic looking, there was no chance we were going to pass it up without trying." Chin was equally determined to get this shot of British climber James Pearson working the route, despite low-quality rock and nonexistent protection. "After making it to the top, we literally counterweight rappelled," he says. "Meaning, we threw the ropes over either side of the arch and then had a climber weight each side to avoid having to put anchors in the rock."

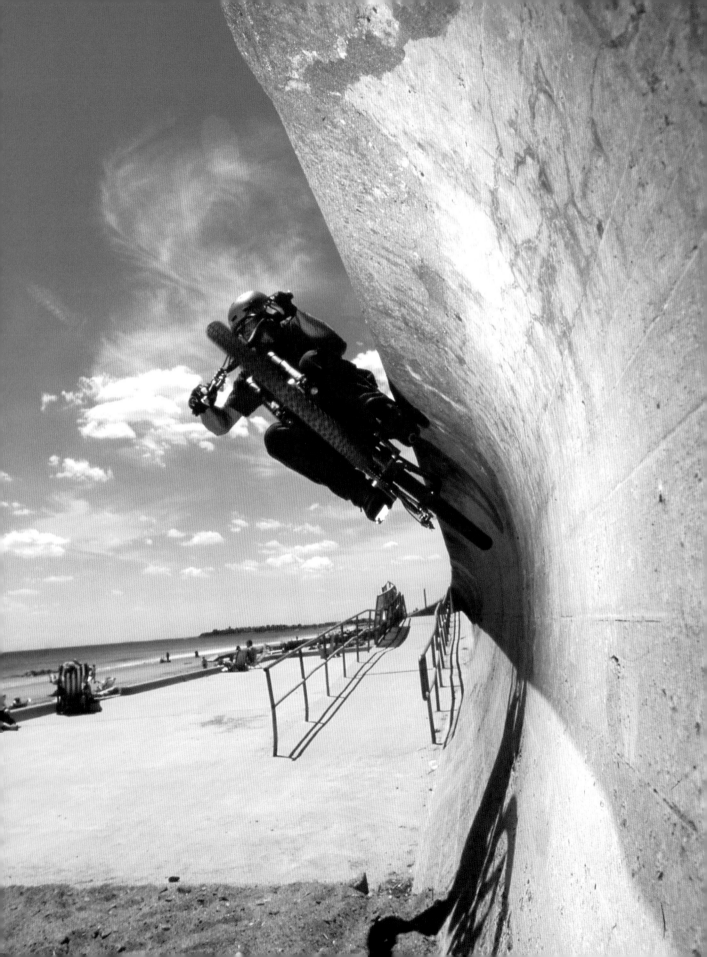

Ian Hylands was in coastal Rye, New Hampshire, at June 2004's Big Wheels street-mountain-biking competition, when twenty-six-year-old pro Eric Porter dragged him to the ocean. "Eric saw this seawall and just had to ride it," says the thirty-seven-year-old Vancouver, British Columbia–based action-sports photographer. But Porter wasn't content just to roll seven feet up the concave embankment. "He kept trying to get his pedal above the lip," says Hylands.

To capture his friend Michael Shen climbing the Red Dragon route on Moon Hill, outside Yangshuo, China, Alex Manelis traveled seven thousand miles, braved freezing December winds, and charmed a few guards who didn't want to let them onto the 164-foot limestone arch. "We told them how far we'd come, and they said, 'OK, but the minute you see other tourists, you have to come down,'" says the Palo Alto, California, photographer. "Getting there was like meeting a celebrity you've been obsessed with for years. I was above the clouds."

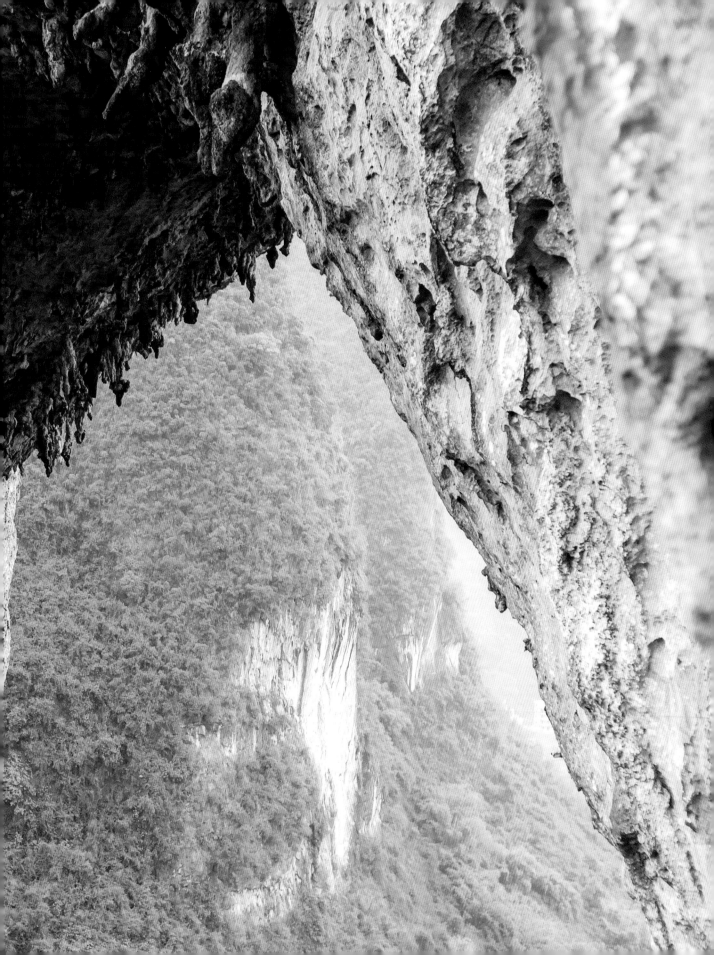

snow & ice

When elite ice climber Will Gadd proposed a mission to scale Newfoundland icebergs in 2007, this is the exact image Pondella had in mind before they even embarked on the trip. "The locals thought we were nuts," says the Mammoth, California–based photographer, who spent more than a week with Gadd in a remote Inuit village while they searched for the right berg. "We'd go out to sea every day with binoculars. We'd see a little white dot and two or three hours later, we'd get to it," he says. "We could tell this one was quite large from a distance and it ended up being gorgeous." Pondella got just the shot he wanted, but Gadd had a less-than-perfect dismount. "As Will was walking off, he lost his footing and started sliding," remembers Pondella. "But he was able to sink an axe in and self-arrest before taking a swim."

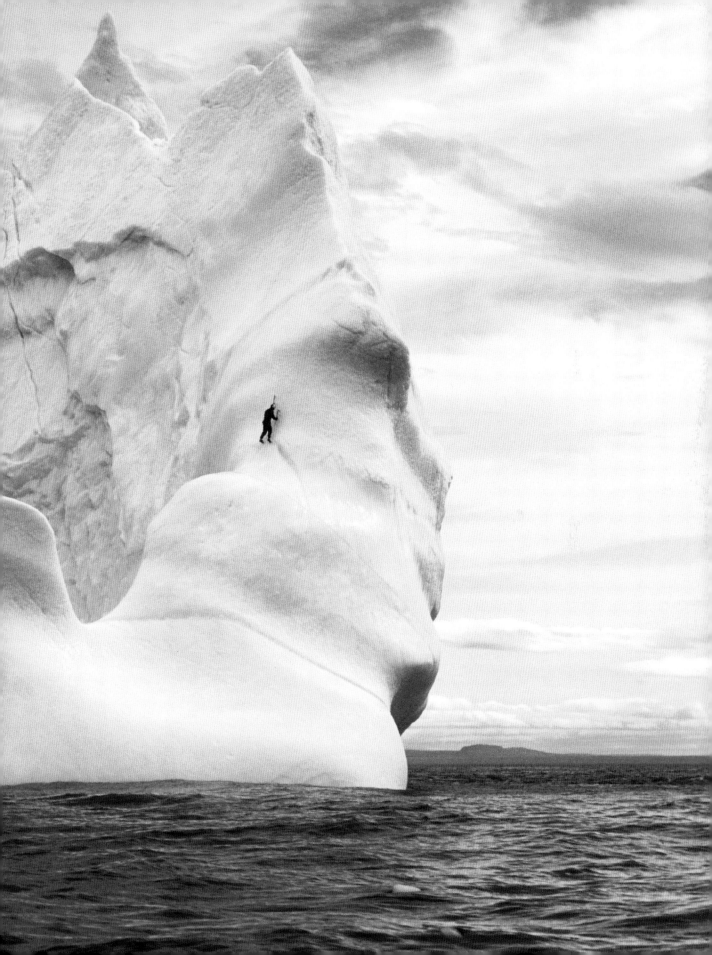

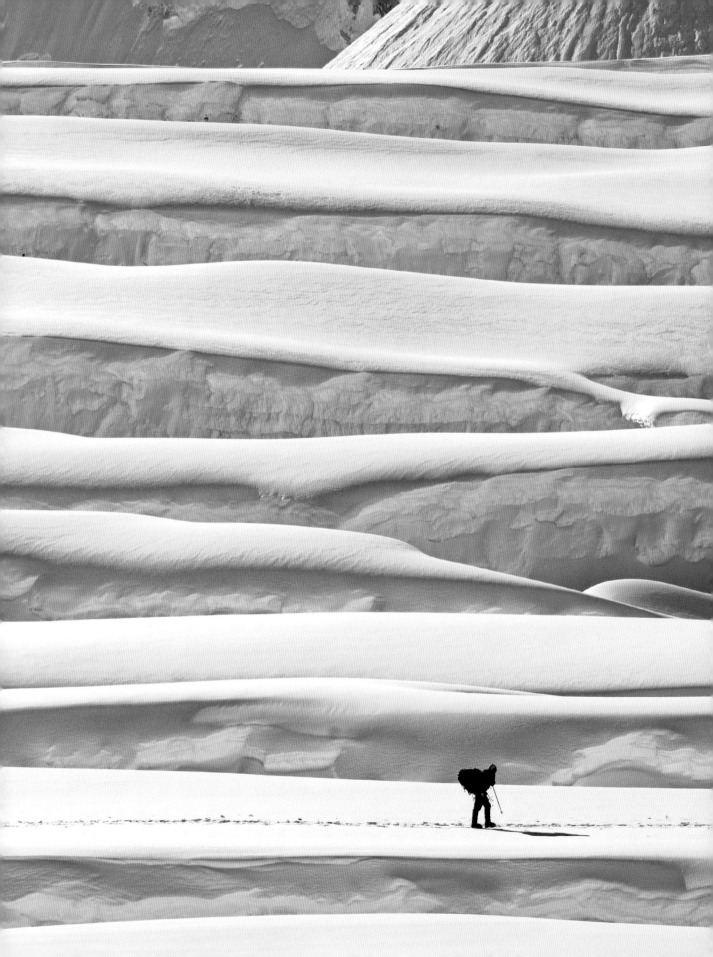

For *Outside* readers, Mount Everest has long represented the epicenter for human drama in the mountains. But while the top of the world remains an endless source of tragedy and incredible feats, the truth is that most of the heroic journeys and remarkable events of alpinism and skiing unfold in places few people have ever heard of. As the images on the following pages demonstrate, the best stories involve daring souls chasing epic experiences that would be almost impossible to imagine if an adventurous photographer hadn't been there to capture the moment.

snow & ice

Jimmy Chin shot this image of Kami Sherpa just above Camp 1 on Mount Everest in 2006, during an expedition that would have Chin, Kit DesLauriers, and her husband, Rob, becoming the first Americans to ski from the summit. He used a telephoto lens and very purposeful angle to make the lines on the glacier look compressed. But the lack of crowds is no illusion. "The spring season on Everest is a circus but this was early October, following the monsoon season, and we were the only team on the mountain," says the Jackson Hole–based climber and photographer. "In fact, we were the first team to climb Everest post-monsoon in six years. It's definitely way cooler that time of year."

During a ten-day road trip through British Columbia, Heath Korvola hit the backcountry near Rogers Pass, in Canada's Glacier National Park, with friend Mike Richards. They'd finished roughly half a dozen runs down the shoulder of a peak when Korvola decided to sit one out and wait at the top to shoot Richards skinning back up. "It was one of those days when you don't expect much as a photographer," says Whitefish, Montana–based Korvola. "In the morning, it was cloudy and overcast, but you try to stick with it. Sometimes it pays off." Minor problem: After this shot was taken, the binding on Korvola's left ski broke, and he was forced to duct-tape it together for the two-hour slog back to the car. "It was a long, one-legged ski out," he says. "At the end, my leg was throbbing. The beer that night was good."

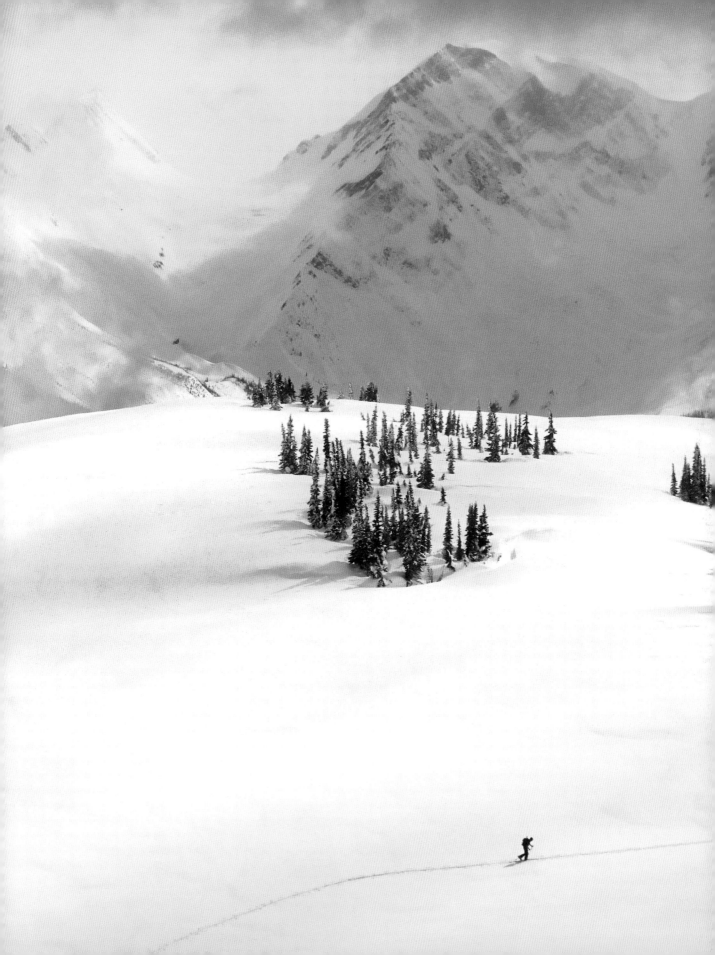

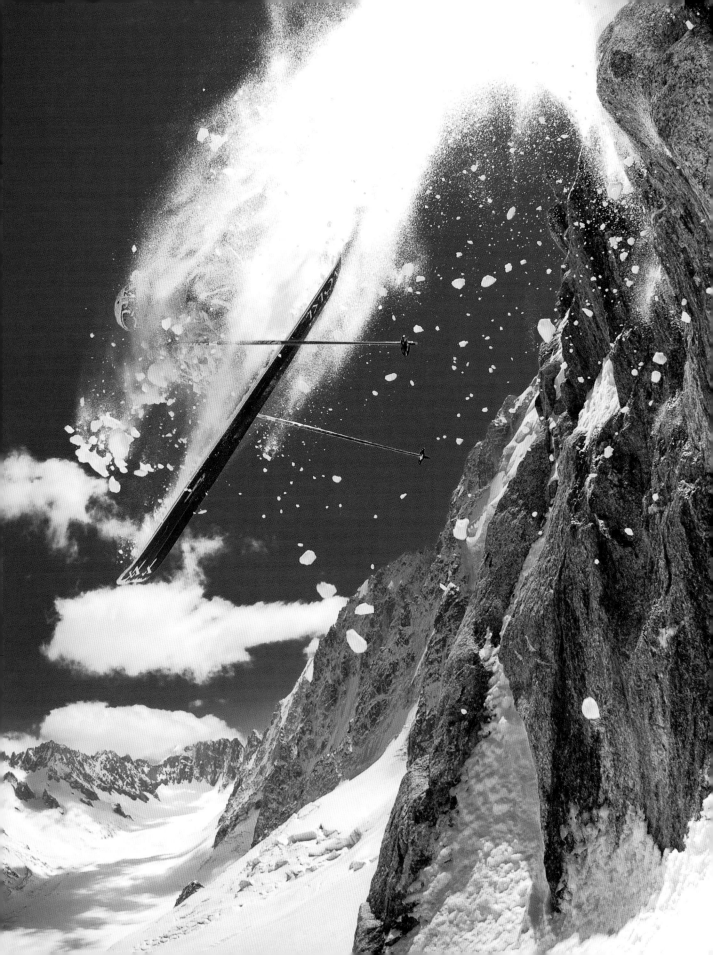

In April 2009, John Norris captured professional free skier Matt Reardon dropping off a cliff at Grands Montets ski resort, in Chamonix, France. The day before had seen two feet of new powder. "It was one of those epic days—blue skies and fresh snow—and the guys had been hucking cornices and rock bands all morning," says the Chamonix-based photographer. "The clouds above the glacier—they start forming as the temperature rises around midday. In another hour, the snow would have turned heavy and I wouldn't have gotten this shot."

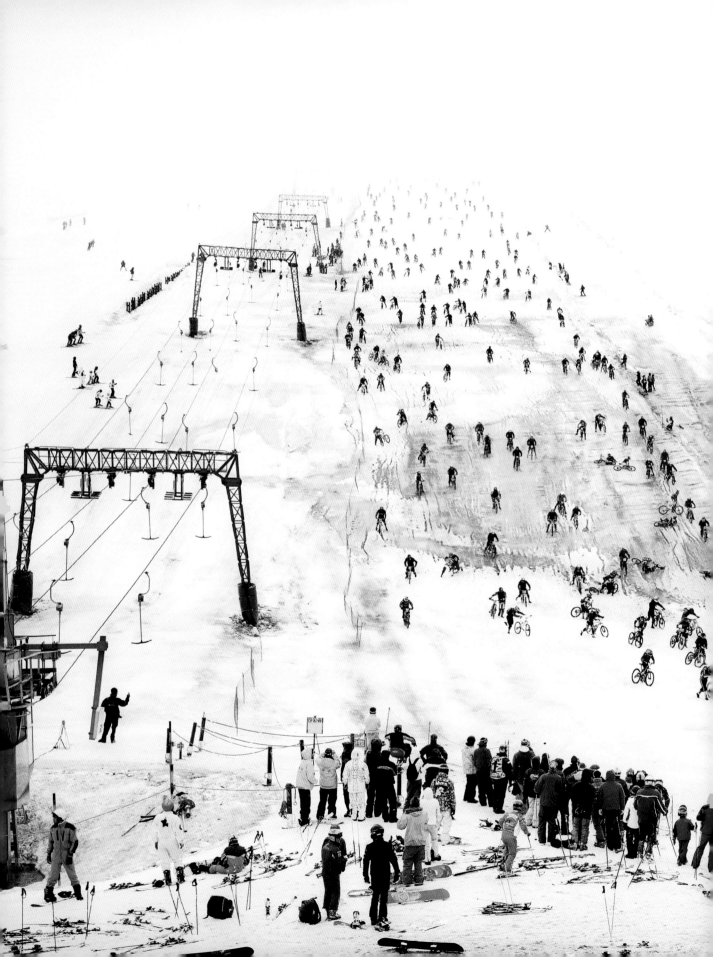

As a summertime tourist draw, France's Les Deux Alpes resort, home to Europe's largest skiable glacier, hosts the Mountain of Hell bike race. The fifteen-mile downhill sprint drops eight thousand vertical feet, with upwards of five hundred entrants jostling for position in a mass start atop Mantel Glacier. "That's the only time the racers are all together," says German photographer Berthold Steinhalber, who got this shot in July 2008. "About seven hundred feet down, the trail turns to a moon-scape of rocks and the riders spread out."

During an extended cold snap in Wolfenschiessen, Switzerland, Rainer Eder photographed Swiss guide Walter Hungerbühler picking his way up a section of nearby Al Kaida icefall. The frigid temps created safe conditions for climbing, a rarity on the frozen five-hundred-foot cascade, and Eder set up across the valley to shoot. "Afterwards, Walter told me he'd heard the whole icefall settle with a *whoomph*," says the Baar, Switzerland–based Eder. "Frightening if you're climbing, but I didn't even notice." Two days later, after warmer weather moved into the area, the icefall was completely gone.

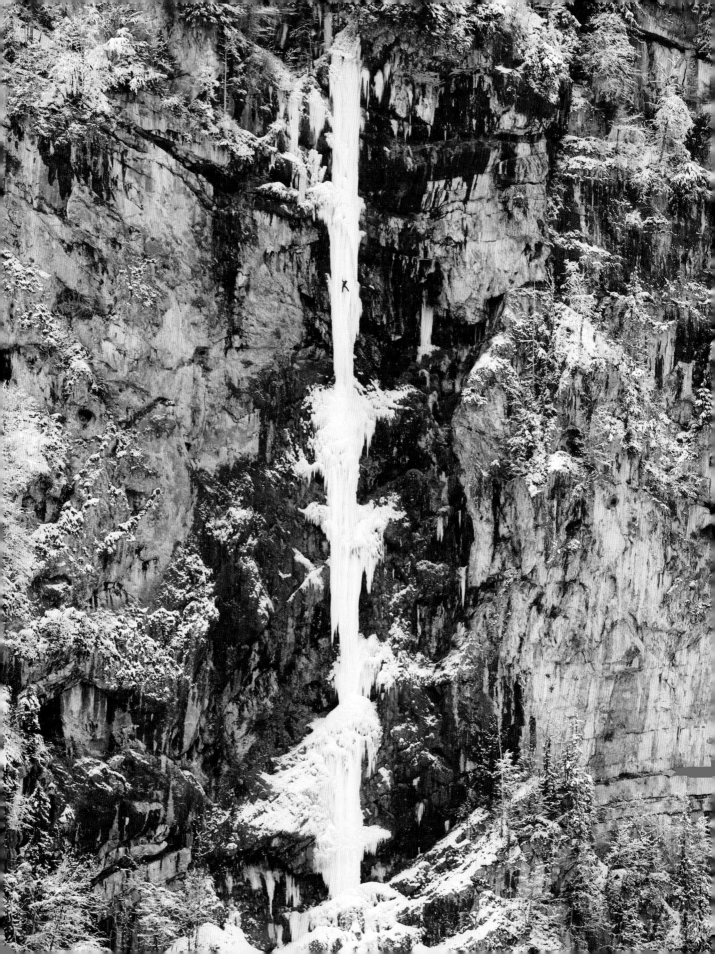

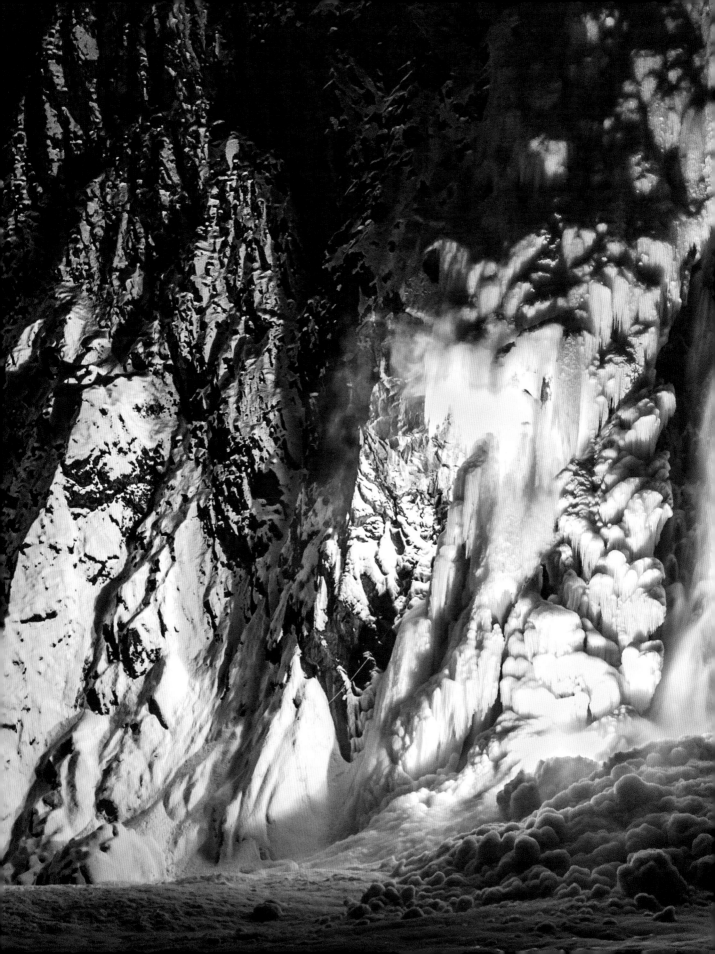

To shoot climber Stephan Siegrist scaling a frozen waterfall near Eidfjord, Norway, in February 2014 Thomas Senf set up three pocket flashes, triggered them by remote control, and captured this single image before the lights burned out a few seconds later. "We'd planned on installing a whole lighting system around the falls, which would have given us more time to work, but the conditions were too dangerous," says the Interlaken, Switzerland, photographer. "By the time we packed up thirty minutes later, the flashes were covered in ice."

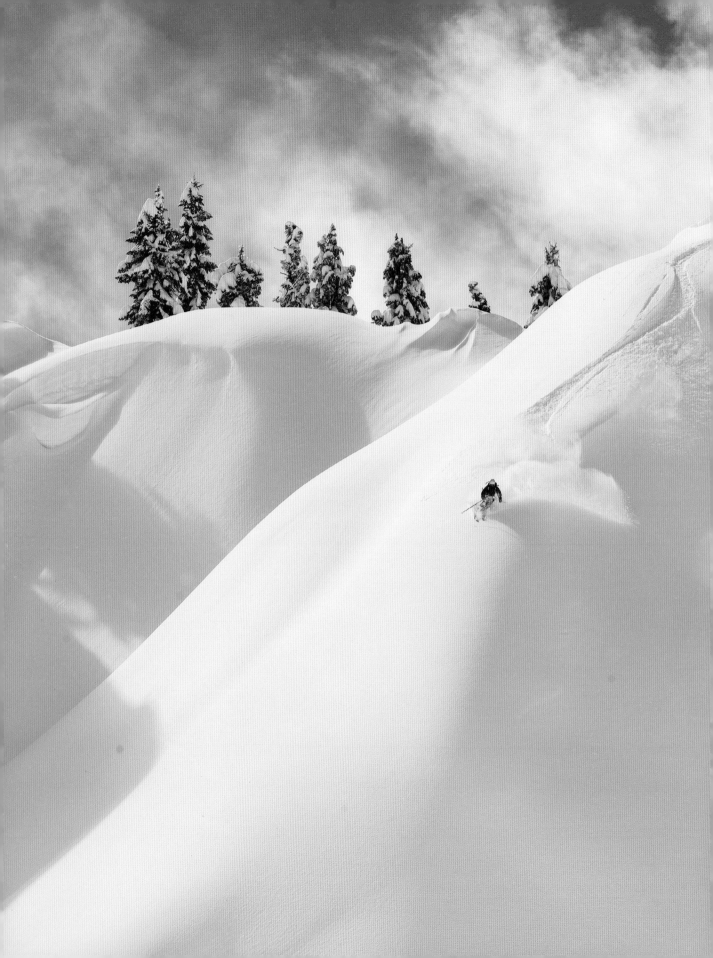

The winter of 2013/2014 was unusually dry in Bellingham, Washington, where photographer Grant Gunderson lives. But in late February 2014, ten inches of new snow blanketed the North Cascades, and in the first week of March, the thirty-five-year-old lensman headed into the backcountry with professional skier Adam Ü and Ü's girlfriend, Tess Golling, captured here carving a spine on Mount Shuksan. "It was a bluebird day, the kind you wait all year for," Gunderson says. "Clear skies, fresh powder, and Tess skied it beautifully."

Marcus Caston was almost certainly
the first person of the season to ski the
fjords in Nordurfjördur, Iceland, where he
and photographer Mike Schirf traveled in
April 2015. "The roads were just being cleared
up," says Schirf. "Marcus spotted this line and
said, 'I want to jump off that corner.'" Schirf, who
lives in Salt Lake City, followed Caston to the
top of a 1,500-foot run, wearing crampons on the
climb to keep his footing in the icy spring condi-
tions. "I was a little nervous, but Marcus hit it like a
true pro. It's definitely my favorite shot of the trip."

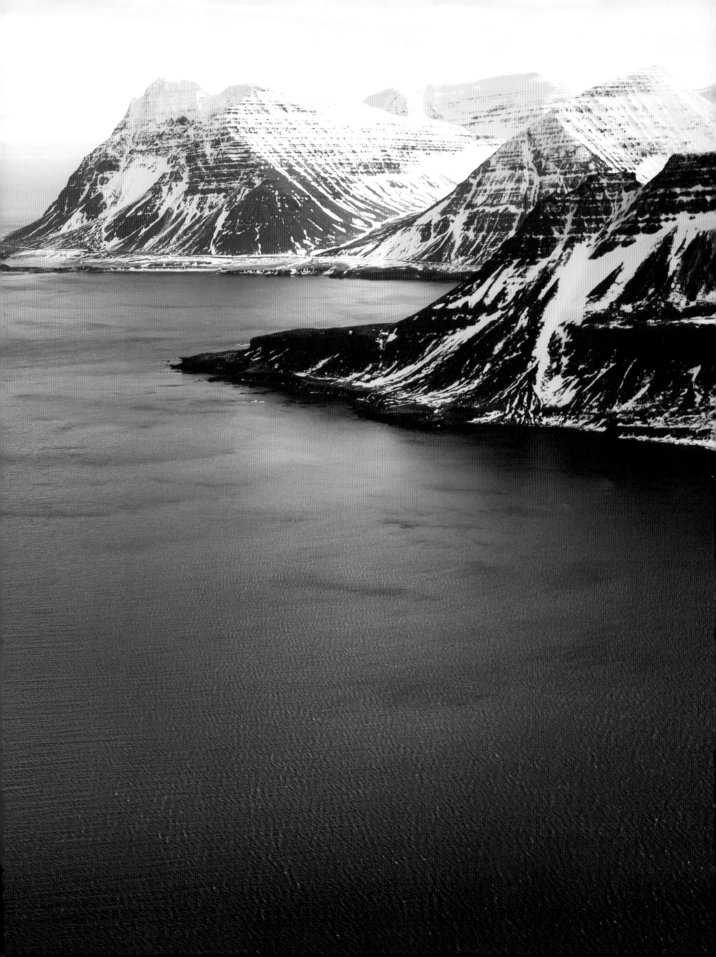

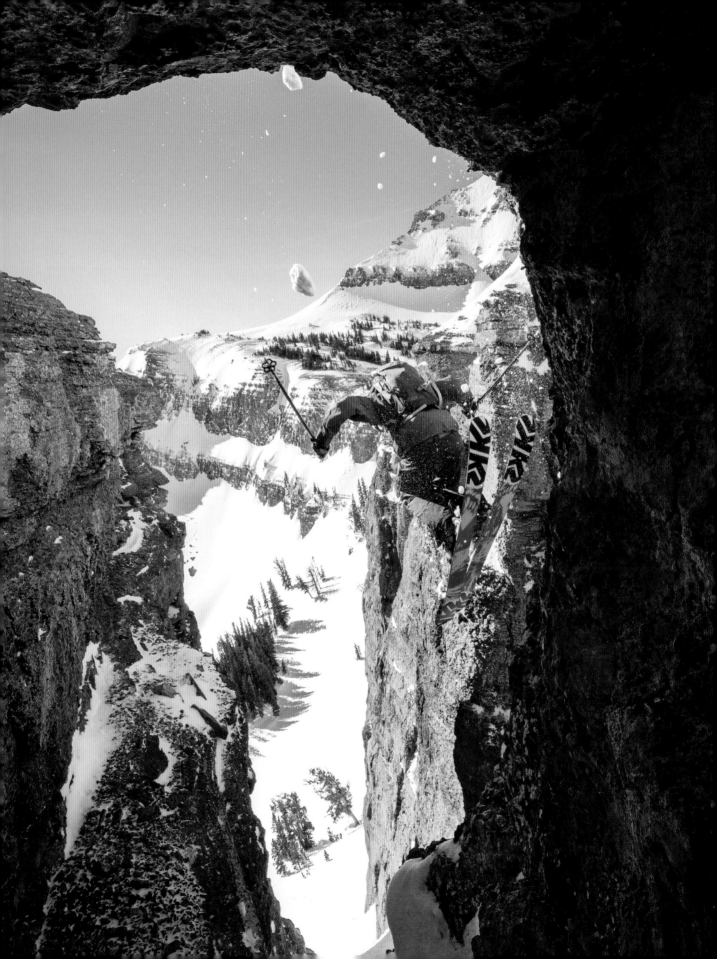

Carson Meyer and skier Sam Schwartz had spent many winters exploring the Jackson, Wyoming, backcountry together, but neither noticed this cave until a sunny day in February 2016. The then-twenty-year-old photographer was rappelling down Gothic Couloir, a two-hundred-foot-long chute in No Name Canyon, when he discovered the opening just below the lip. Realizing that it was the perfect vantage point, Meyer wriggled in to catch Schwartz as he cleared the thirty-foot drop. "In that canyon, you don't really have the option to circle around and try again," says Meyer. "It was our one-shot wonder."

Ryan Creary and split-boarder Mikel Witlox
came across this snow-covered boulder field
in British Columbia's Lizard Range on an early
April morning. "It was like skiing through a
Dr. Seuss book," says Creary, of Revelstoke,
British Columbia. He snapped Witlox skinning
beneath a twenty-foot boulder moments after
the sun crested the ridge to the east, casting
fifty-foot shadows. "It was very abstract," says
Creary. And fleeting. Ten minutes later the sun
was up, and the light went flat. "That's the joy
of the mountains. Sometimes the perfect shot
exists for only a single moment."

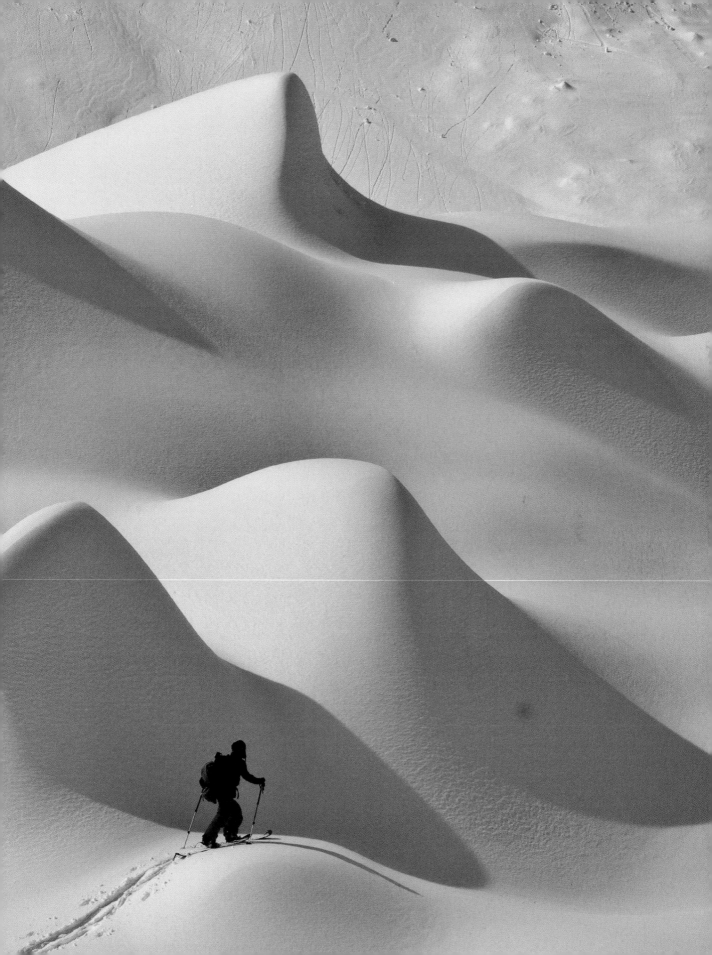

"We spent half our monthlong trip sitting in a hotel in Juneau, Alaska, waiting for the storms to break," says photographer Mark Fisher, age thirty-five, of Victor, Idaho. When good weather arrived, Fisher helicoptered into the Coast Range to capture skier Ian McIntosh on this line, which required a twenty-foot jump over a crevasse. "There was six feet of fresh snow, and the conditions were absolutely perfect," Fisher says. The bliss was short-lived. Four days later, McIntosh hit a patch of ice and fell one hundred feet, fracturing his femur.

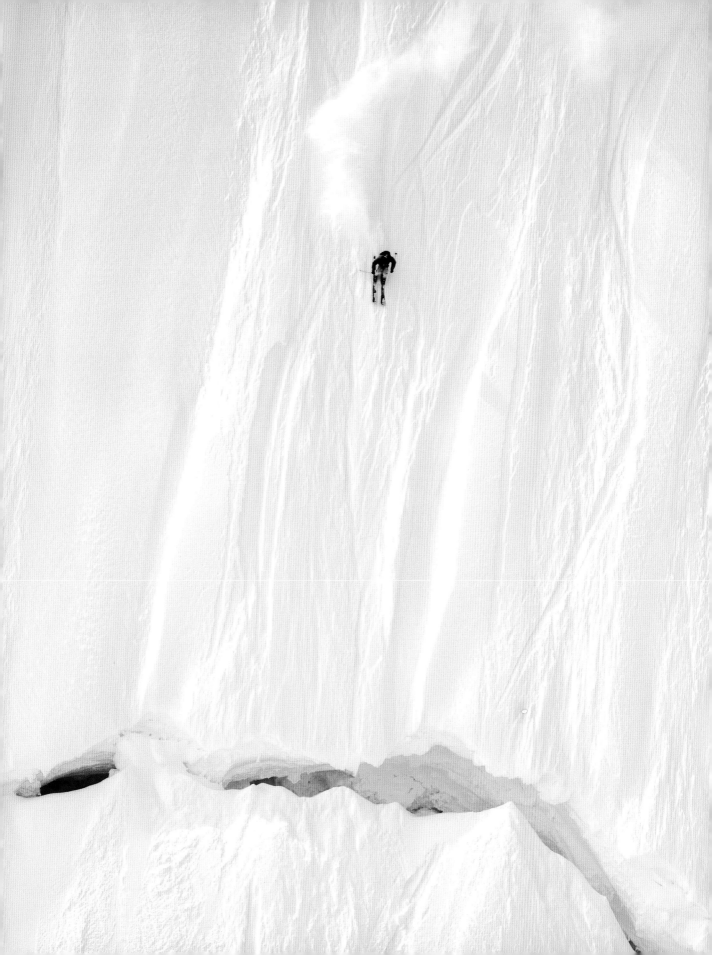

Jimmy Chin, Conrad Anker, and Renan Ozturk's daring 2012 first ascent of India's twenty-one-thousand-foot Meru Central via its Shark's Fin feature was dramatically chronicled in the documentary *Meru,* which won the audience award at Sundance and is considered one of the most powerful modern films about mountaineering. But few people realize that the trio survived a far more harrowing ordeal on a failed attempt of the peak four years earlier. "I took this shot on the 2008 trip," says Chin. "We had put this portaledge up in the middle of the night. It wasn't the best spot—normally, you look for a little bit of a ledge, but there wasn't any of that here." It was good enough, though. The structure sheltered the climbers from a brutal rations-depleting storm that hit just hours later and lasted for four days. Here, as the sky finally cleared, Ozturk surveyed the conditions before one of the biggest days of climbing on the expedition.

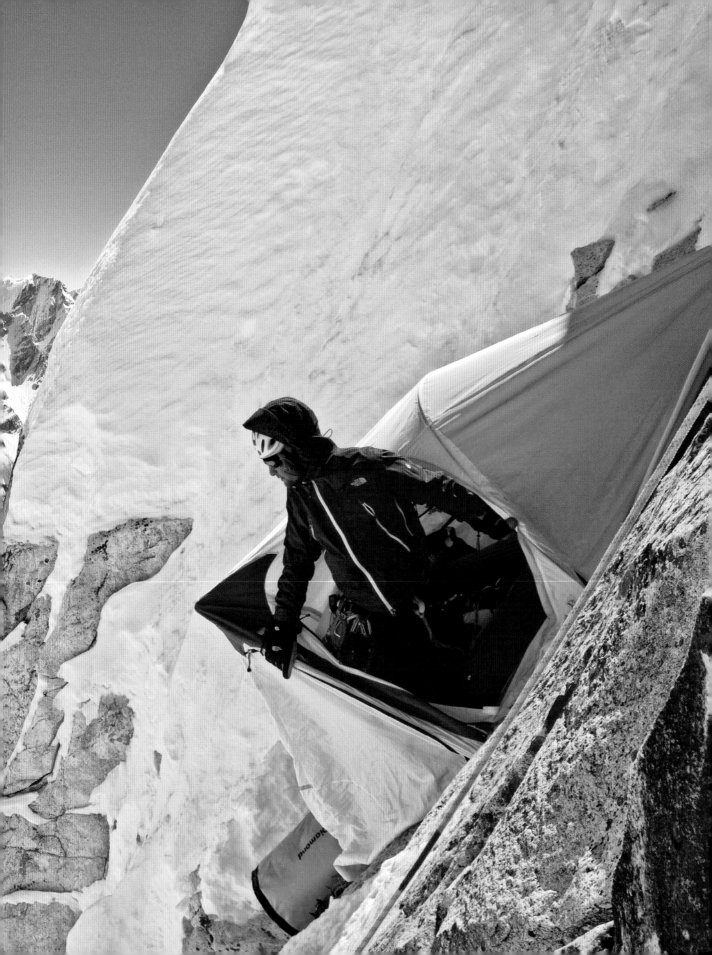

When a cold spell rolled through the Sea-to-Sky Corridor near Squamish, British Columbia, in December 2013, Jim Martinello didn't pass on the opportunity to shoot Tim Emmett climbing this three-pitch feature, formed from frozen spray ice. "Tim had been working on it for two days when it disappeared as a result of warmer weather," says the Squamish photographer. "Now we'll have to wait for the next freeze."

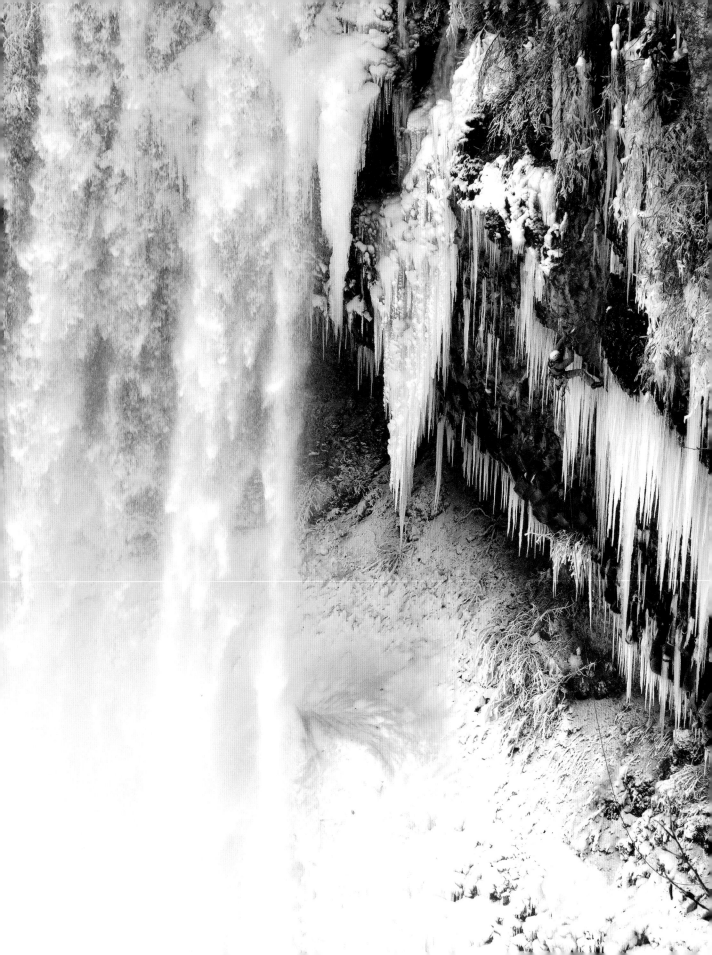

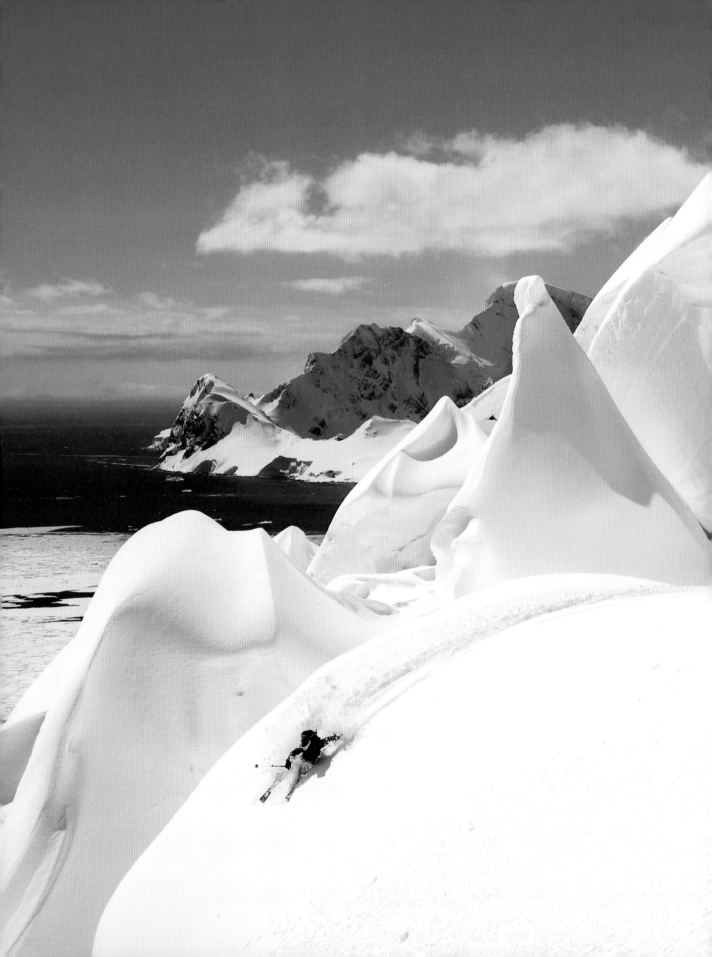

Ben Shook was halfway down Antarctica's 2,264-foot Mount Tennant when Gabe Rogel captured him skiing beside a series of ice pillars. "The terrain there is endless," says Rogel, of Driggs, Idaho. "Everywhere you look is snow and ice." For five days, the two men skied lines on the five-thousand-foot peaks that rise from the Gerlache Strait. Their shuttle vehicle—and temporary home—was a 387-foot polar-research vessel. "We skied every line summit to sea," says Rogel.

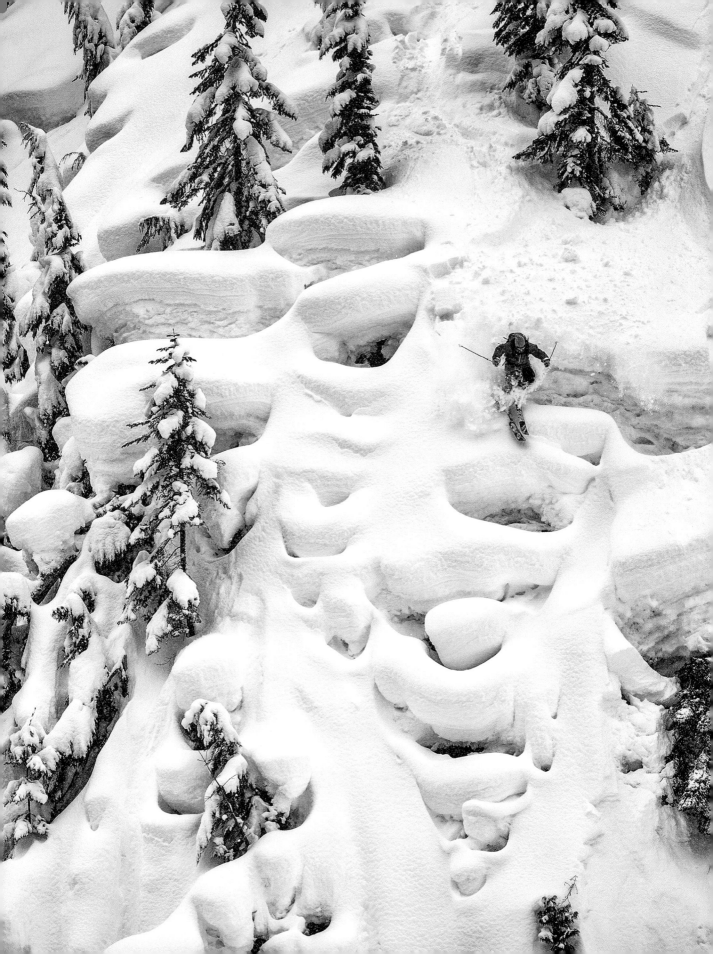

In March 2013, after a blizzard dropped nearly ten feet of snow on Washington's Mount Baker, Grant Gunderson and ski partner Josh Daiek headed into the backcountry and discovered a series of short cliffs near the resort. To get this shot of Daiek dropping off the rocks, the Bellingham, Washington, photographer positioned himself high on a ridge four hundred feet away. Between him and Daiek: an avalanche path. "I was a little nervous to finish the line in the danger zone," says Daiek, of South Lake Tahoe, California. "But I stayed on my feet and blasted right through to the safety of the trees."

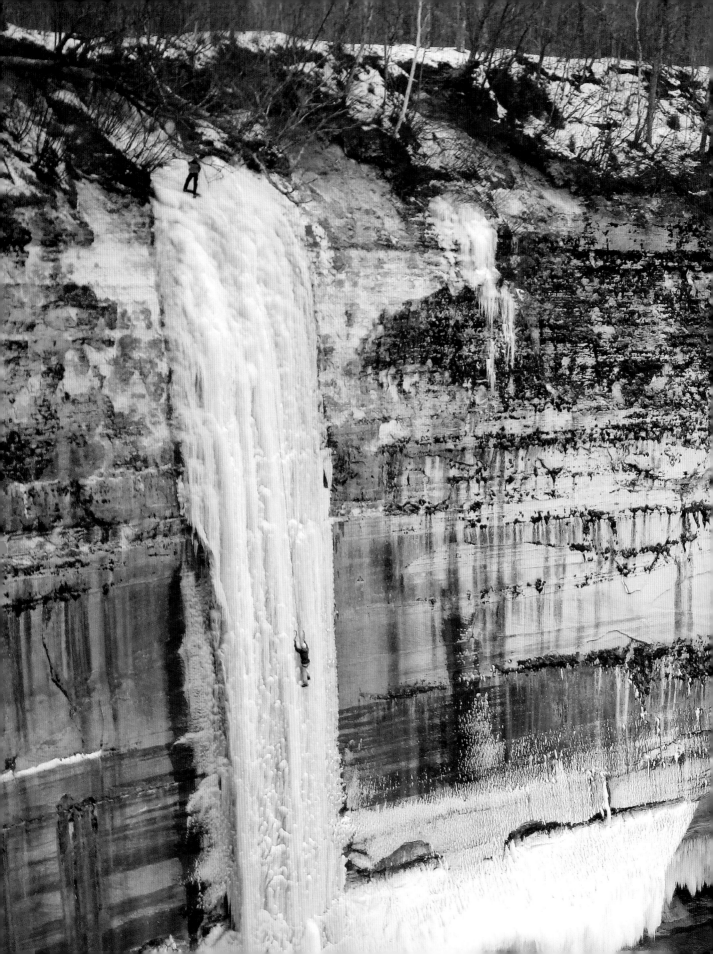

As soon as temperatures drop low enough to freeze the water seeping out of the sandstone cliffs around Lake Superior, ice climbers like Austin Fogt and Ross Herr flock to Michigan's Pictured Rocks National Lakeshore. "I was supposed to be in class at Northern Michigan University but played hooky to climb," says twenty-three-year-old Fogt. Luke Tikkanen, who's not a professional photographer, was perfectly positioned to take this image of him halfway up a 175-foot iron-stained column of ice. "It was actually a really bad day to skip, because I was supposed to be helping out on a big group final," says Fogt. "But missing out on that climb would have been worse. Besides, I still managed to graduate."

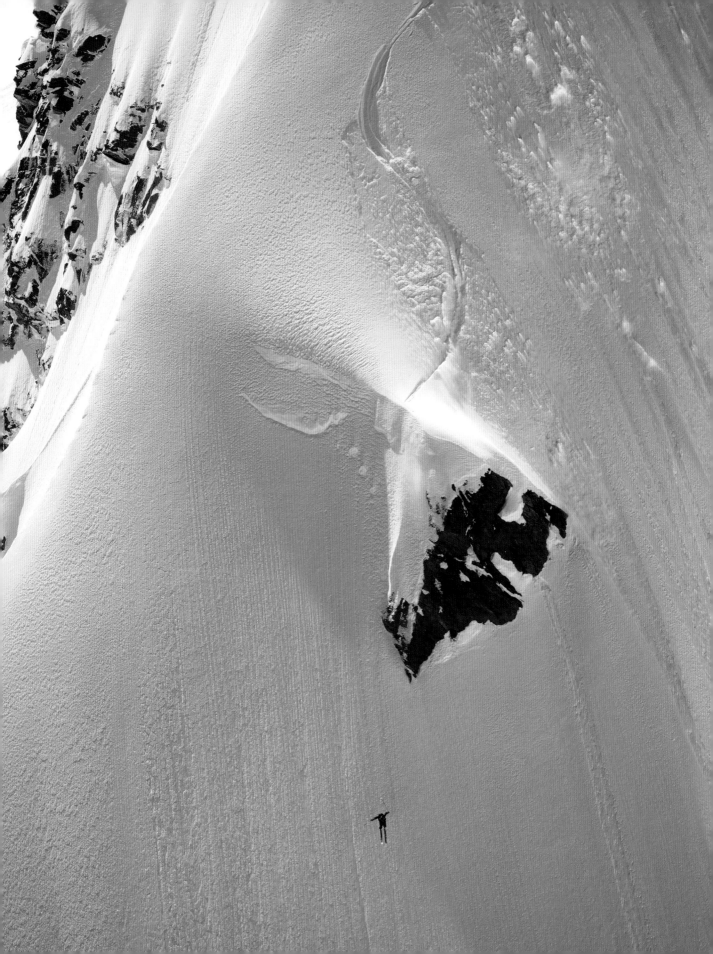

Minutes before Jeremy Bernard captured Jeremie Heitz dropping off a twenty-foot cliff near Zermatt, Switzerland, their skiing partner, Swiss mountain guide Samuel Anthamatten, tore his ACL on the same line. "We'd just lost the only guy who knew where the best skiing was," says Bernard, of Annecy, France. Fortunately, Anthamatten, who skied down to the bottom, insisted he wasn't in (much) pain. So what did he do? "He sat in the passenger seat and guided us to some of the most epic lines in the Alps. Needless to say, we bought him a few beers to show our thanks."

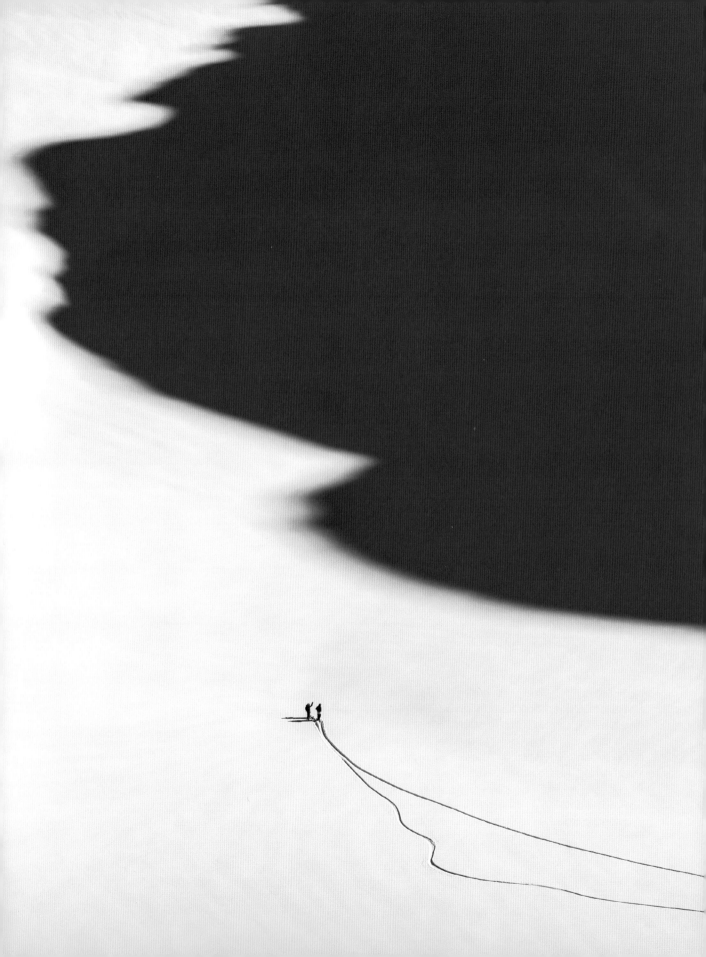

Last spring, after traveling thirty hours from Whistler, British Columbia, Andrew Strain landed in Akureyri, in northern Iceland, and immediately boarded a helicopter bound for the mountains of the Hidden Land Peninsula. He was exhausted, but when you get a chance to heli-ski in Iceland with Olympic snowboard-ers, "you do what you can to stay awake," says the thirty-two-year-old photographer. Strain watched Scotty Lago and Greg Bretz shred a line down a long ridge, and when they stopped to wait for the helicopter near the shadow of the peak they'd just descended, he knew he had a good shot. "I didn't direct them, they just ended up there," he says. "It's such a simple composition."

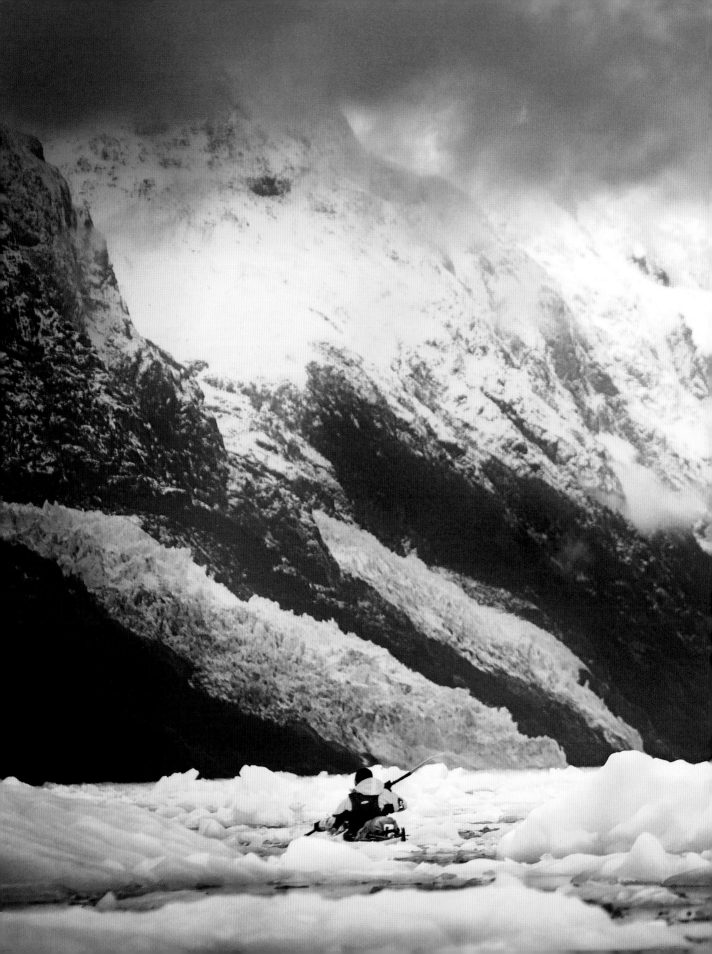

There is no camera lens in the world capable of capturing the scale of Patagonia's vast glacial fjords, so photographers try all kinds of stunts to boost their field of view. "I wanted to show just how much ice there was and how locked in we were," says *Outside* editor-at-large Grayson Shaffer. "So I just took off my spray skirt and stood up in my kayak—it was a balancing challenge." With the help of a Gore-Tex Shipman-Tilman expedition grant, Shaffer and veteran Patagonia paddler Reg Lake spent three weeks in 2007 picking their way through an ever-shifting maze of ice to reach this spot near the end of the Peel Inlet. "Changes in the wind or tide could pack it even more and make the channels smaller," says Shaffer. "It was like constantly trying to pick the right fork in the road."

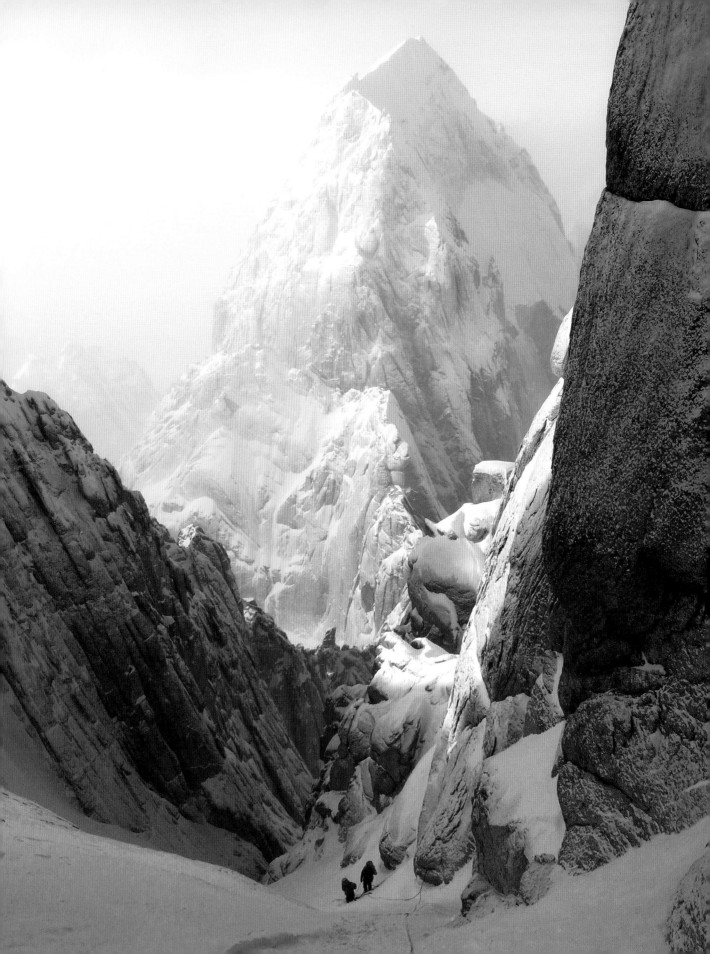

Kristoffer Szilas was a few minutes into his third day of climbing Alaska's 8,520-foot Citadel, in the Kichatna Range, when he snapped this photo of his two partners ascending the final couloir. "We'd just endured an extremely cold night, sitting on a tiny ice ledge that we'd chopped out of a seventy-degree face," says the Danish photographer, who lives in New York City. Szilas wasn't sure they were going to make the summit, until he saw the dawn light on the Kichatna Spire. "It was a magical moment. The weather was clear, and I knew we could push through the last section to the top."

Scott Serfas didn't know what John Jackson, pictured here, was thinking when the professional snowboarder launched off a twenty-foot cornice in Alaska's Tordrillo Mountains and dropped one hundred feet to a fifty-degree slope below. "I was wondering what he was going to do at the cornice band," says Serfas, who lives in Vancouver, British Columbia. "It was the biggest air I'd ever seen." That's saying something, considering that the photographer spent two years shooting snowboarders during the production of Brain Farm's *The Art of Flight.* "I couldn't believe he landed it," says Serfas.

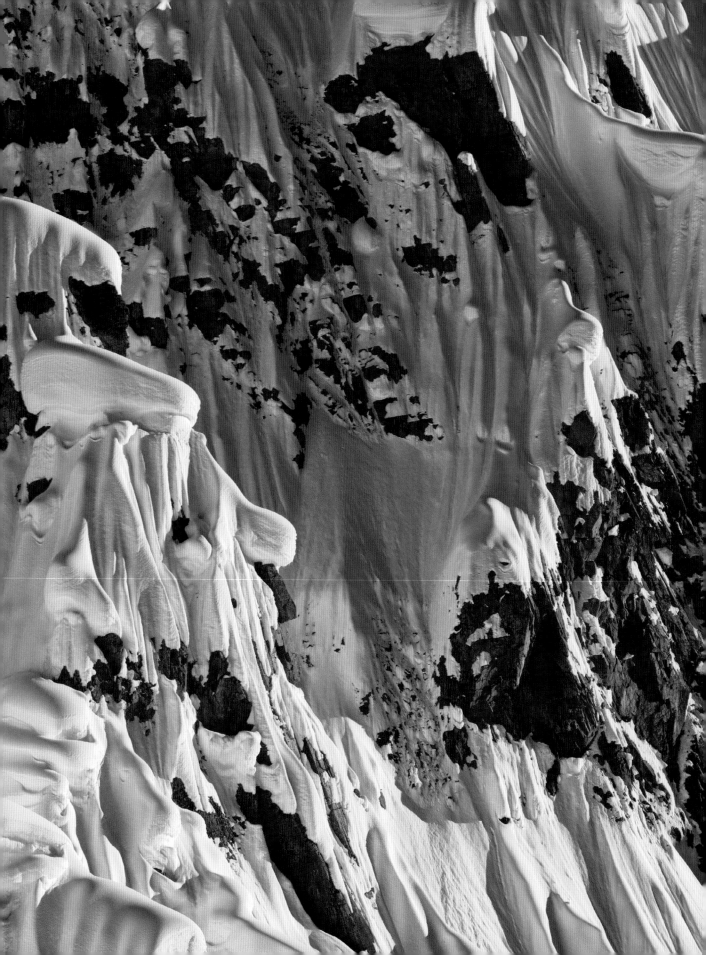

When Grayson Shaffer waited patiently on the frigid flanks of 23,494-foot Pumori to capture a time-lapse video of the annual conga line of headlamps marching up Mount Everest during the height of the 2012 spring climbing season, he had no clue that a historic tragedy was about to unfold. Six people died the night he took this still, and the year would be one of the deadliest on record for the mountain. This award-winning still from the video was the cover of *Outside* that September, but what Shaffer remembers most from the experience was the scene he witnessed the day after the shoot: "It was this surreal mix of people banging on oxygen bottles, celebrating the summits of their team members, and then one camp over would be another team sobbing and consoling each other because they had just lost somebody."

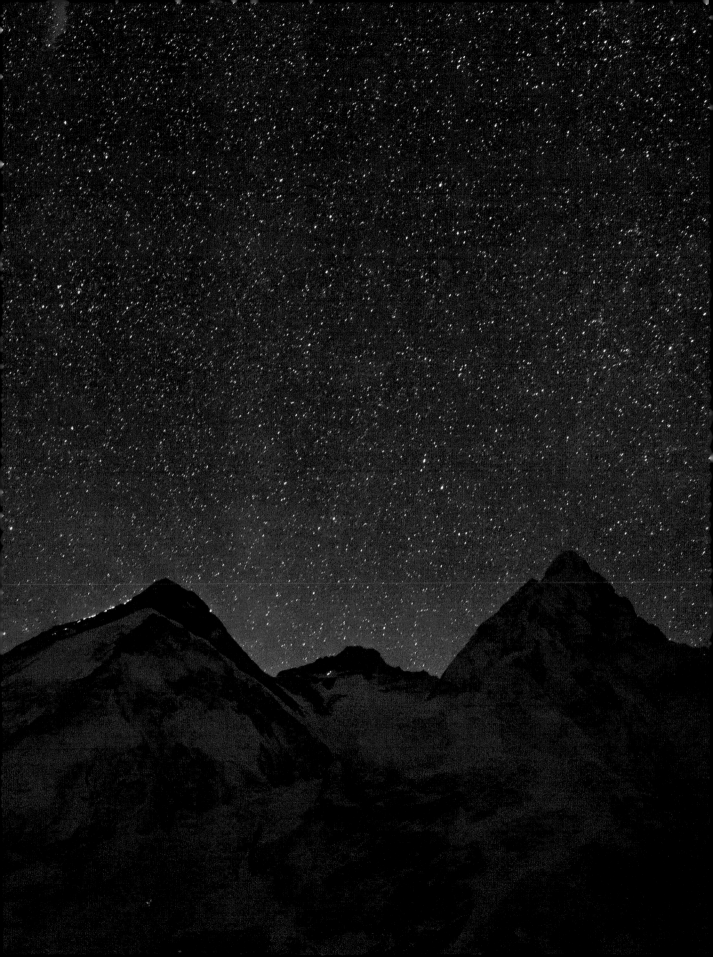

While fat biking in Duluth, Minnesota, in 2013, Hansi Johnson stood on the edge of an ice shelf above the thirty-three-degree waters of Lake Superior to shoot his friend Casey Krueger riding the floes along the shore. The city had endured the longest string of below-zero days in its history, and the photographer, who lives nearby, wanted to capture the icebergs and gargoyles that had formed along the beaches at Park Point. "It looks like we could have been in the Arctic," Johnson says, "but we were so close to Canal Park that even if I'd fallen in, I could have gotten out and walked to a coffee shop three blocks away.

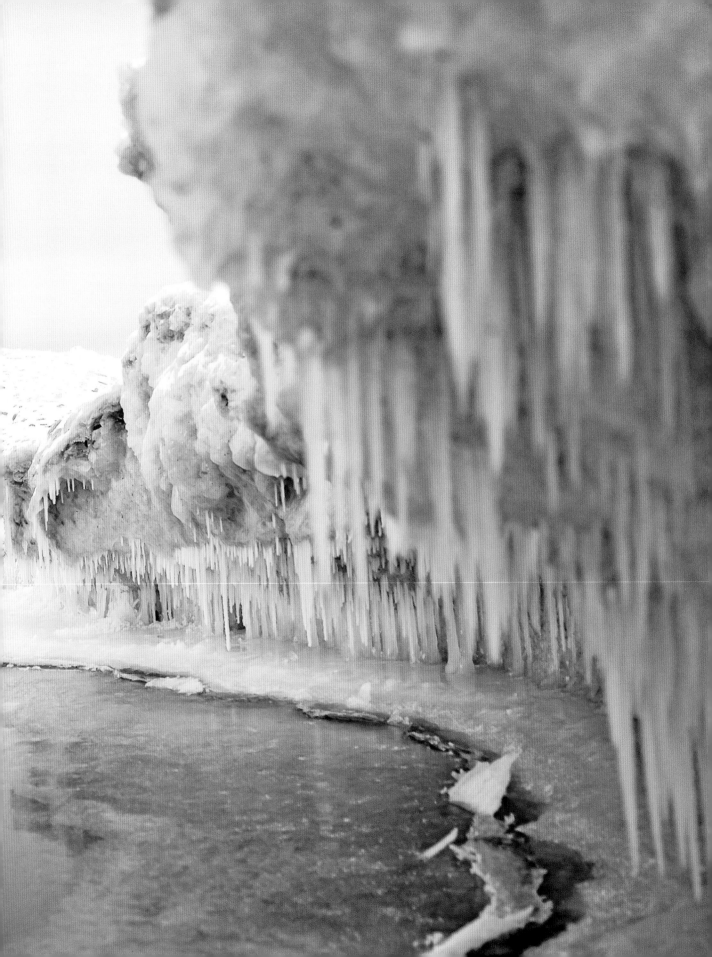

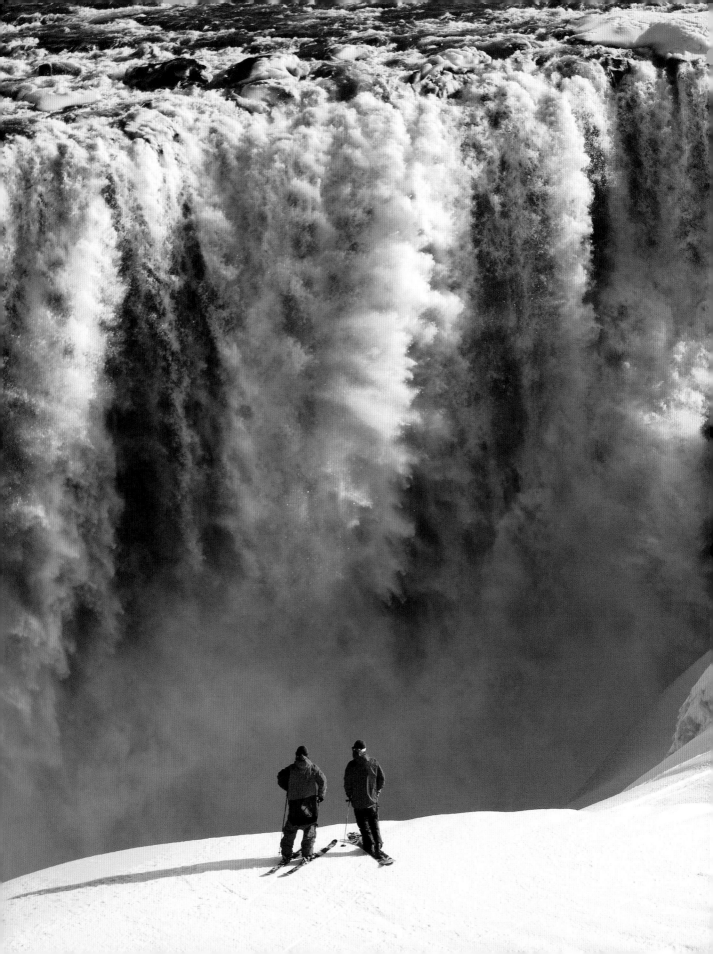

When conditions grounded production on TGR's 2011 film *One for the Road* in Iceland, the cast and crew took a break from risking life and limb to play tourist—but even that was a challenge. "It was blowing like fifty miles per hour—the kind of wind that's hard to stand up in," says Mark Fisher, who snapped this photo of pro skiers Rory Bushfield and Nick Martini as they stared into Dettifoss Falls, one of the most powerful in Europe. The Idaho-based photographer and TGR regular says that, while filming ski flicks is always conditions dependent, the athletes always find a way to put on a show. "The guys were doing little tricks down there," he remembers. "There was a tiny little cliff band just out of frame and they were launching 360s off of it."

In July 2015, British photographer Jon Griffith's longtime friend Ueli Steck, the elite alpinist, invited him to scale four peaks in the Mont Blanc massif, on the border of France and Italy, in a single day—part of Steck's attempt to climb all eighty-two four-thousand-meter summits in the Alps. They were done by noon, with Griffith having captured Steck at the top of Grand Pilier D'Angle around eight o'clock. "When you're with Ueli, there's no hanging around," says Griffith, who lives in Chamonix, France. "You have to shoot quite literally from the hip."

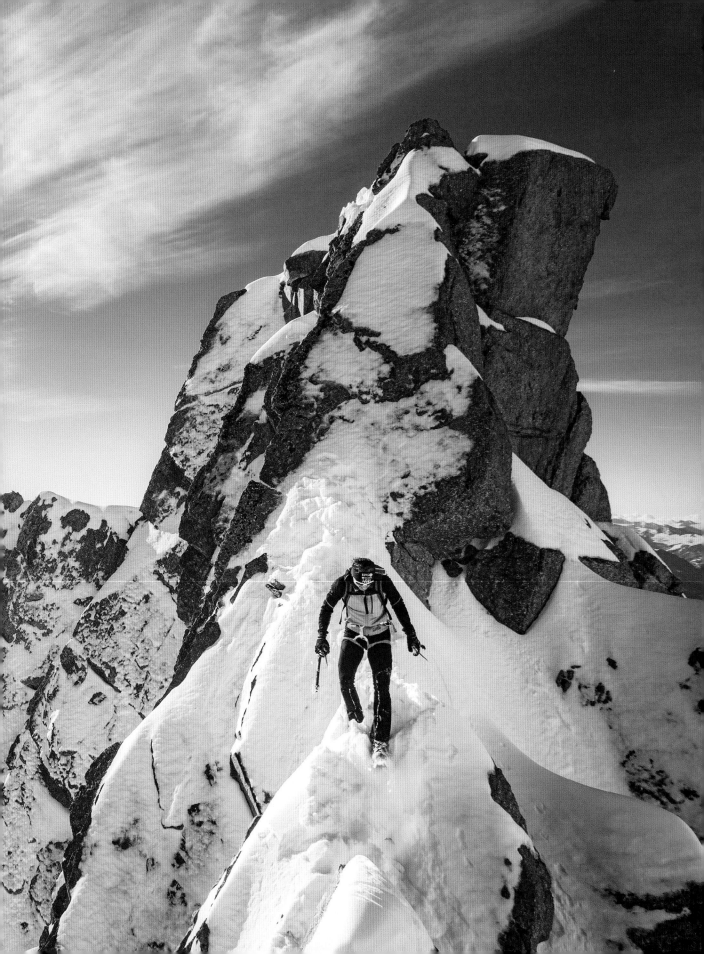

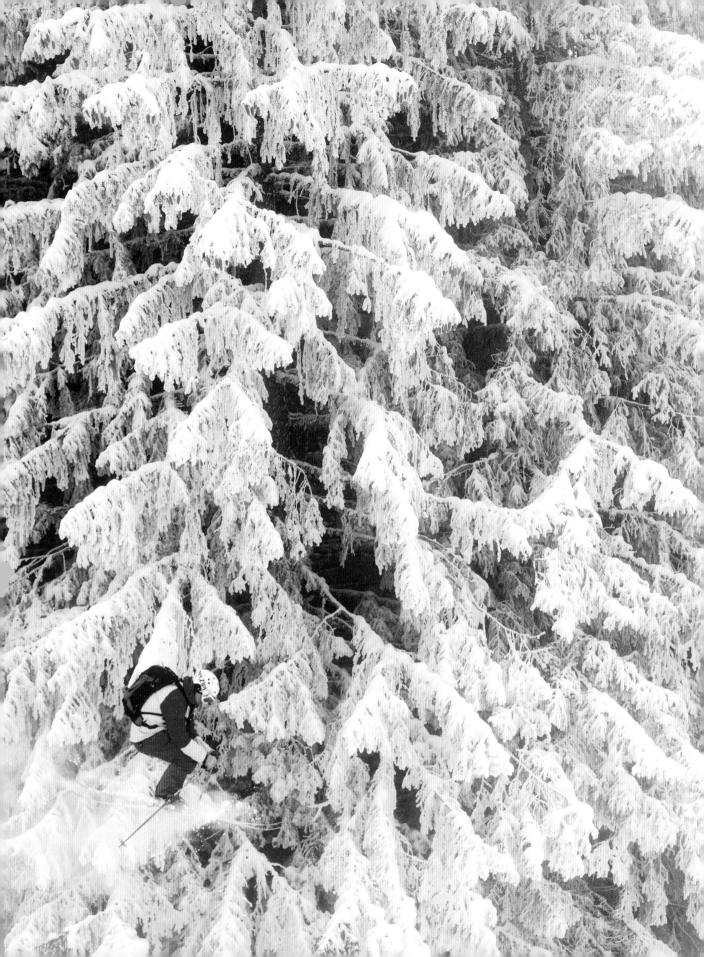

It was a crisp January morning when Fredrik Schenholm captured this image of Swedish freeskier Linus Archibald catching air beside a stand of spruce trees in Switzerland's Engelberg resort. "The night before, the temperature dropped and everything froze," says Schenholm, of Gothenburg, Sweden. "There were millions of tiny icicles on the trees." To capture this phenomenon, plus a bit of what it felt like to ski through it, he had Archibald hit a small kicker the two had built in the resort's sidecountry. "This is exactly the photo I wanted: a little bit of action, a lot of these crazy beautiful trees."

Erik Boomer and Jon Turk, pictured here dragging a three-hundred-pound kayak beside ice floes on Canada's Ellesmere Island, walked and paddled 1,486 miles in 104 days to complete a human-powered circumnavigation of the Arctic island. "Every day, we were committing to an epic," says the McCall, Idaho, photographer. That included a walrus attack, a twenty-four-mile open-water crossing, and an emergency evacuation. Forty hours after completing the expedition, while the pair were recovering in the fourteen-person village of Grise Fiord, Turk, age sixty-five, nearly collapsed from being on the verge of kidney failure. "He flew directly to a hospital," says Boomer. "The epic just wouldn't end."

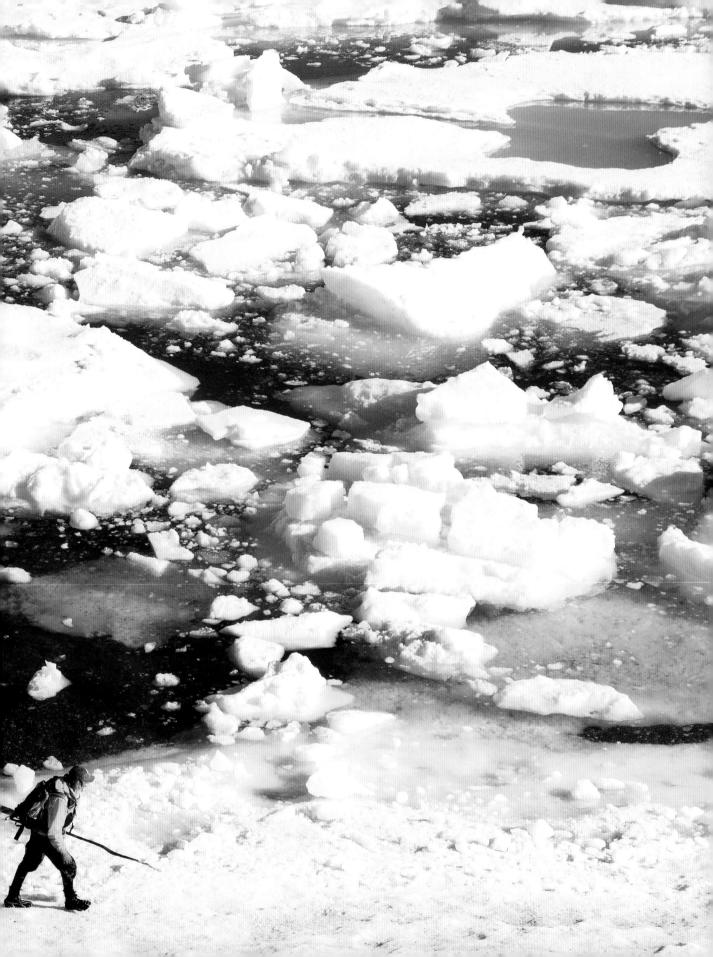

Blake Jorgenson had just headed out to photograph heli-skiing in the Coast Range near Bralorne, British Columbia, when the weather turned foul, grounding him and his crew at the base of the mountain where he'd planned to shoot. "The fog was so thick, we ended up sitting in the helicopter for almost four hours," says the Whistler, British Columbia, photographer. But shortly before sunset, the skies cleared, the chopper took off, and Jorgenson captured this photo of Mammoth, California, skier Parker White airing off a wind lip.

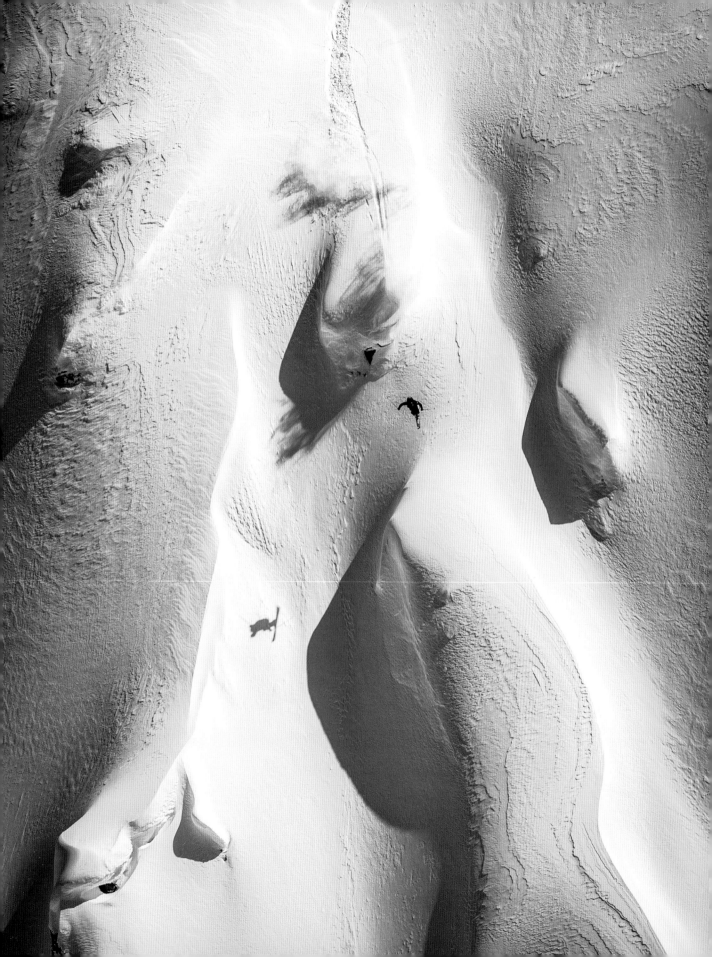

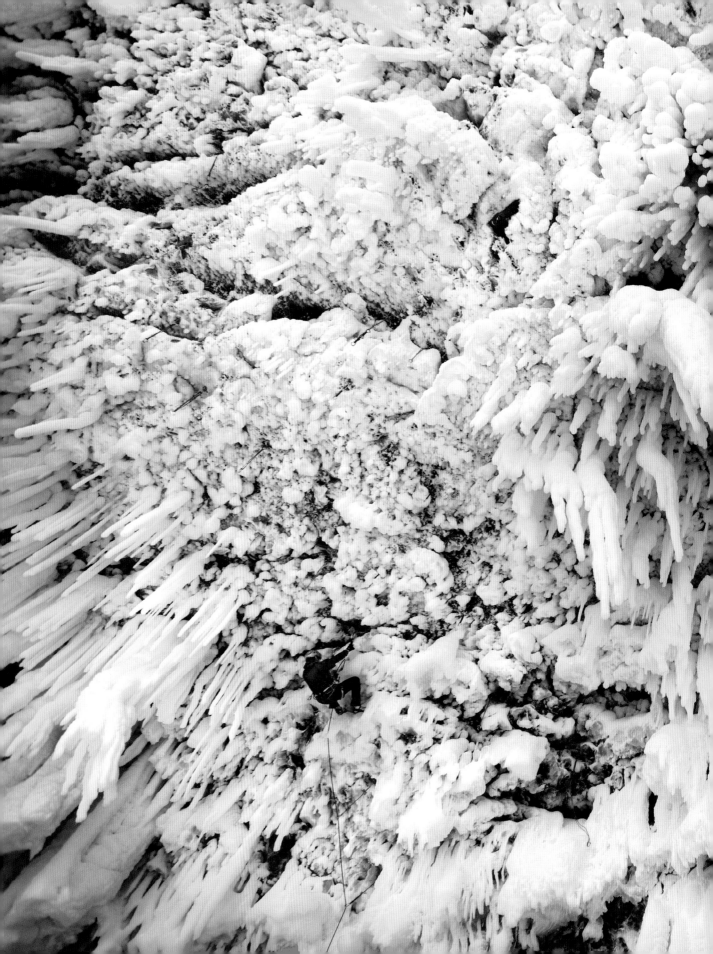

"It was absolute sensory overload in there," says Wiktor Skupinski of the spray cave behind Helmcken Falls in British Columbia. That's where the Calgary shooter spent five days with UK climber Tim Emmett last January. "We eventually managed to top out—eight pitches in a single push. This one was the hardest," says Emmett. "The ice has the texture of a bag of sugar. You don't know if your tools will hold or you're going to bring it all down with you."

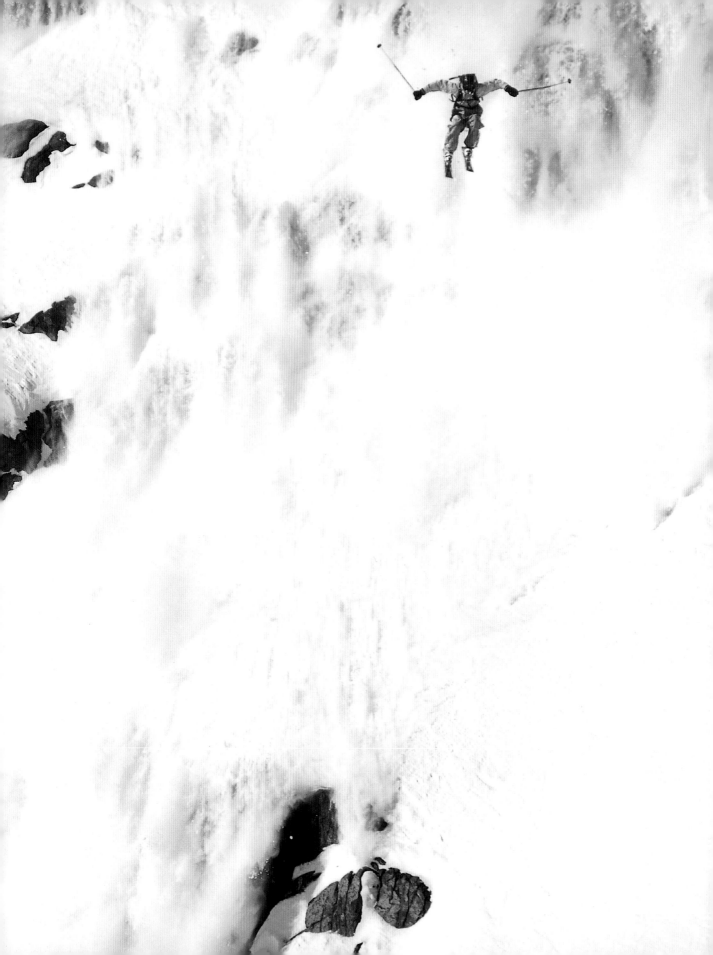

Ilja Herb wasn't sure where big-mountain skier Ryan Oakden was going to land when he snapped this shot of the pro in the midst of a hairy huck on British Columbia's Mount Currie. "A small slough avalanche hit as Ryan approached the cliff band," says the twenty-nine-year-old Vancouver-based photographer, "so there was no turning back. But he avoided the exposed rocks and stomped it, then skied to safety—on freshly broken boards."

In May 2010, while photographing a ski-mountaineering course at British Columbia's Icefall Lodge, Ryan Creary captured student Eliel Bureau-Lafontaine negotiating an ice saddle between two glaciers. The group was heading up to simulate crevasse rescues on the walls. "We happened to come across these super-unique holes in the glacier," says the Canmore, Alberta–based photographer. "I'd never seen anything like them before." The payoff after a long day of work? A five-thousand-foot descent back to the valley floor through fresh powder.

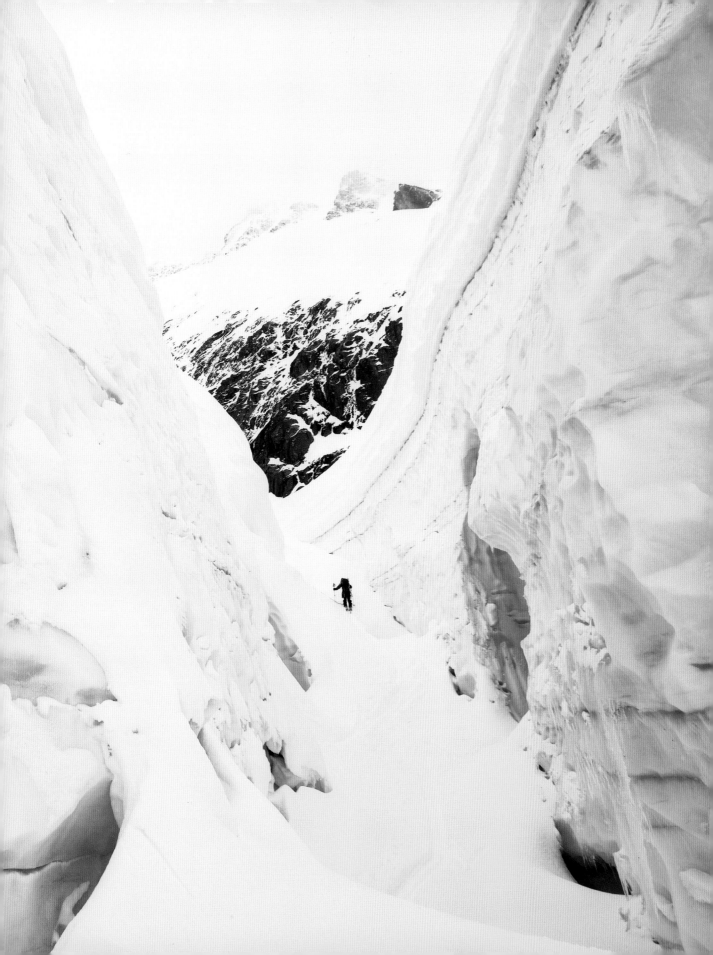

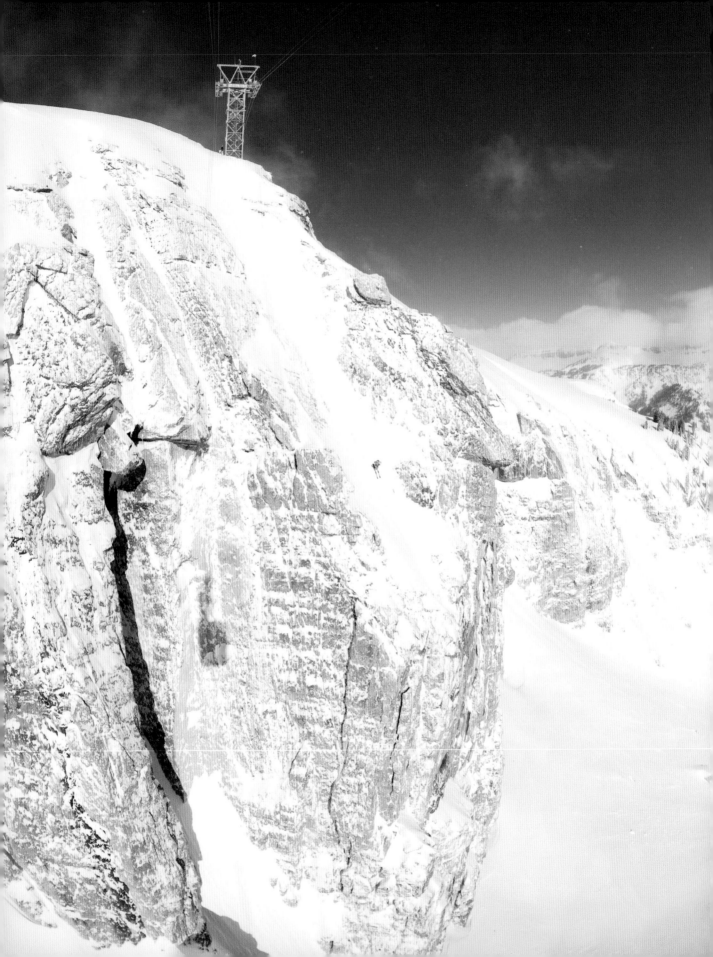

Erik Roner, of Lake Tahoe, California, reaches for his rip cord during the first ski-BASE jump off Jackson Hole Mountain Resort's Cajun Couloir, a 190-foot drop, in April 2007. "For a jump to work, you need at least 150 feet, so he was pushing it," says Salt Lake City–based ski photographer Adam Clark. "He had to execute everything perfectly." The cliff was located right beneath the resort's iconic aerial tramway. To get the perfect angle, Roner and a film crew got permission to reopen the retired tram, saving them a helicopter rental. "It was a lot cheaper," says Clark.

Chase Jarvis waited for the light at the end of the day before photographing American Scott Rickenberger carving this forty-five-degree slope at First, a Swiss ski area near the town of Grindelwald. "Fresh backcountry snow lasts a lot longer at the smaller European resorts," he explains. "The locals stay on-piste."

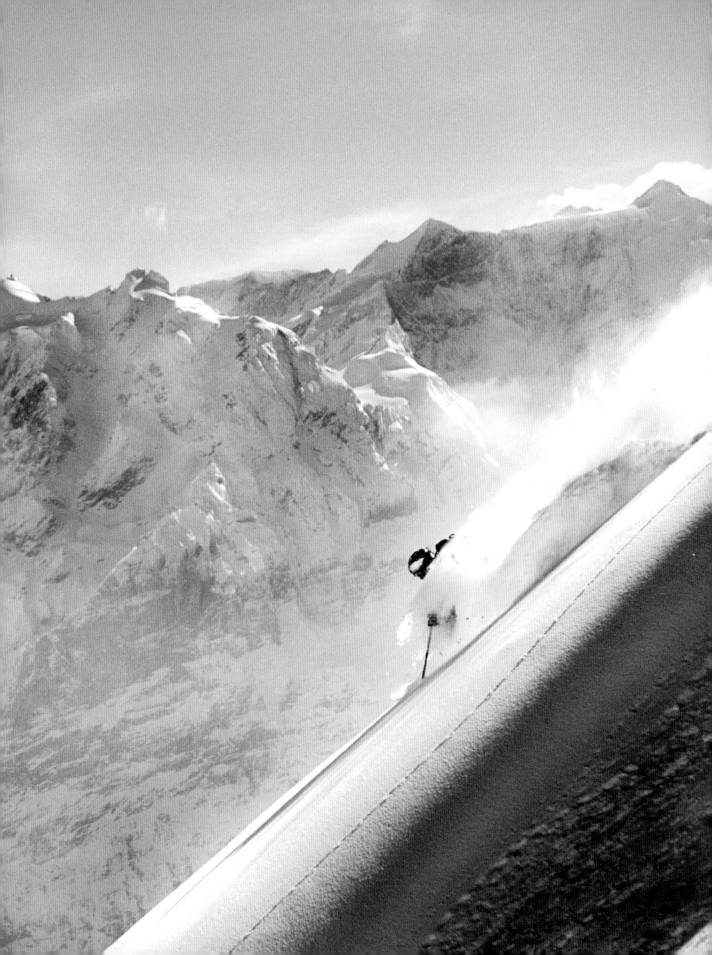

Sandy Calhoun spent two Austral summers at McMurdo Station, the Antarctic research center run by the National Science Foundation, as editor of the *Antarctic Sun* newspaper. That gave him a chance to cover two editions of the Polar Plunge, in which dozens of "polies" would strip to their swim-suits, wrap a rope around their waists, and jump into the Weddell Sea from a New Zealand station that was just over the hill from McMurdo. During his first season, in 1998, Calhoun snapped this image of a Coast Guard rescue diver who opted to push things a bit further by skipping the bathing suit. The Maine-based photographer points out that on the Last Continent such absurdity is as old as exploration. "There's a rich tradition of making fun of one's self, going all the way back to Ernest Shackleton," he says.

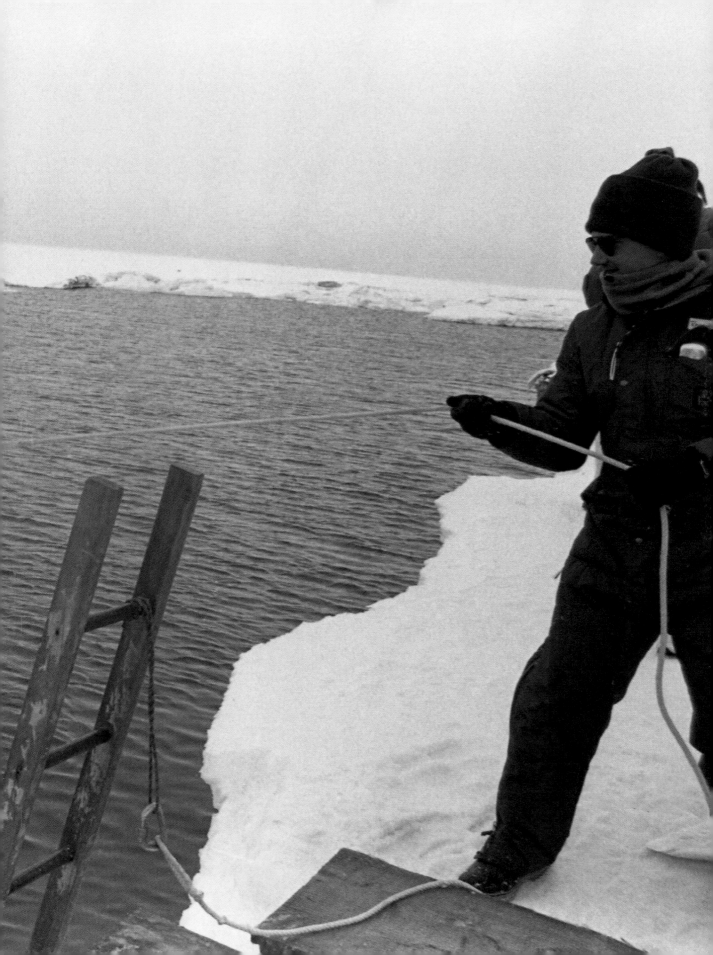

Nothing inspires a bit of ridiculousness quite like cabin fever. "This ten-year storm came through Hood River," says Michael Hanson, who shot this image of his brother, David, in December 2016. "We had some friends over, there were young kids around—this is what happens to cooped-up parents." The Pacific Northwest–based lensman says they spent three days improving the course, eventually allowing younger kids in on the fun. "Everyone was on pins and needles when one dad took both his one-year-old and three-year-old down with him," he says. "But they did stick to what we designated the 'green' slope, on the left."

To photograph the 2009 Nelscott Reef Big Wave Classic, held a mile off Oregon's coast, Ben Moon hitched a ride on a single-engine Cessna, where he caught surfer Peter Mel outrunning a twenty-five-foot wave. "The plane makes it exceptionally tricky to time everything right," says the Portland, Oregon–based Moon. "You're often behind the waves when they break. This ended up being my favorite image, because you can see the foam trails of one wave leading into the next. You can't capture that from the water."

river & ocean

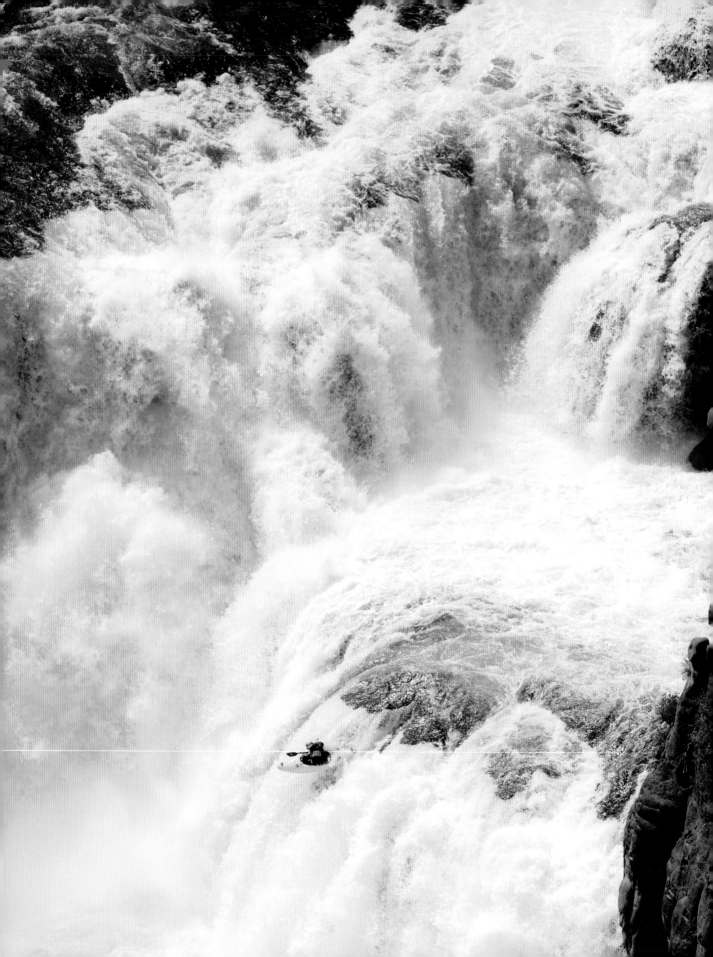

Of all the planet's adventure playgrounds, waterways have a unique power to seduce us—or send us running for higher ground. For the athletes and explorers that are drawn to the water, the goals vary as wildly as the settings. Some are compelled to ride thundering waves, while others dream of paddling frothing rapids or seek out whole new worlds hidden below the surface of the seas. Photographers working in these environments face daunting physical and technical challenges. Risk is constant. Failure is frequent. But when it all comes together, they return with images that compel all of us to stare and imagine what it might feel like to excel in, on, or under the water—no matter how that makes us feel.

river & ocean

There are two ways to huck Lower Mesa Falls, on Idaho's Henrys Fork River: Take one seventy-foot free fall (paddler's right) or run the first forty-foot drop and then recover in time for the second, as kayaker Jesse Coombs did before this shot was taken. Denver-based photographer Lucas Gilman had options, too: Shoot from below, to emphasize the height of the waterfall, or from on high. He went with the latter, setting up downstream of an overlook above the falls. "From above, it gives you that sense of place and scope, of just how inconsequential the kayaker is in comparison with the waterfall," says Gilman. "You don't get that from below."

During the second leg of the 2008 Volvo Ocean Race, Paul Todd shot Aussie bowman Casey Smith getting drenched by a wave on the deck of *Il Mostro,* outside Cape Town, South Africa. "It was like a fire hydrant hitting him," says the UK-based photographer. "He got absolutely hosed." Todd was shooting from the open door of a helicopter trailing the yachts as close as possible. How close? After this shot was taken, the engine sputtered and the helicopter plunged thirty feet, likely the result of a rotor blade clipping the mast of a spectator boat. "We thought it was all over," says Todd.

After learning how aggressive and unpredict-able giant humbolt squid can be, photogra-pher Paolo Marchesi had serious reservations about joining a 2010 expedition to seek out the creatures off Baja, Mexico. "They're cannibalistic animals and go after the other squid that have been hooked by the fisher-man," says Marchesi, a master scuba diver who splits his time between Montana and the Baja town of Todos Santos. "So the way to see them is to hang beneath the boats like the bait." Ultimately, he decided he couldn't pass up the once-in-a-lifetime opportunity. "I took the assignment thinking I probably wasn't going to die," he says, "but that I had a very high expectation of getting hurt."

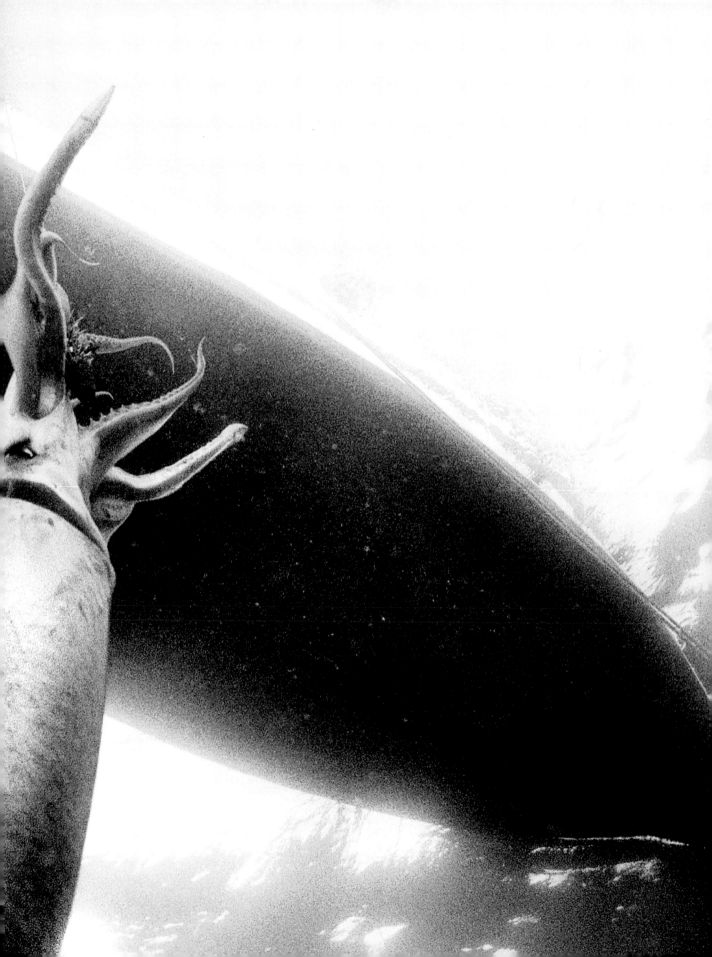

While competing in the 2013 La Jolla Shores Invitational, a paddling event in La Jolla, California, Donald Miralle noticed an unusual number of leopard sharks in the shallows along the racecourse. After finishing his first heat, the Encinitas, California, photographer grabbed a GoPro and a small drone helicopter from his car and raced to shoot the other paddlers passing through the schools. "The sharks migrate there every year to spawn," he says, "but I've never seen so many in one place before."

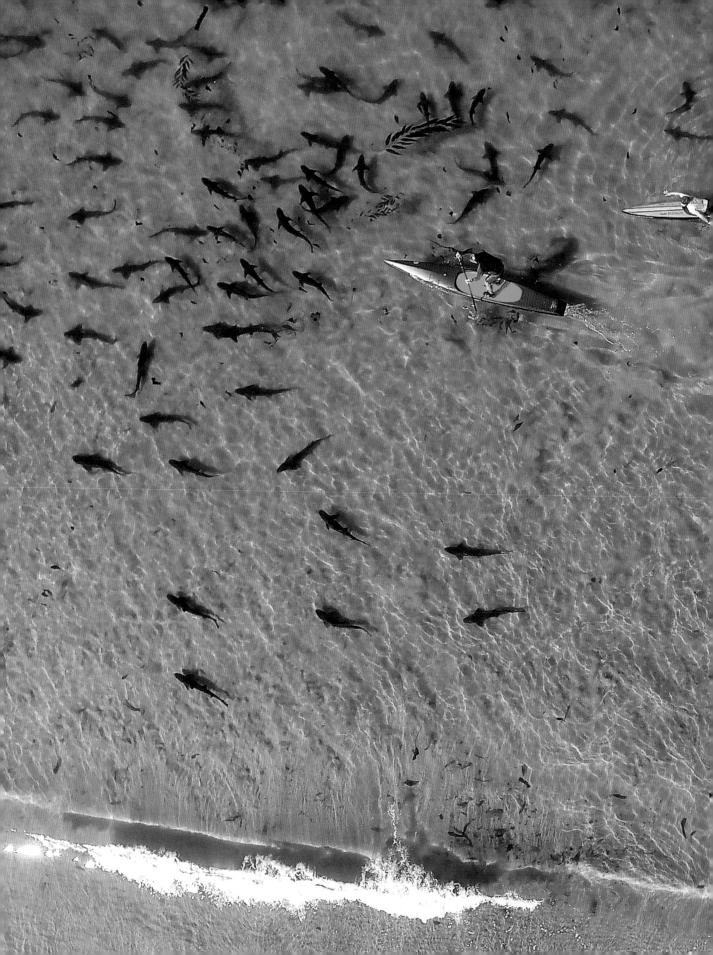

"When it happens, Teahupoo feels like the center of the universe," says nine-time ASP World Champion surfer Kelly Slater, who was photographed by Tim McKenna tackling a small pass just north of the infamous break in September 2008. "It's the one wave others are measured by." Slater was there as the star of *The Ultimate Wave Tahiti,* an IMAX film about Teahupoo and its effect on local culture. "Kelly, as usual, was boosting huge airs right in front of the camera," says the Tahiti-based McKenna. "Suddenly, after carving up the face of the wave, he spun around and did a complete 360, floating back over the whitewater."

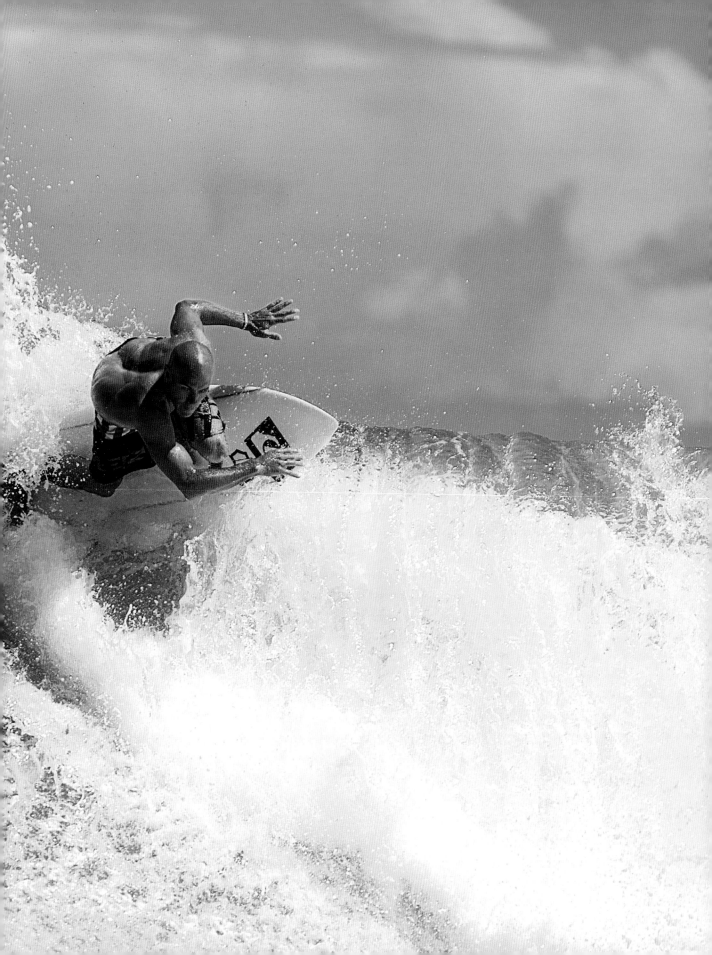

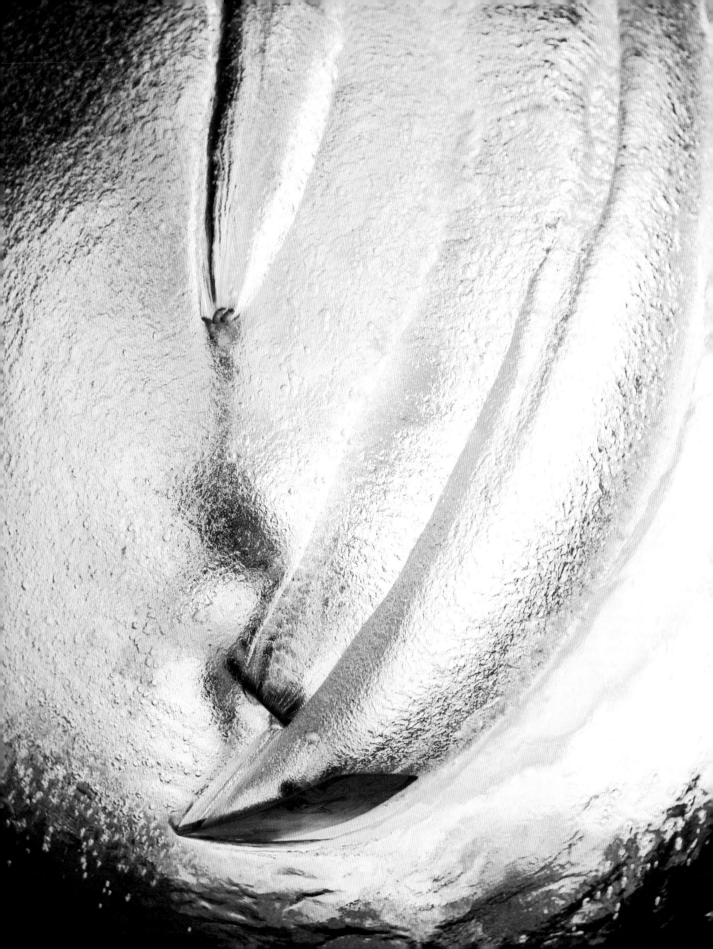

Bryan Soderlind was determined to shoot
Scott Byerly wake skating—wakeboarding
without bindings—in the clearest water possi-
ble. So in January 2014, the two traveled from
Orlando, where they both live, to Cypress
Springs, Florida. "It's the clearest water you
can get—no Jet Skis, no motorboats. We even
filled our jugs with it," says Soderlind, who set
up a land-based winch to pull Byerly. "When
Scott rode by, I knew I had the perfect shot. All
I had to do was hold my breath."

In November 2014, while riding with the Abu Dhabi Ocean Racing team during the nine-month Volvo Ocean Race, Matt Knighton, who lives in Chicago, captured helmsman Adil Khalid as he was hit by an eighteen-foot wave 1,500 miles west of Cape Town, South Africa. That particular section of the South Atlantic is considered the coldest part of the race, with icy swells that drenched the crew every twenty seconds. "The timing of the shot had to be perfect, since a split second later I got wiped out as well," Knighton says. "The waves were so cold, they literally took your breath away."

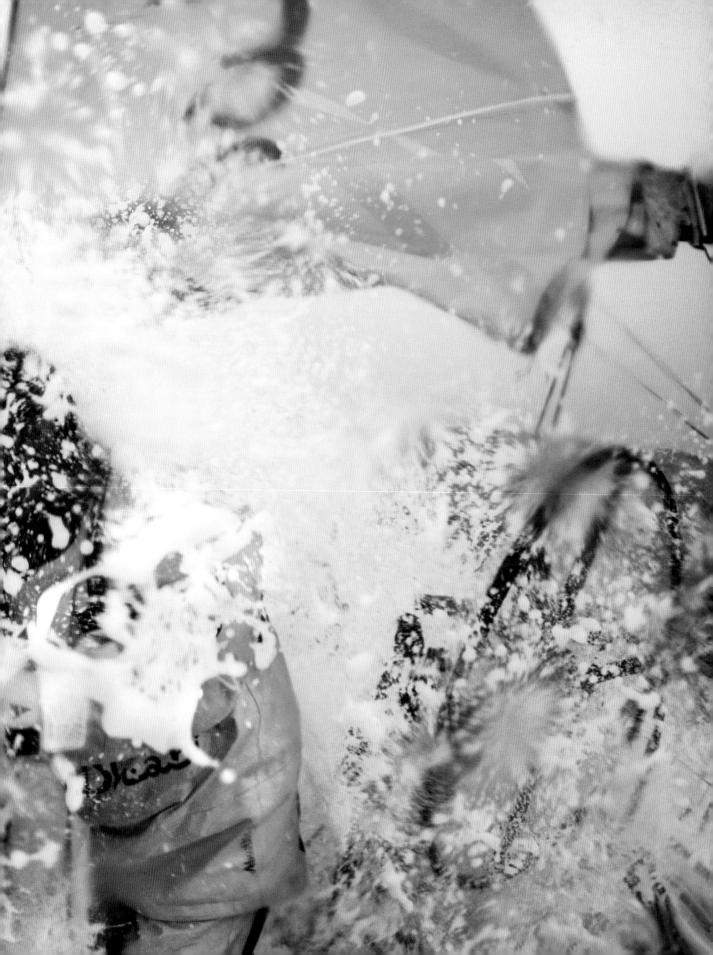

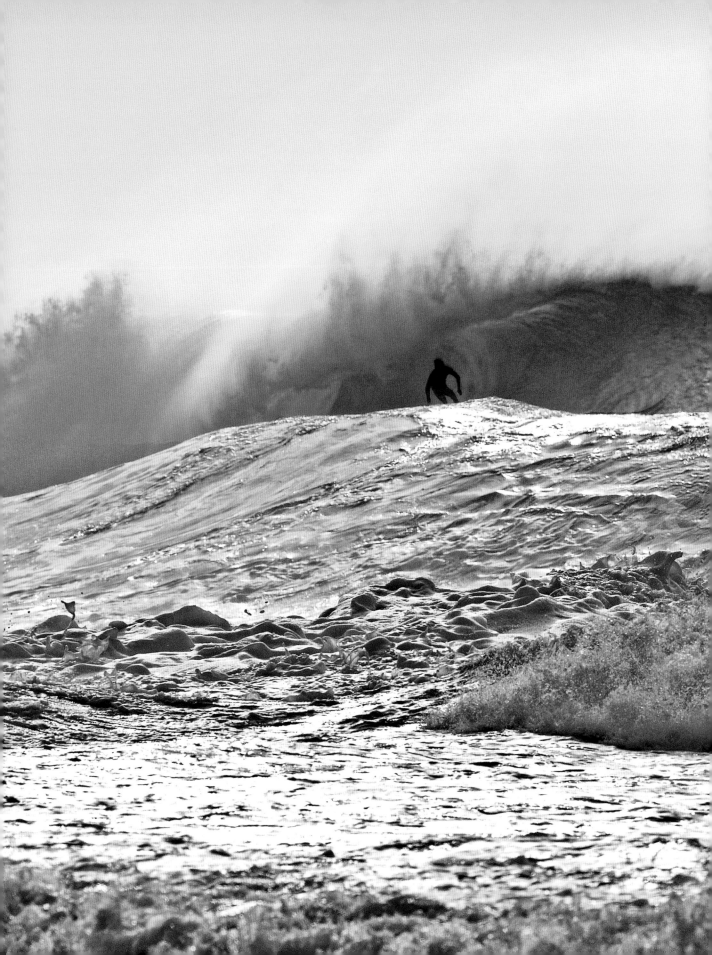

Every year, the Billabong Pipeline Masters draws the best surfers in the world to Banzai Pipeline, off Oahu's North Shore. After each day, pros and locals alike crowd the lineup hoping to catch another monster barrel. "As soon as the competition ends, it's basically a free-for-all because the waves are so good," says Daniel Looman, who shot this surfer after one such day. For the Michigan-based Looman, good waves can be a mixed blessing. "They make for great photos, but you want to be surfing them."

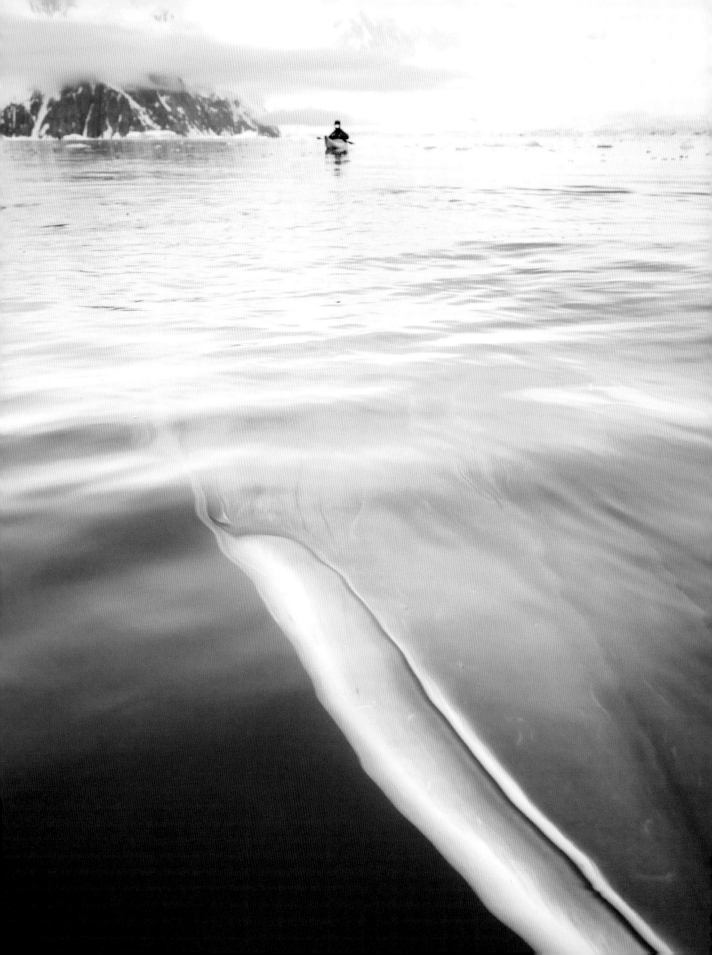

In May 2012, Andrew Peacock was guiding three clients on a sea-kayaking tour of Antarctica's Neko Harbor when he snapped this shot of a twenty-foot minke whale swimming under his boat. "I've never been that close to such a huge animal," says the Queensland, Australia, photographer. "I thought it was going to flip one of us, and I started to wish I'd brought a waterproof camera." But after an hour of paddling beside the whale, Peacock relaxed. "We realized he was just as curious about us as we were about him."

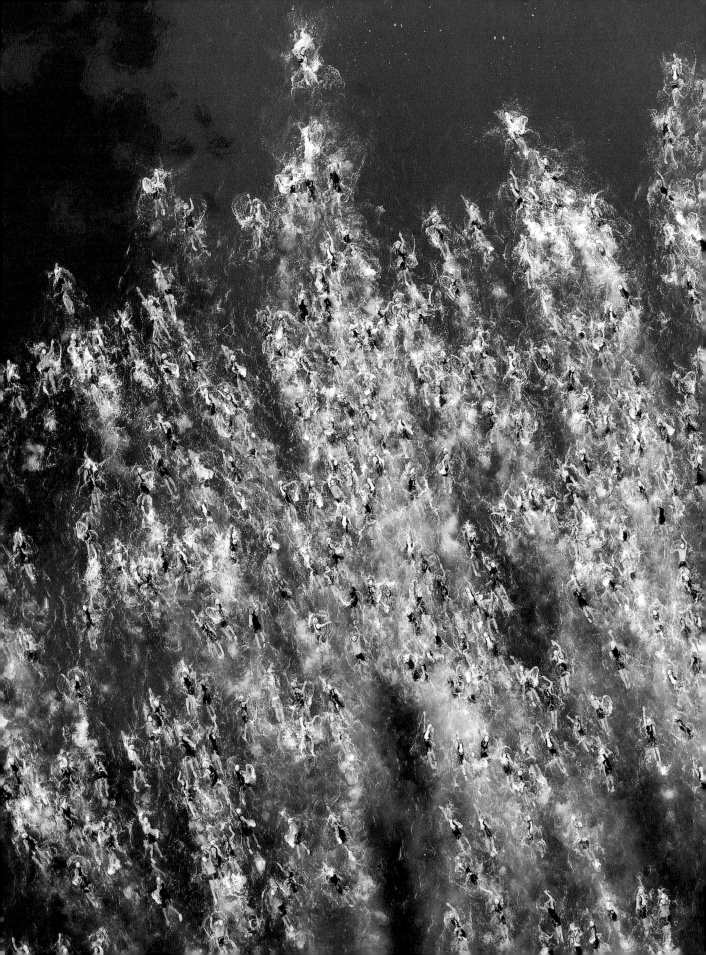

To capture two thousand triathletes swimming across Kailua Bay at the 2012 Ironman World Championship in Kona, Hawaii, Donald Miralle needed to get above the action. "It's the only way to show the madness of that mass start," says the San Diego photographer. After shooting this photo from a helicopter at seven o'clock in the morning, he spent the next ten hours on a motorcycle, following the athletes through all three stages of the 140-mile race. "I competed in a few triathlons years ago but nothing like this. It's incredibly inspiring what these people can do."

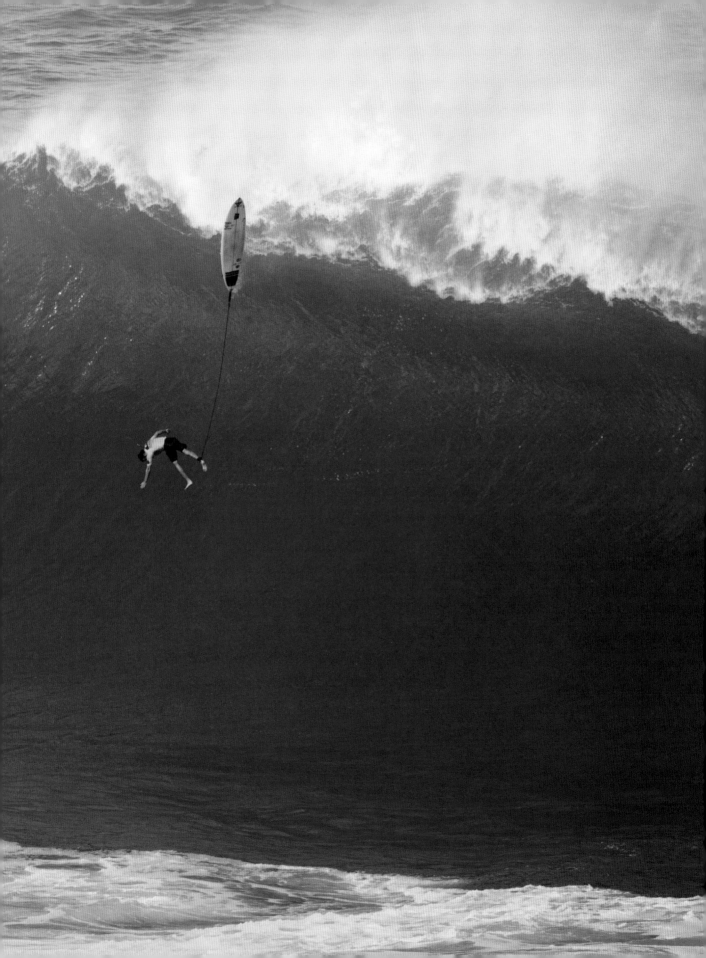

Before taking this 2016 photo, Bo Bridges had traveled to Hawaii's Waimea Bay to document The Eddie, an infamous invite-only big wave contest that happens only when conditions are perfect, three times with nothing to show for it. The rarity of the event made the Los Angeles–based lensman's decision to set up on a high cliff instead of on the water all the more consequential. "Shooting from above flattens things," he explains. "But my background is aerial photography and I love that perspective. This image really shows the magnitude of the beating Twiggy is about to take." Twiggy is the nickname of Grant Baker, a celebrated South African big-wave rider, who had his board snapped in half during this wipeout before he was sucked through the water the length of a football field. Rescuers on Jet Skis eventually pulled him from the water. "I knew it was a banger photo as soon as I shot it," says Bridges.

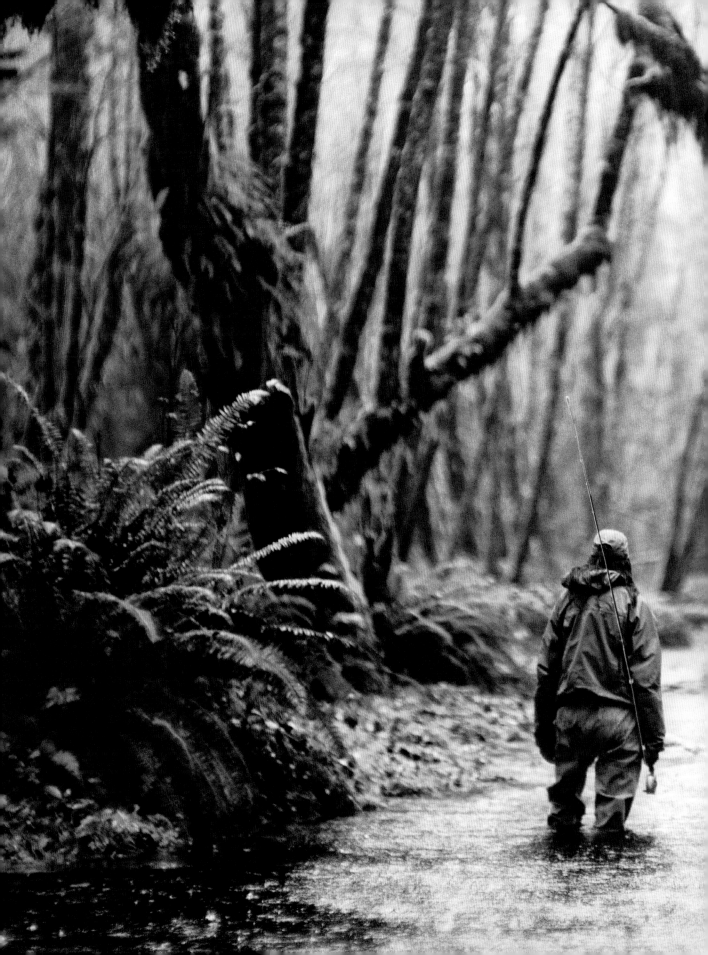

In December 2013, when photographer Andy Anderson and Montana fly-fishing guide Jenny Grossenbacher headed for the Olympic Peninsula, near the town of Forks, Washington (of *Twilight* series fame), hoping for a week of perfect steelhead fishing, they never expected the weather to get the better of them. "It was nasty the whole time, and the fishing was completely miserable," says the Mountain Home, Idaho, photographer, who spent five days shooting with a vintage camera in the pouring rain. "On the bright side, the conditions made for great lighting."

In November 2015, Jasper Gibson captured professional kayaker Ben Marr running a seventy-foot waterfall on the Jalacingo River in Veracruz, Mexico. It wasn't an easy place to reach—the two had to bushwhack through the jungle for a mile and a half. "To get into position, I climbed down a steep canyon wall full of gnarly trees and wiggled my way through the mud," says Gibson, age twenty-three, who paid for the five-week trip with money he'd earned as a wildland firefighter in White Salmon, Washington. "Getting there was a struggle, but the shot came easy."

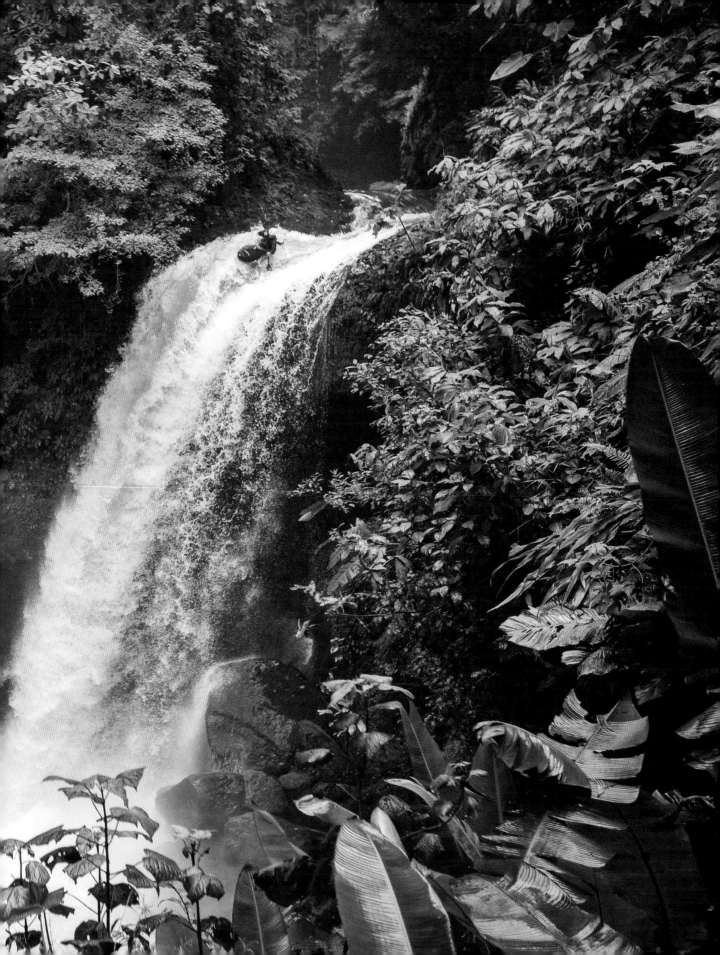

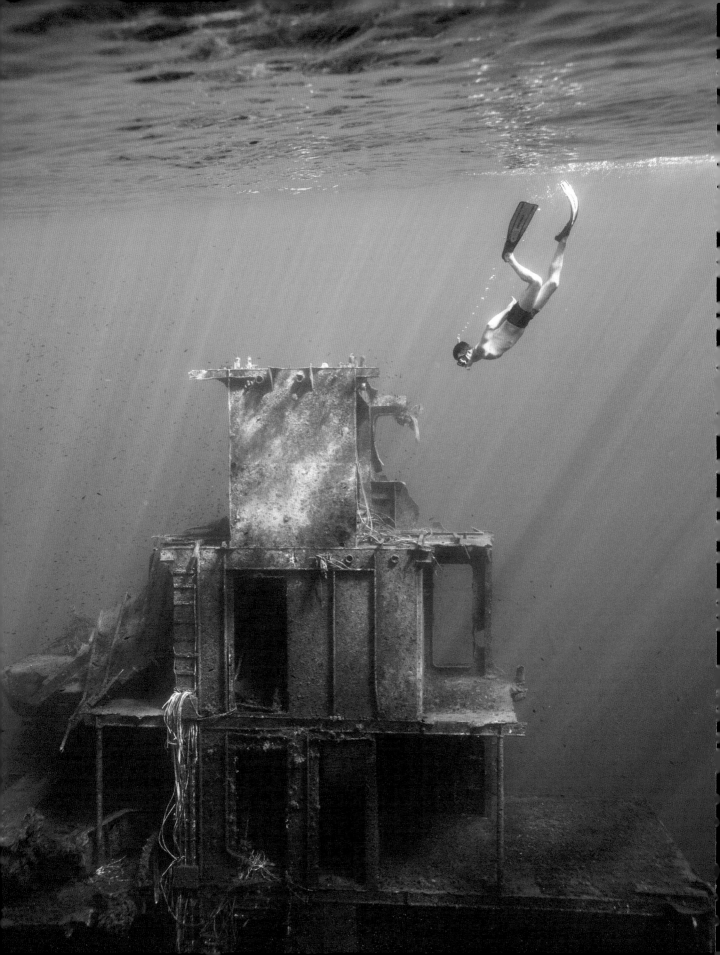

"It kind of blew my mind," says Corey Arnold of the moment in September 2011 when he came upon the hull of a cargo ship jutting out of the Mediterranean Sea just east of the Greek island of Kythira. For Arnold, who was aboard a yacht lent to him by a friend, the wreck presented a good opportunity to go snorkeling. That's when the Portland, Oregon–based photographer snapped this shot of a deckhand diving toward the bridge of the sunken freighter. "There wasn't another person out there," he says.

When setting up this shot of waterman Kai Lenny at Jaws on Maui's north shore, Franck Berthuot knew he wanted a different perspective than the other photographers would get. "Most people shoot from the cliff in front of the wave," says the Maui-based photographer. "Instead, I ran as fast as I could out to the left side of the wave to be parallel to Kai. It was worth the extra work. This ended up being my favorite shot of the day."

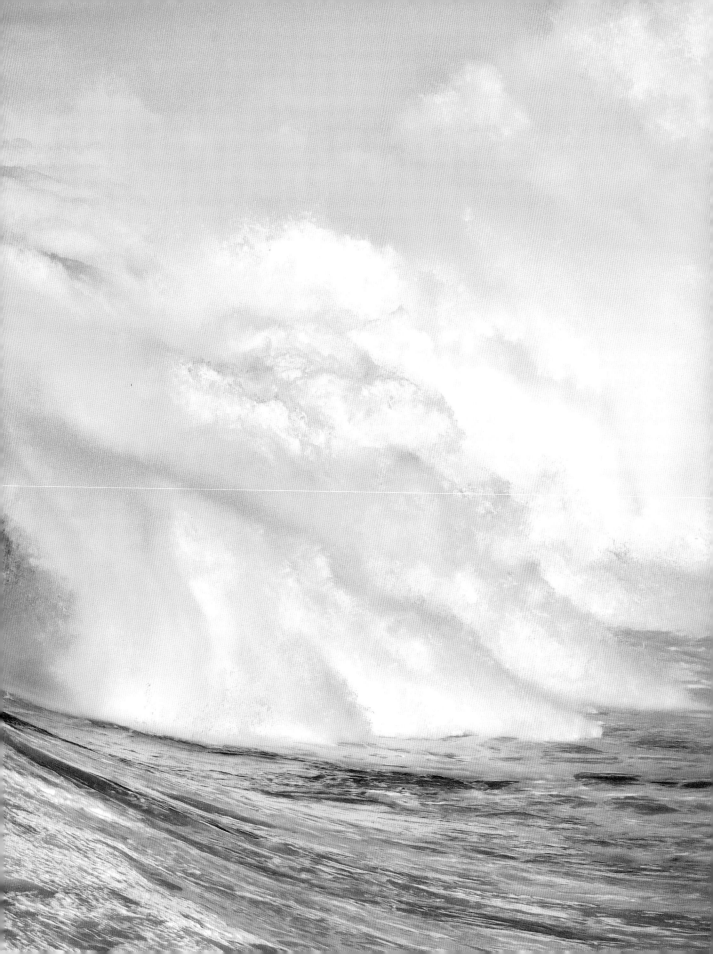

In September 2014, Eric Parker traveled by floatplane to Clendinning Lake, British Columbia, where he captured pro kayaker Nouria Newman running this Class V rapid on Clendinning Creek. "Right on the lake, there's insanely steep whitewater," says the photographer, who lives in Jackson Hole, Wyoming. "But the higher we hiked, the more we could see these perfectly sculpted granite waterfalls slowly being exposed. Nouria is one of the most talented kayakers on the planet, and a dramatic slide like this really shows what she can do."

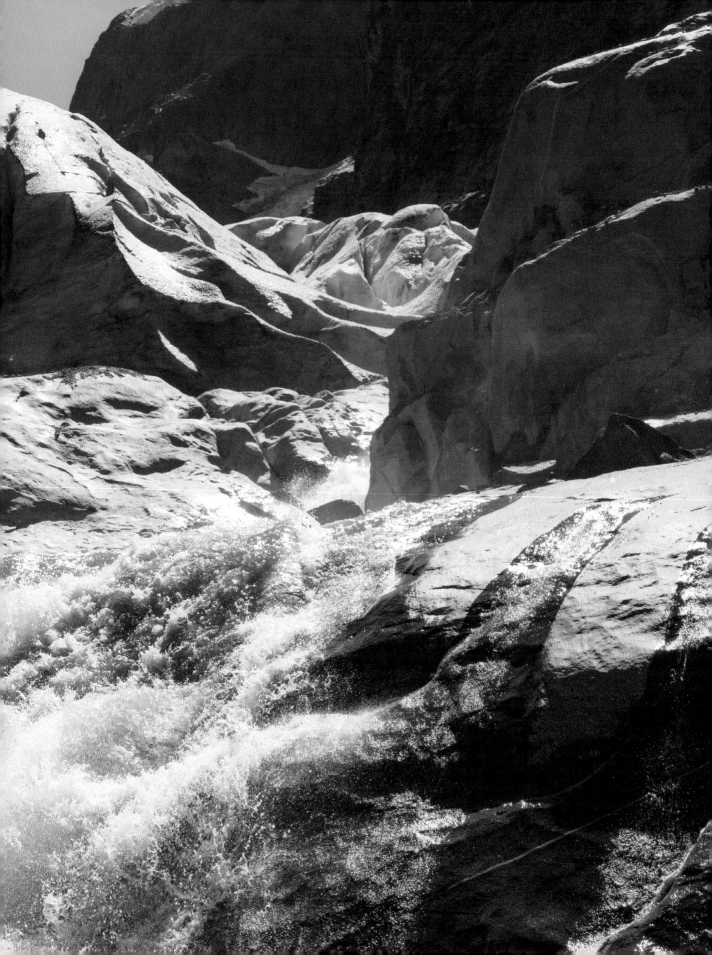

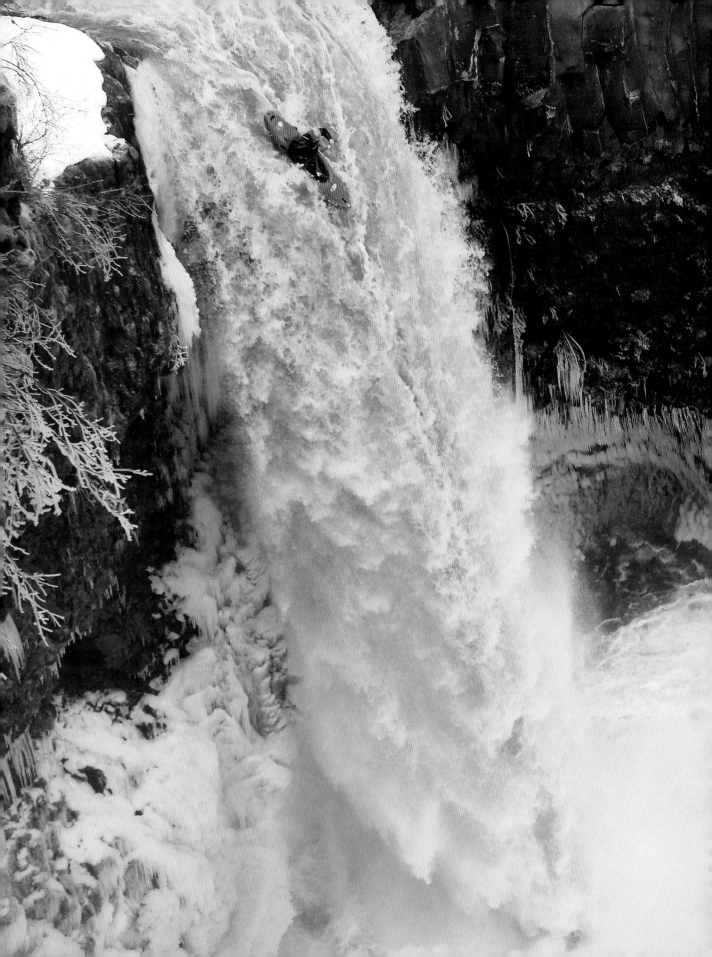

A warm storm from the South Pacific slammed into Washington State in January 2009, flooding usually tame Outlet Creek, near Yakima. Jed Weingarten rappelled down a cliff opposite seventy-foot Outlet Falls to get a better angle as kayaker Luke Spencer paddled over the edge. "I've got mixed feelings about watching this type of stuff," says the Portland, Oregon–based Weingarten. "It's always mildly concerning knowing they could get hurt, but if they don't go, there's no photo." The day before, three kayakers had completed the first three descents of the waterfall; no one, on either day, ran it more than once. "I knew right away I'd sustained some sort of injury that would hurt for quite a while," says Spencer. "It took three months for my ribs to fully heal."

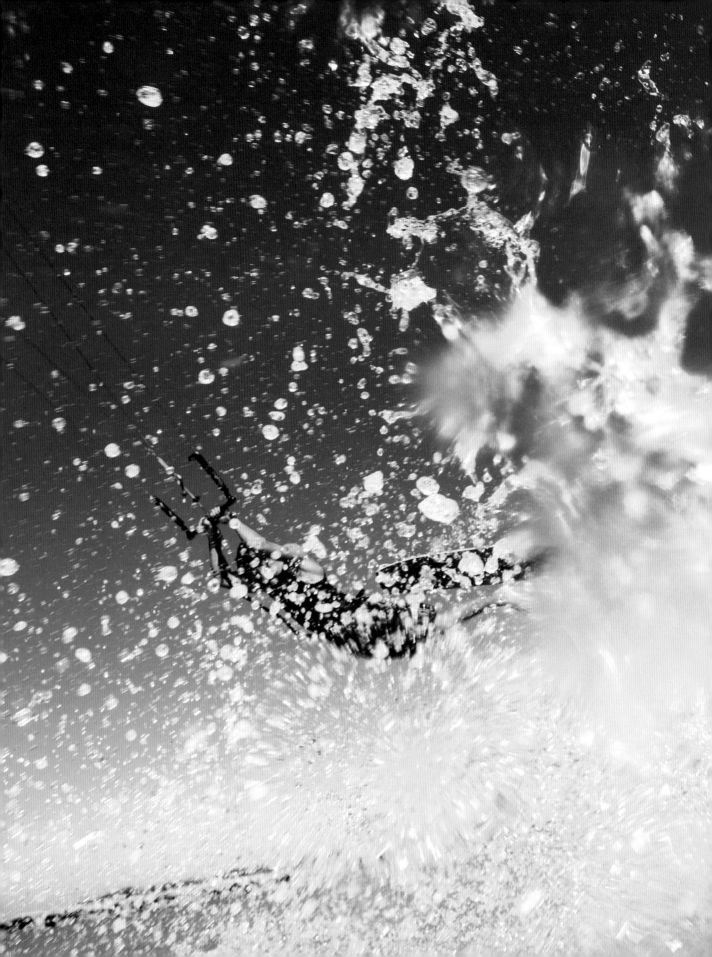

While cutting across Oahu's Kailua Bay at twenty knots, kiteboarder Luke Dunkley arced a little too close to photographer Mark Johnson, who was floating on a boogie board. "I think it kind of freaked him out," says Brisbane, Australia–based Johnson, age forty-nine. "He came really close and then tried to jump so he wouldn't hit me." To Johnson, the close call was just an opportunity to shoot a fresh angle. "You can tell he's not going to land it," he says. "But I like the dynamism."

While on a two-month South American kayaking expedition in 2009, John McConville photographed Andy McMurray dropping this 50-foot waterfall on the Río Claro, in central Chile. The waterfall, Garganta del Diablo, or "Throat of the Devil," is on a two-mile section of the Claro that the paddlers were tackling that day. "We got into this situation where we had to run it," says the Jackson, Wisconsin–based photographer. "There were 40-foot, overhanging basalt walls above us. We'd run one waterfall not knowing what was next." Several months later, an 8.8-magnitude earthquake that struck Chile opened a fissure above the falls, rerouting the entire river underground. "We were some of the last kayakers to run it," says McConville.

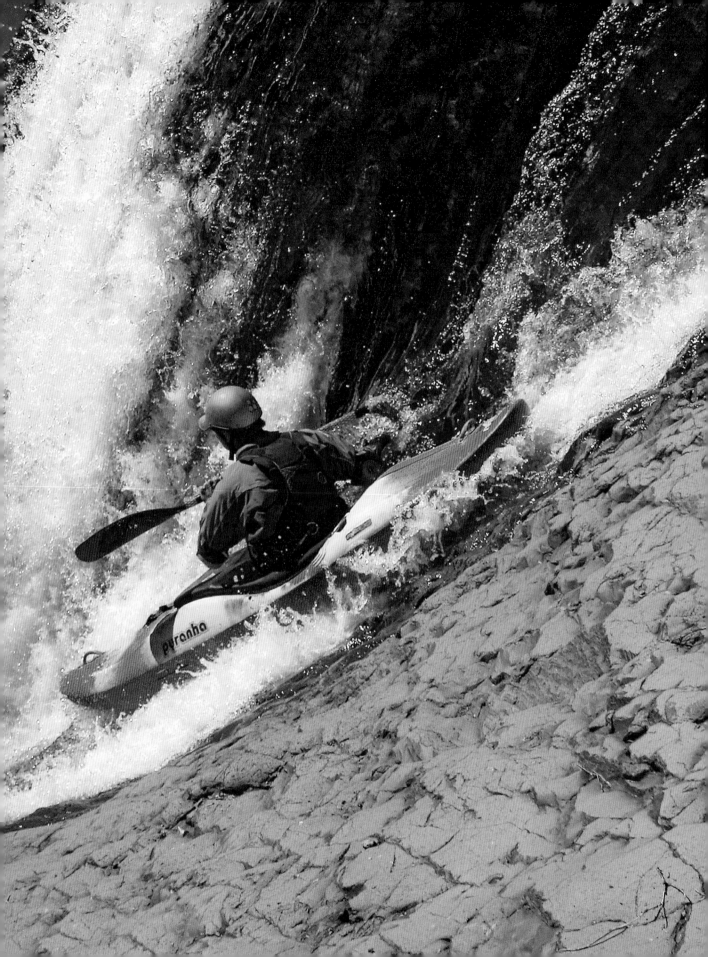

"I was two hundred meters out and this dark mass just appeared in front of me," says David Sheridan, who was kitesurfing off Valla Beach, on Australia's east coast. "Next thing, I get this almighty whack in the back of my head." Luckily, the native Aussie's kite pulled him away just as the tail of this southern right whale struck him. How did he get the shot? He'd attached a camera to his kite and programmed it to shoot at ten-second intervals. But Sheridan wasn't sure he'd captured the monster at all. "When I got home and told my wife, she was like, 'Yeah, yeah, sure.' But the evidence is right there."

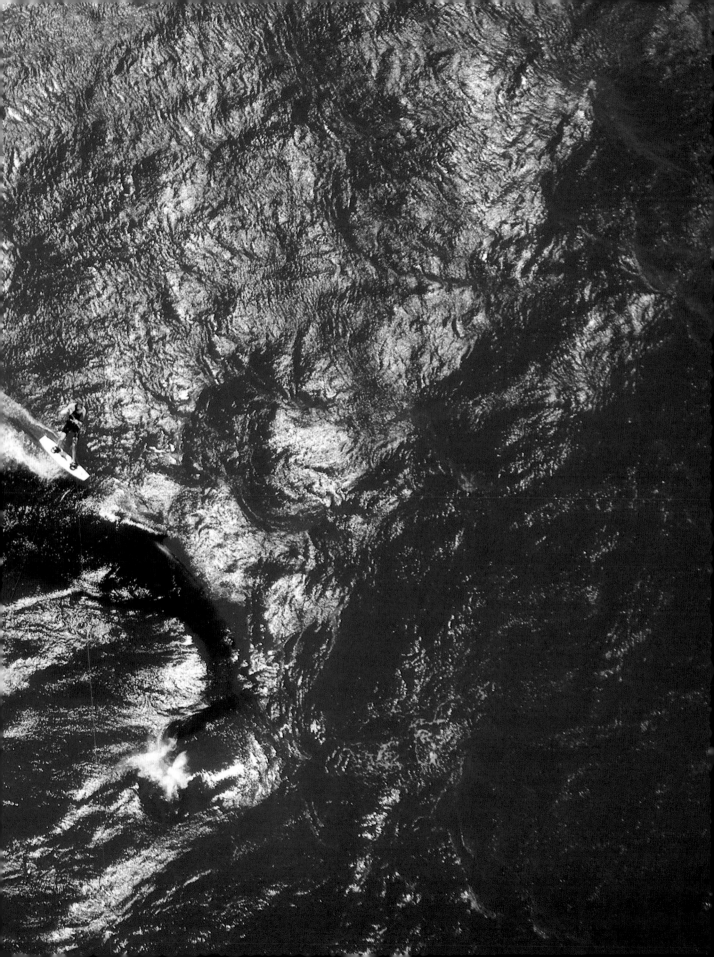

Jeremy Koreski wasn't expecting great surf in January 2013 when he shot this image of Noah Cohen getting barreled off the west coast of Vancouver Island, British Columbia, with a five-thousand-foot range in the background. "It's gorgeous out there, but the waves are usually bunk," says the photographer, who lives nearby. This time, though, swell, tide, and weather lined up perfectly. "We spent the whole day on the water, which was pretty impressive considering it was forty-four degrees," says Koreski.

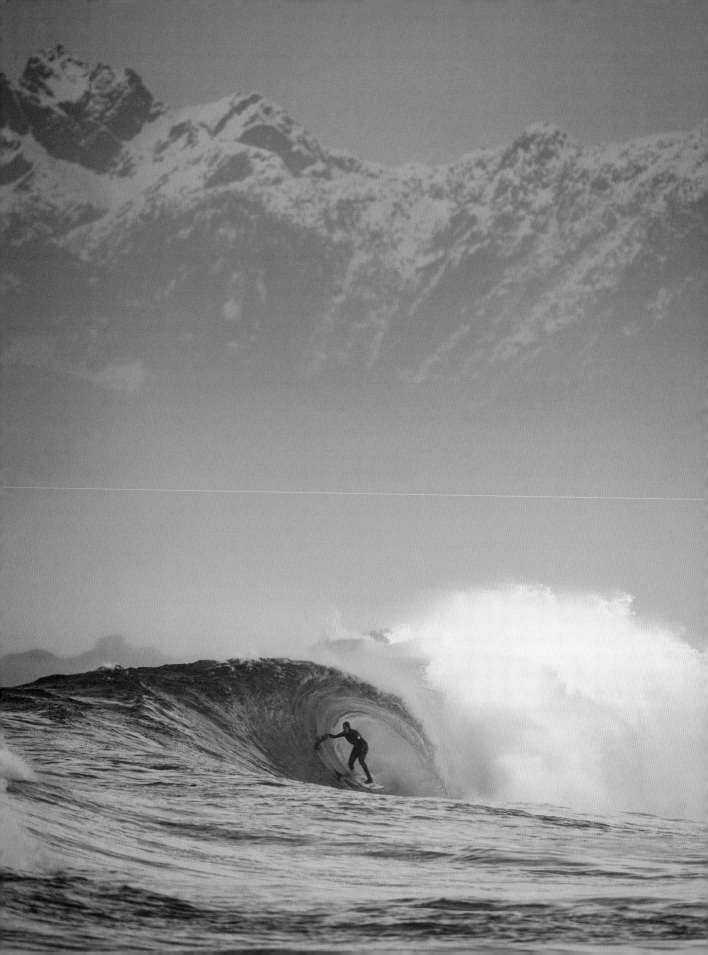

In November 2014, Tait Trautman and professional kayaker Gerd Serrasolses traveled six hundred miles from Santiago to Entre Lagos, Chile, to paddle the Golgol River, which was swollen with record floodwater. "It rained as much as two inches a day during last winter's storms," says the Driggs, Idaho, photographer. Two weeks into the trip, Trautman shot this photo of Serrasolses running a twenty-foot waterfall in a heavily bouldered section of the river, normally impassable were it not for the endless days of heavy rain. "I was pretty sure Gerd was one of the first people ever to paddle it," Trautman says.

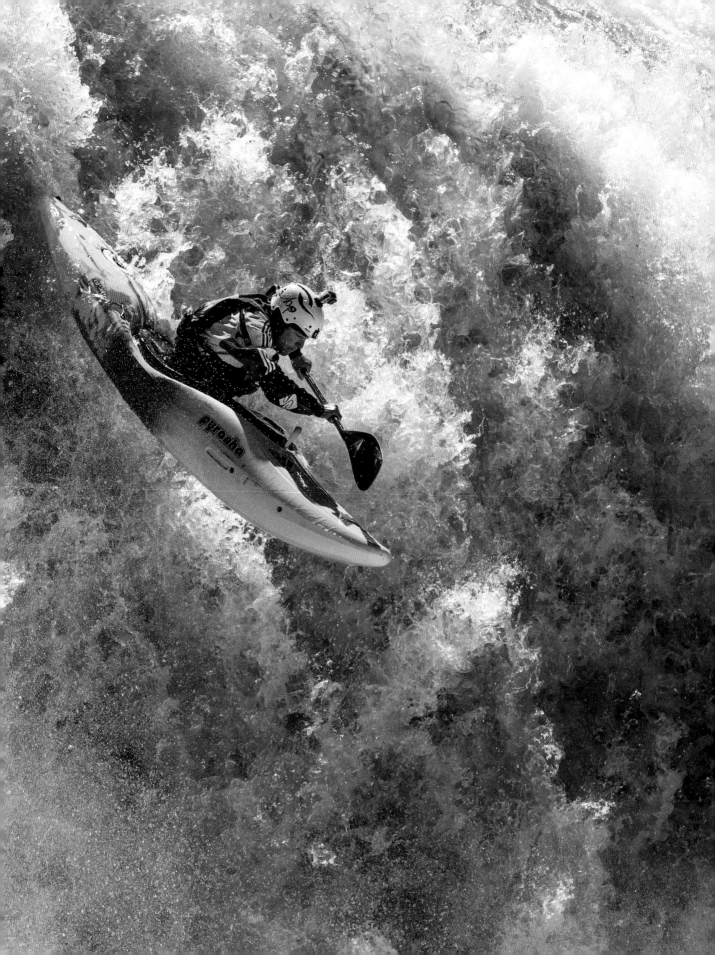

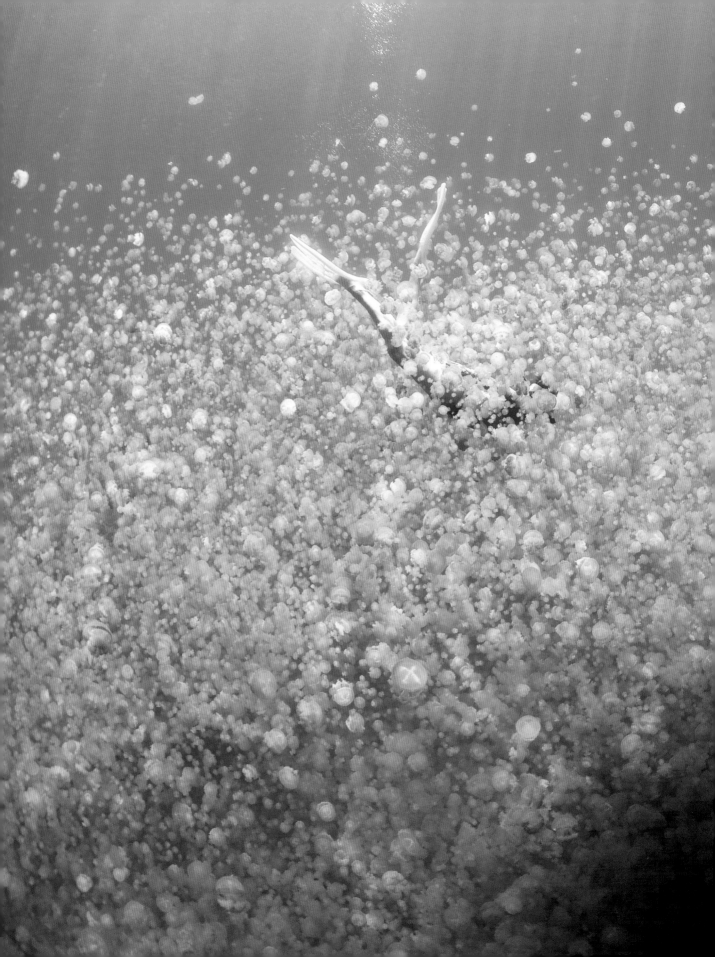

Every day, millions of golden jellyfish migrate across Palau's aptly named Jellyfish Lake, following the sun's rays to encourage photosynthesis in the symbiotic algae that live in their bodies. While guiding a snorkeling trip there in April, Berkeley, California–based Ethan Daniels, who lived in the island nation for nine years, photographed one of his clients swimming among them. "We've been brought up thinking jellyfish sting and to stay away," says Daniels, but thousands of years of isolation have left the invertebrates with drastically weakened venom. "Being in a lake with millions of them, these pulsating animals that look like UFOs, bouncing off you harmlessly—there's nothing else like it."

Shooting from a helicopter, Kirk Lee Aeder caught pro surfer and native Hawaiian C. J. Kanuha paddling within twenty feet of this lava spilling out of the Big Island's Kilauea volcano. Beforehand, Kanuha paddled to a nearby black-sand beach and made an offering to Pele, the Hawaiian fire goddess, asking permission to paddle out. "It's mostly a spiritual thing," says the Waikoloa-based photographer, "but it's always a good thing to do when you're screwing around with a volcano and molten lava." Still, Kanuha didn't feel entirely welcome: Boiling water burned his feet, and his skin peeled for days.

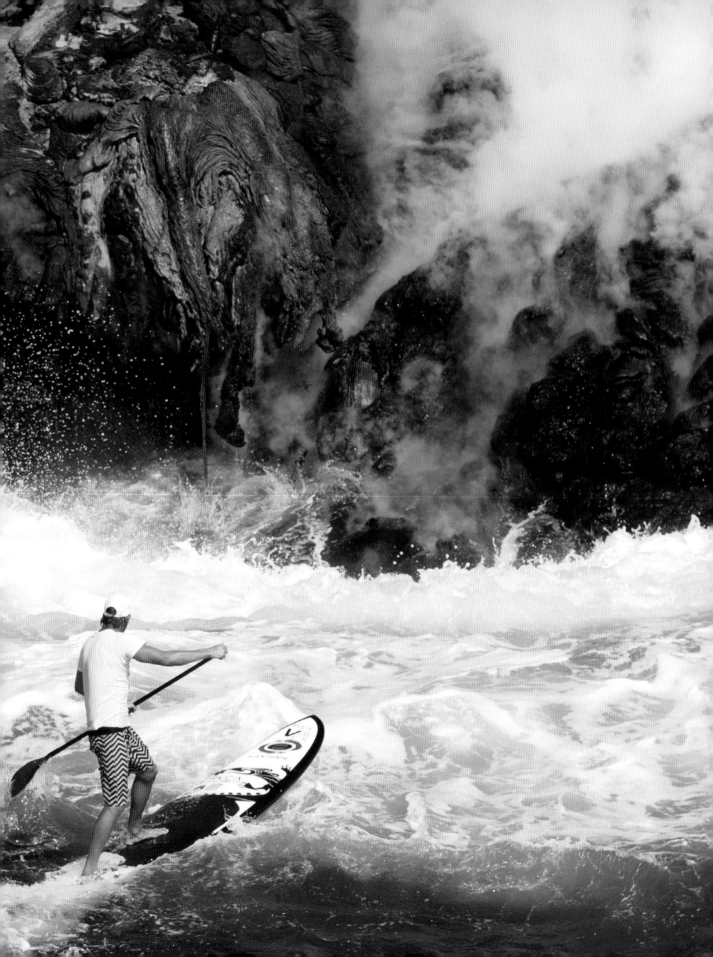

It's no wonder so few have ventured deep enough into Patagonia's Calvo Fjord to stare down its skyscrapers of ice. "If something went wrong and we needed a rescue, it would have taken at least forty-eight hours to reach us," says *Outside* editor-at-large Grayson Shaffer, who held back as his teammate Reg Lake got up close and personal with the Lotus Glacier during their 2007 expedition. Shaffer says that while it looks as though Lake is within touching distance of the ice, he was actually playing it pretty safe: Lake is a good hundred yards from the face—just out of the impact zone for falling ice. "This thing was actively calving," remembers Shaffer. "It was dropping apartment building–size blocks into the water."

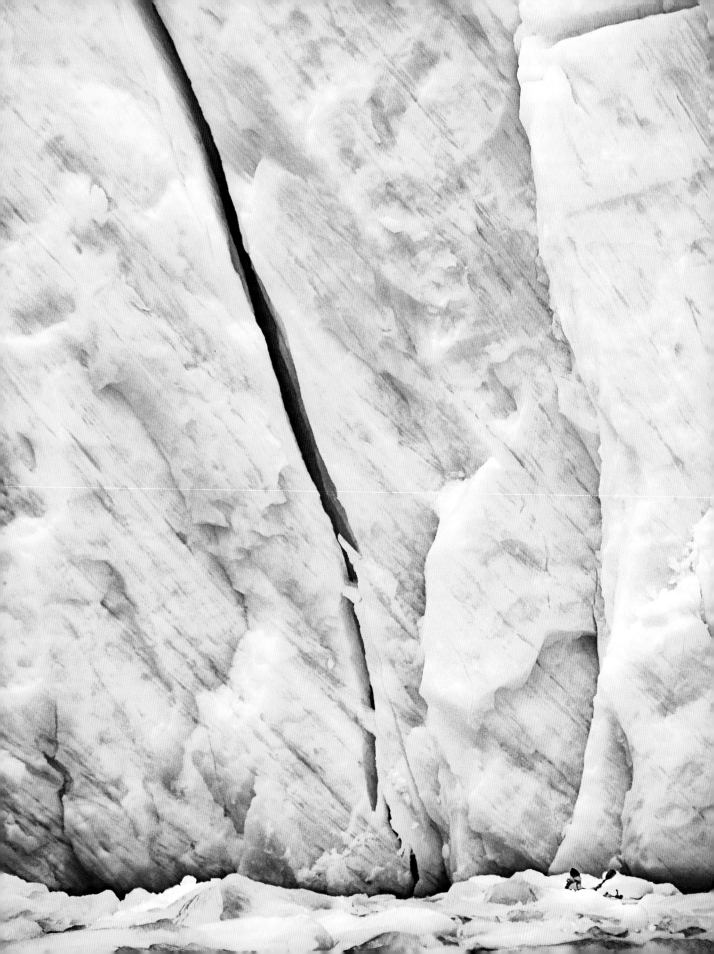

"The first thing people ask me when they see this image is, 'How did you Photoshop it?'" says Denver, Colorado, photographer Lucas Gilman. "I didn't." Thirty minutes before sunset, Gilman positioned himself on a suspension bridge just downstream of the sixty-foot Rainbow Falls on Michigan's Black River. When kayaker Steve Fisher paddled into the calm water beneath him, Gilman snapped the photo. "It was like a kaleidoscope of foam patterns," says Gilman. The suds, which aren't pollution, form when air mixes with water and the gas bubbles released by decomposing leaves.

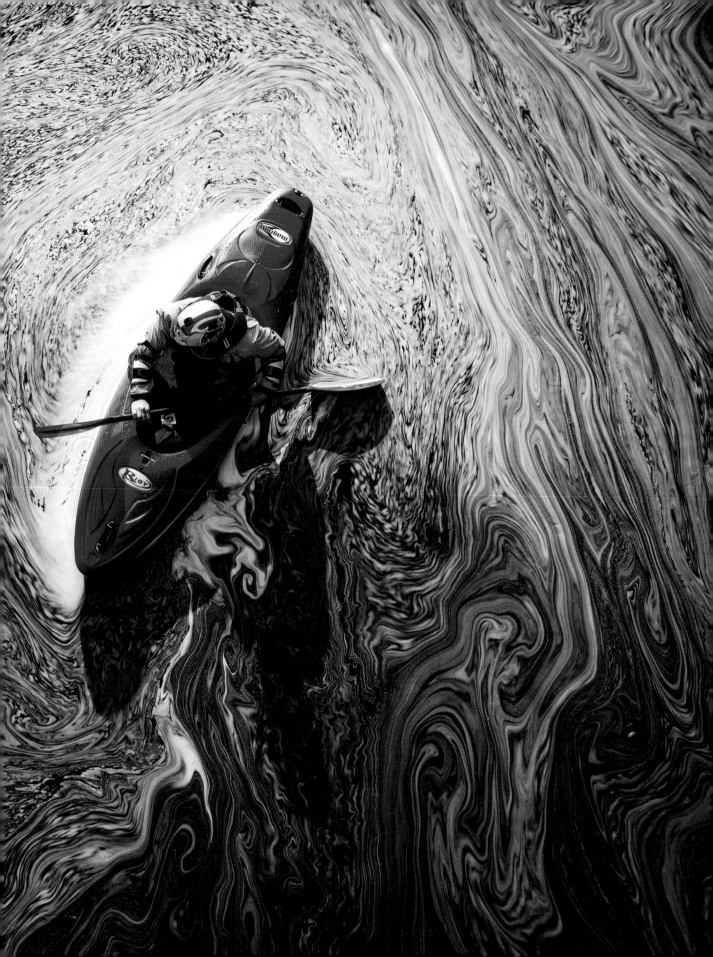

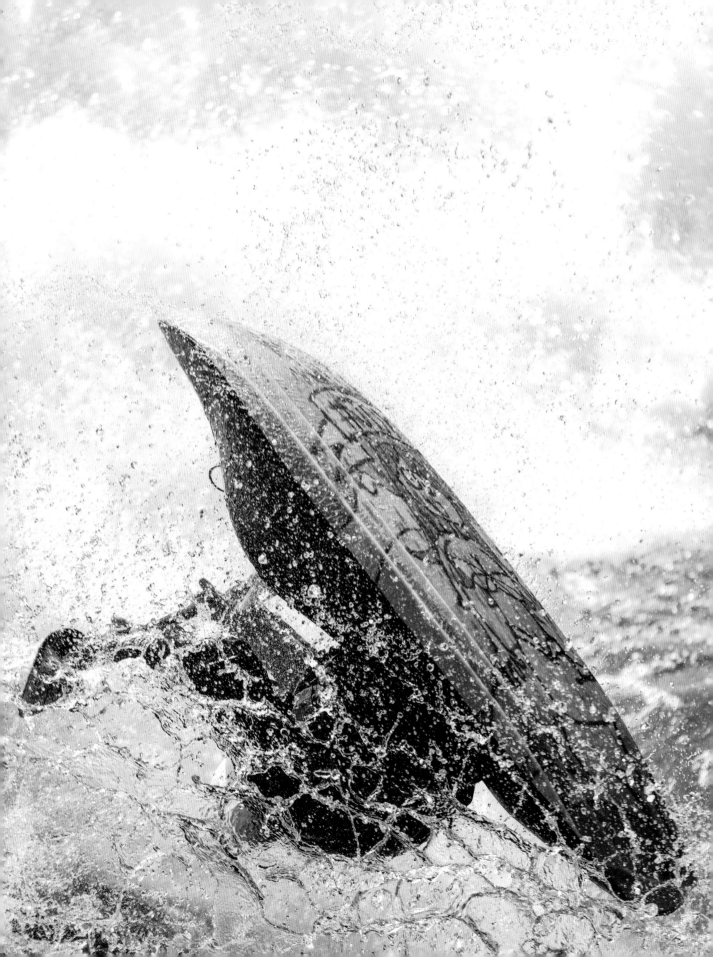

As the banks of the Ottawa River flooded with snowmelt in April 2016 near his home in Eganville, Ontario, photograpger David Jackson knew it was time to capture white-water heavyweight Ben Marr at work. "The river gets serious at that time of year," Jackson says. "It's icy, it's filled with logs, and it has the biggest waves in the world." To capture Marr performing a Sasquatch at the bottom of a twelve-footer that locals call the Buseater, Jackson stood on an island in the river. "This is Ben's home wave," Jackson says. "He's in his happy place."

Stuart Gibson traveled three hours by car and on foot from his home in Hobart, Tasmania, in July 2014 to Shipstern Bluff, a world-renowned swell in southeastern Tasmania that he visits as often as he can. He arrived just in time to capture his friend Mikey Brennan surfing this thirty-foot wave, which doubled in size when it hit the granite reef and appeared to magically double-break. "For Shipstern, it wasn't a big day, but then this huge thing came out of nowhere. I caught Mikey just in time to get out of the way."

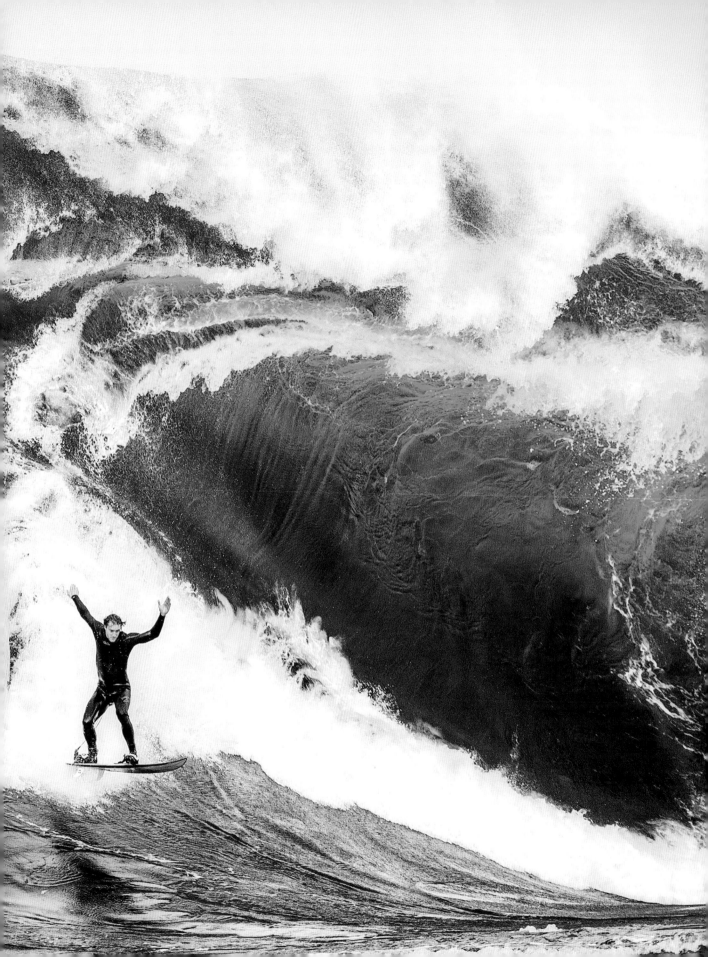

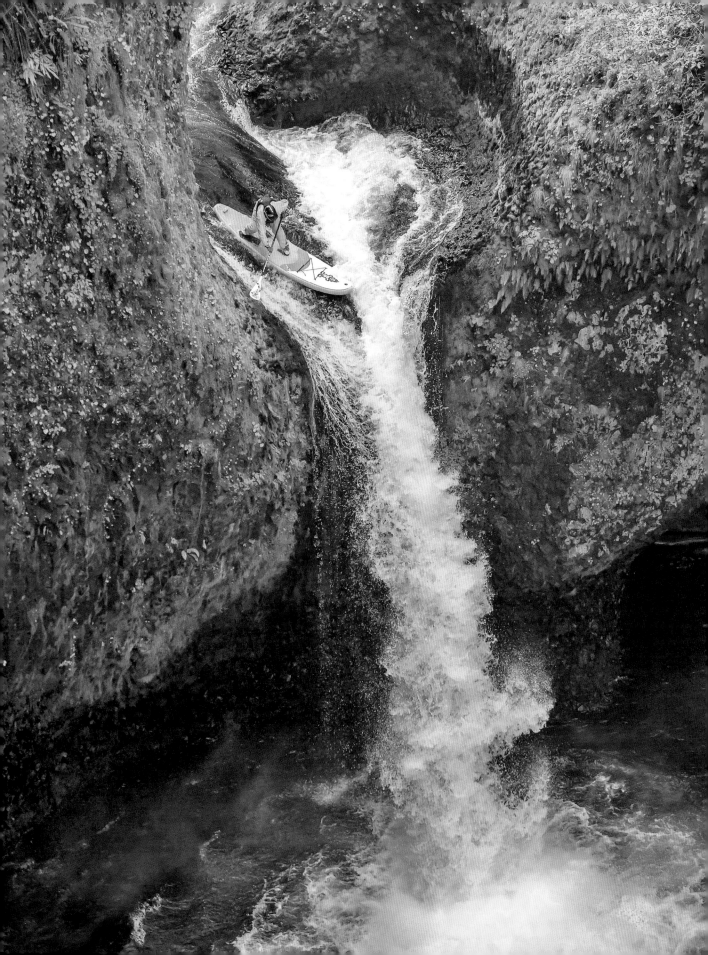

Former professional kayaker Dan Gavere, seen here launching over thirty-five-foot Punchbowl Falls on Oregon's Eagle Creek in 2012, was taking the booming sport of paddle-boarding in his own direction: whitewater. "I'm certain this was the biggest waterfall any-body has ever SUP'd at the time," says pho-tographer Charlie Munsey, of White Salmon, Washington. Gavere and Munsey rose at six o'clock in the morning, hiked two miles to the falls, and spent twenty minutes scouting the line. "Dan was nervous," says Munsey. "But he had an elegant dismount."

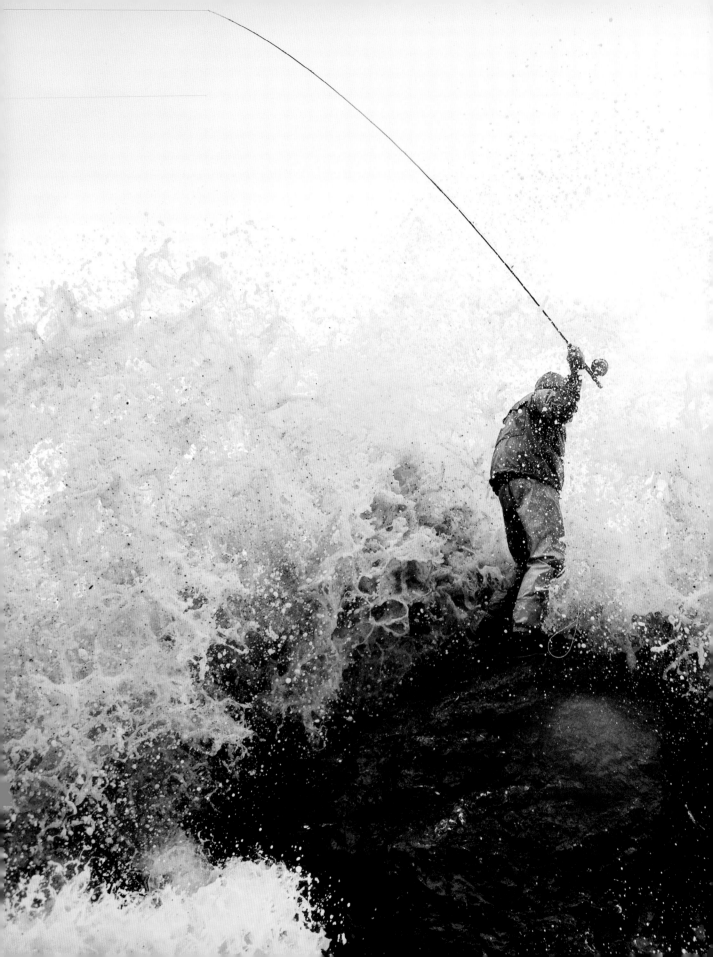

A storm was rolling in off the Pacific in 2010 when Andy Anderson shot fly-fisherman Derek Bond getting hit by a wave. He was casting for black rockfish on a remote beach south of Trinidad, California. "The waves were hammering the coast," says Anderson, of Mountain Home, Idaho. The swell had jumped from four feet to twenty feet in three hours. Anderson hunkered down behind Bond and waited for a wave to break. "I finally had to tell Andy to get back, because it was getting too dangerous," says Bond. "He wasn't afraid at all."

"It took me thirty years to get the best shot of my life," says Hawaiian surf photographer Brian Bielmann, referring to this photo, taken in August 2011, of California surfer Nathan Fletcher at the bottom of a thirty-foot wave at Teahupoo, Tahiti's most famous break. Fletcher's ride earned him three honors at Billabong's 2012 XXL Global Big Wave Awards. The whitewater beside the break was more than forty feet tall. "I love this photo, because it captures the David and Goliath feel of that moment," says Beilmann.

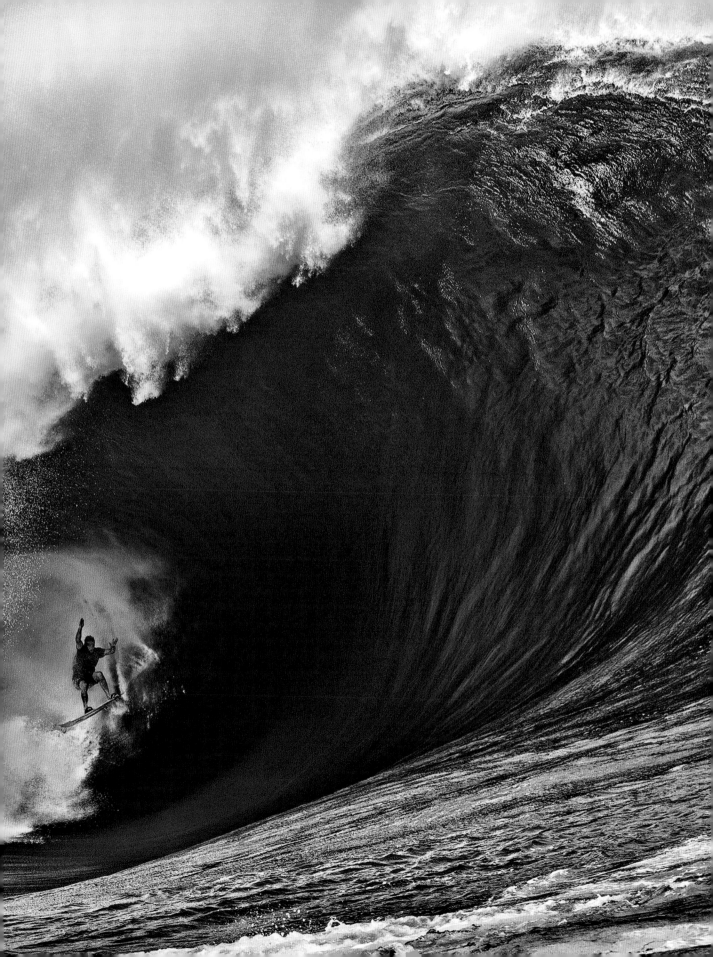

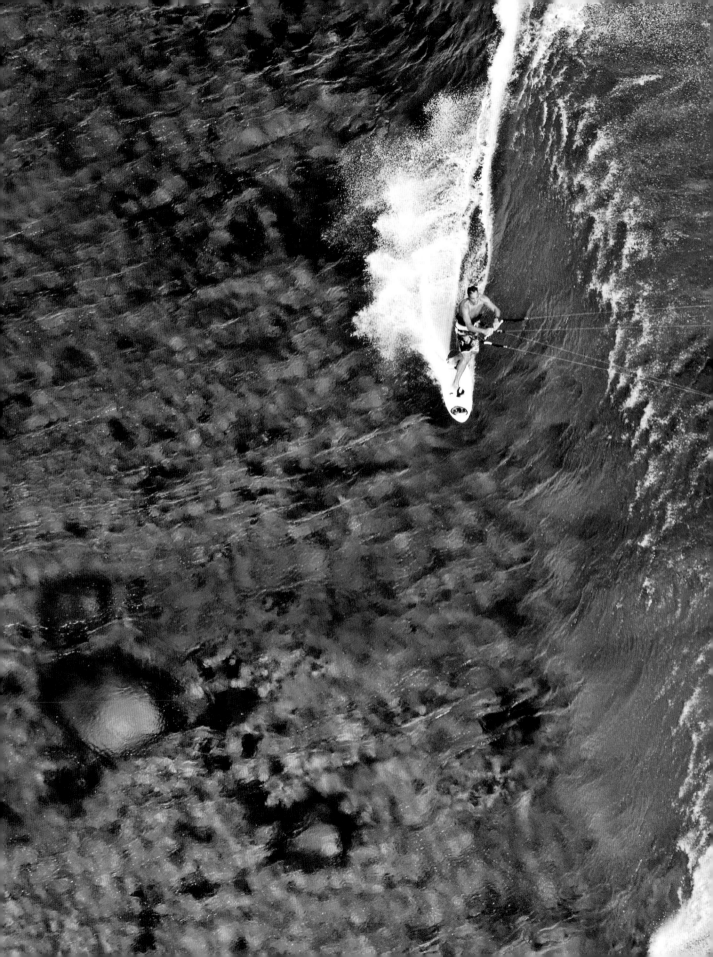

Alberto Guglielmi hovered in a helicopter as Italian kiteboarder Simone Vannucci skimmed across less than a foot of water off the island of Mauritius, in the Indian Ocean. "That break's called One Eye; it's a very shallow reef overlooked by a mountain that appears to have an eye," says Guglielmi, who quit his job as a management consultant to set up shop as a photographer in upstate New York and Sardinia, Italy.

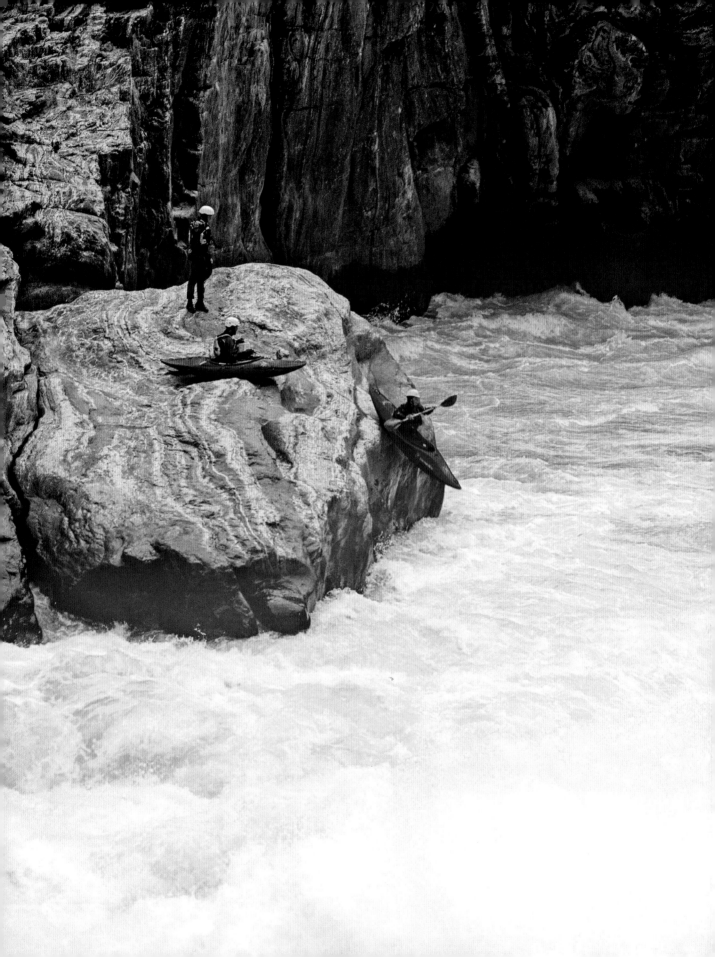

To document a team of elite kayakers making a historic first descent down Tibet's storied Tsangpo River in 2002, Charlie Munsey had a critical decision to make: shoot from the cockpit of his own boat or shadow the team from the flanks of one of the deepest and steepest gorges in the world. "I realized I would get much better shots if I wasn't terrified," says the Portland-based photographer and veteran paddler. Munsey opted for meeting the team at prearranged GPS coordinates, such as this spot where the guys had to seal-drop into the froth after portaging around an unrunnable rapid. "I'd get up early and start running down the trail to the best places for shooting the action," he remembers. "I was going up and down thousands of feet every day, often covered in ticks."

"The tidal bore comes into Alaska's Cook Inlet with every incoming tide, but you can't always surf it," says photographer Scott Dickerson of the wall of water that beckons a particular breed of adventurous surfer. "Sometimes it's just a frothing foam pile, because the tide is too weak or the wind is blowing in the wrong direction or the inlet is frozen. When the elements align, like they did this day at Turnagain Arm in 2011, there's no other wave like it." Three of his friends rode the bore's leading edge for almost five miles while Dickerson flew a motorized paraglider five hundred feet overhead and snapped photos. "Between the sun and the surf, it was the best I'd ever seen the bore—even if I was working."

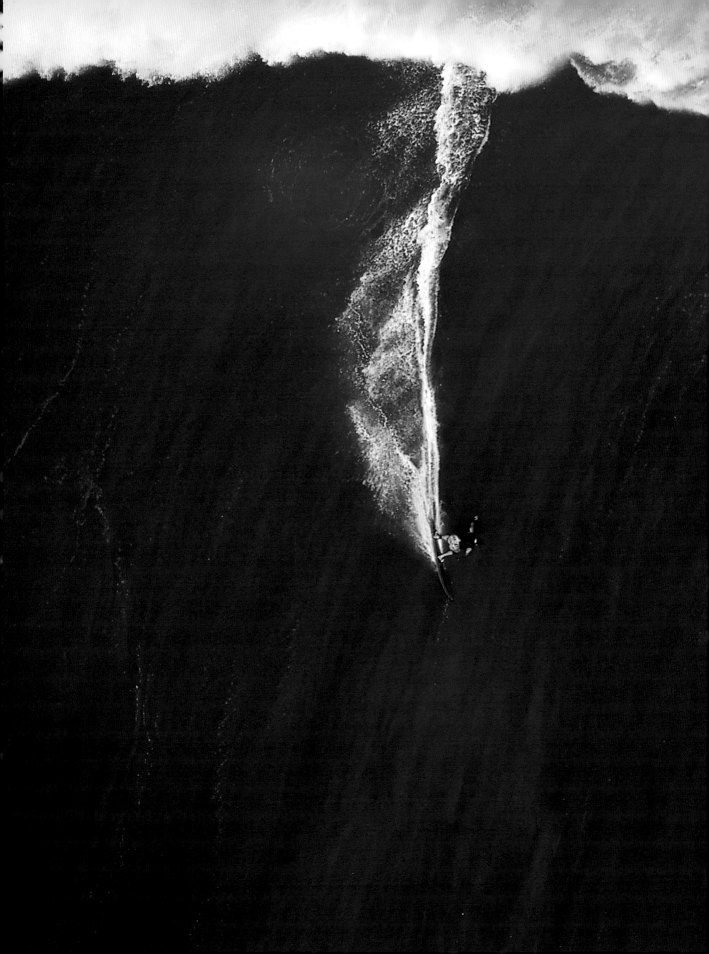

Sean Davey hung out the door of a helicopter to get this shot of Brazilian surfer Fernando Ribeiro riding a thirty-foot swell at Outside Avalanche, off Oahu's North Shore. "The conditions were really smooth and sunny—an uncommon combination here," says the Oahu-based lensman.

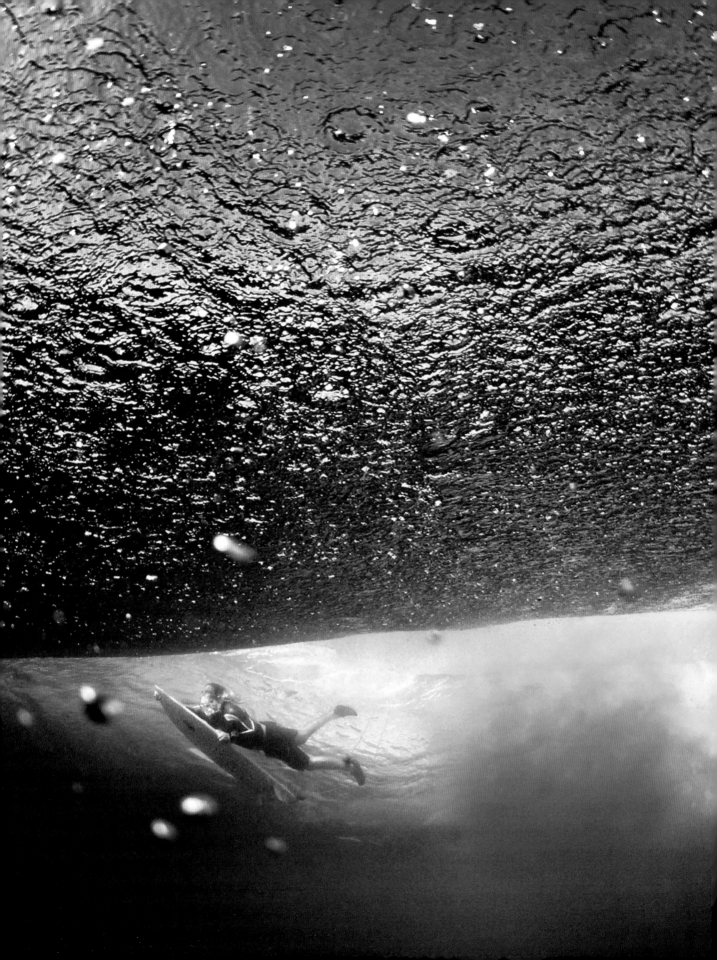

In Sumatra, Indonesia, Jeremy Nicholas caught Damion Fuller duck-diving under this eight-footer. "The wave itself is right on top of me," says Nicholas. "And I'm a lot closer than it looks—probably eight to ten feet—but the distortion of the fish-eye lens makes it seem a long way away." Nicholas, an Aussie photographer based in New York, makes the trip to Indonesia once or twice a year, but these days he spends more time shooting than surfing. "Basically I got into photography because I'm a terrible surfer," he says. "I'd be out in these places where the surf was too big or too strong or too scary for me, so I picked up a camera."

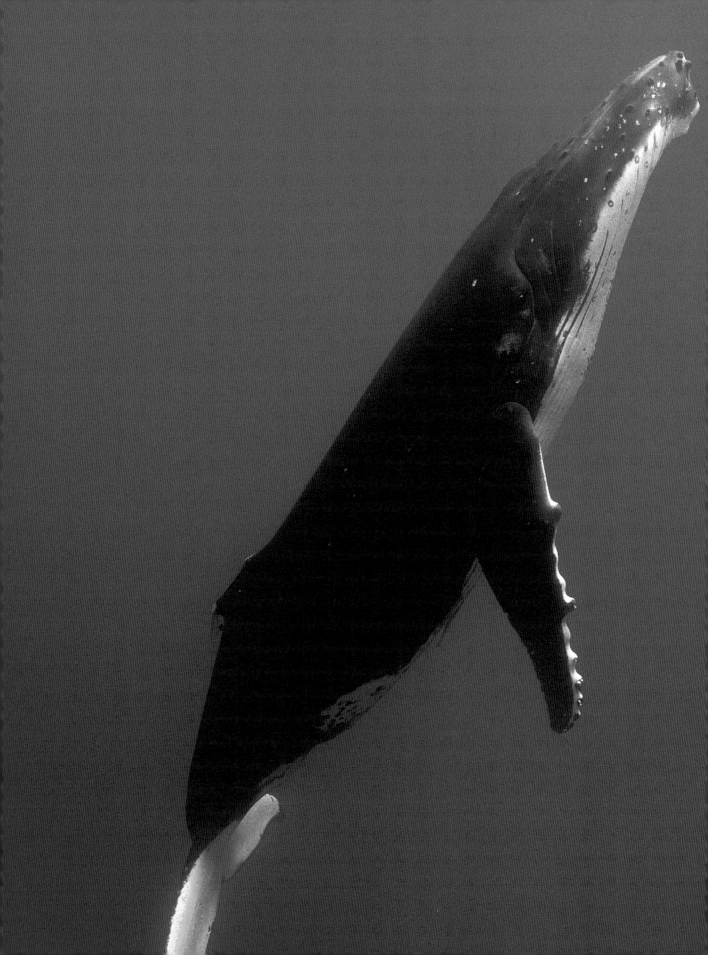

Tim Calver and filmmaker Pete Zuccarini (pictured) were near Tahiti taking a break from work on a documentary about the oceans when they spotted this sleeping humpback. "She would doze for about fifteen minutes at sixty feet and then drift to the surface for a few slow, deep breaths before dropping back down," says the Miami-based lensman. "Her calf was on the surface, just out of the picture."

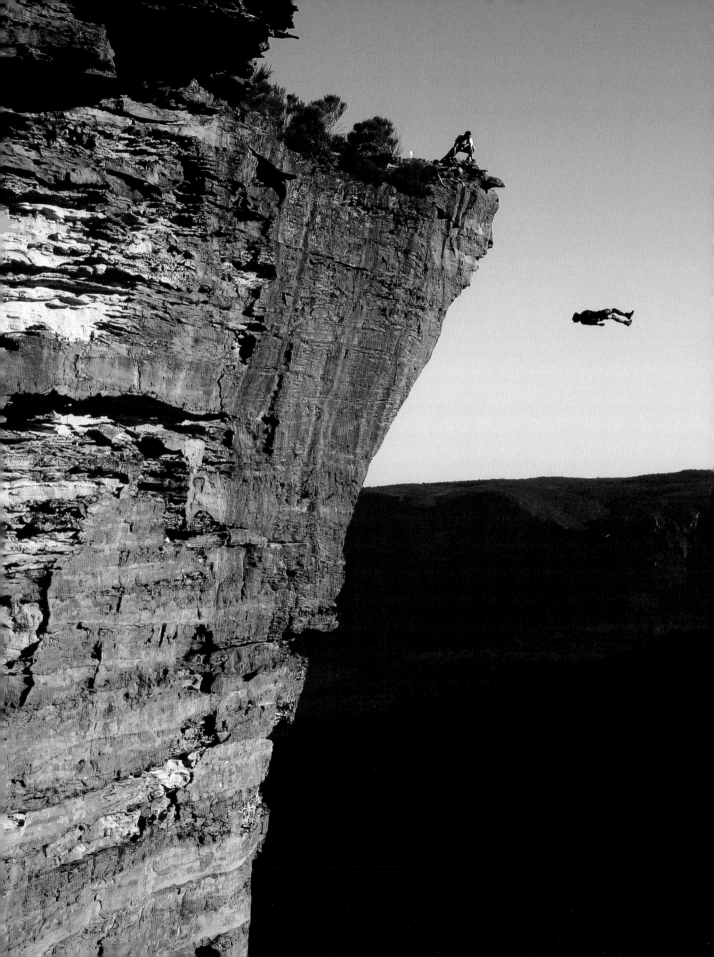

air & space

"BASE jumping is such a fast sport," says Krystle Wright, who shot Ben Gibbs backflipping off this 1,500-foot cliff in Australia's Blue Mountains National Park, west of Sydney. "This photo is just a moment in time. When you see them jump in real life, it happens so much faster." The Blue Mountains, a sandstone plateau divided by a series of gorges, is a favorite of Aussie hikers, cyclists, climbers, and, of course, BASE enthusiasts—though the sport isn't exactly legal in the park. "The jumpers tend to not tell the park rangers when they're jumping, and the park rangers tend to turn a blind eye, as long as they're not causing any hassles," says the Sydney-based Wright. "Of course, some guy drove a mini-motorbike off

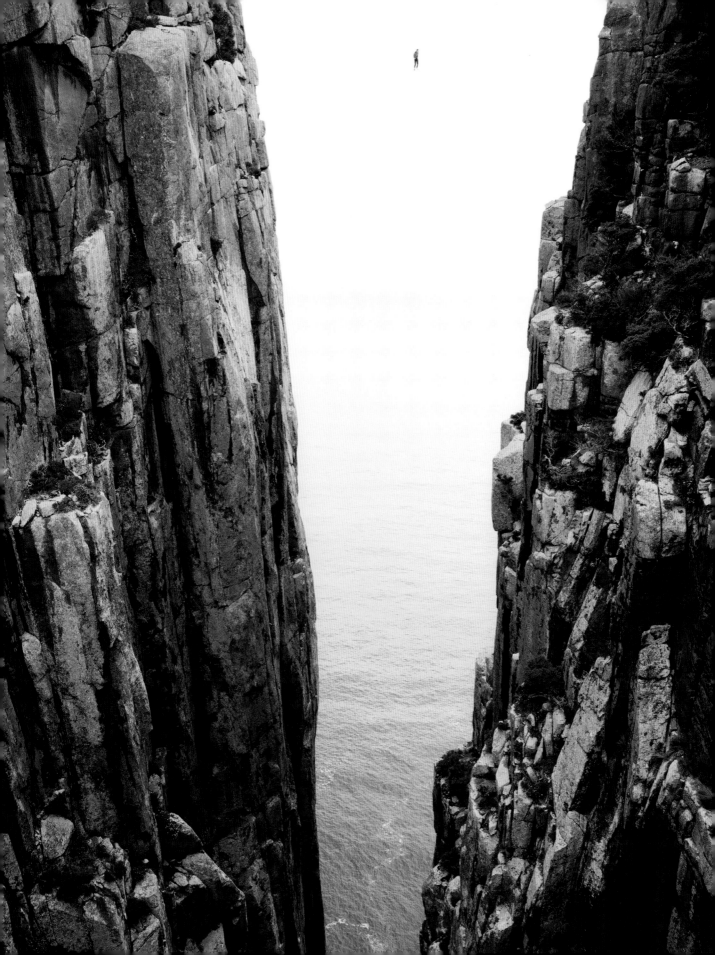

There's no greater adventure photography cliché

than the huck shot. This is because they are often easy to capture: Take a position that makes the cliff/slope/ramp look much taller than it really is, wait for athlete/daredevil/fool-hardy friend to launch, and press shutter button. GoPro built a multibillion-dollar business by convincing millions of amateurs that they, too, could be a huck-shot hero. All of which makes shooting big-air photos a fraught endeavor for professionals. Producing arresting pictures demands a high degree of artistry and an unexpected context or point of view. At *Outside,* we sift through thousands of such photos searching for the gems that, like those presented here, conjure the sense of limitless possibility that arises whenever humans dare to take flight.

During a three-week trip to Tasmania in December 2015, Krystle Wright was part of the first group to set up a highline across a 164-foot-wide gap in Cape Pillar, home to the tallest sea cliffs in the Southern Hemisphere. "This part of Tasmania is insanely beautiful," says the Queensland photographer, who trekked a total of thirty miles to rig the line and then went up to a nearby ridge to shoot professional highliner Ryan Robinson. "I felt like I wanted to make it look like he was walking in midair. A lot of the time, that's what highlining feels like."

In December 2008, David Clifford positioned himself beneath the lip of an eleven-foot jump on the back side of Colorado's Aspen Mountain resort to capture snowcat operator McCabe Mallin as he executed this rodeo 720. "I had the image I wanted in mind, but nobody was going big enough," says the Carbondale, Colorado–based photographer. "Then McCabe came screaming off this kicker." Mallin hit the jump twelve times, but it wasn't all good. On the next try he blew out his knee.

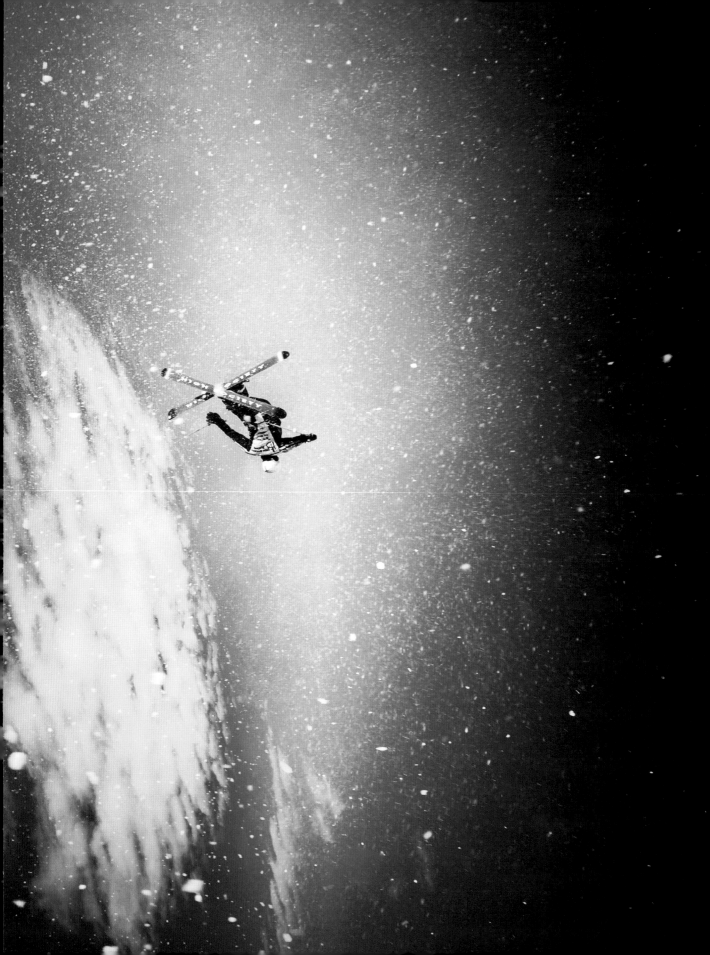

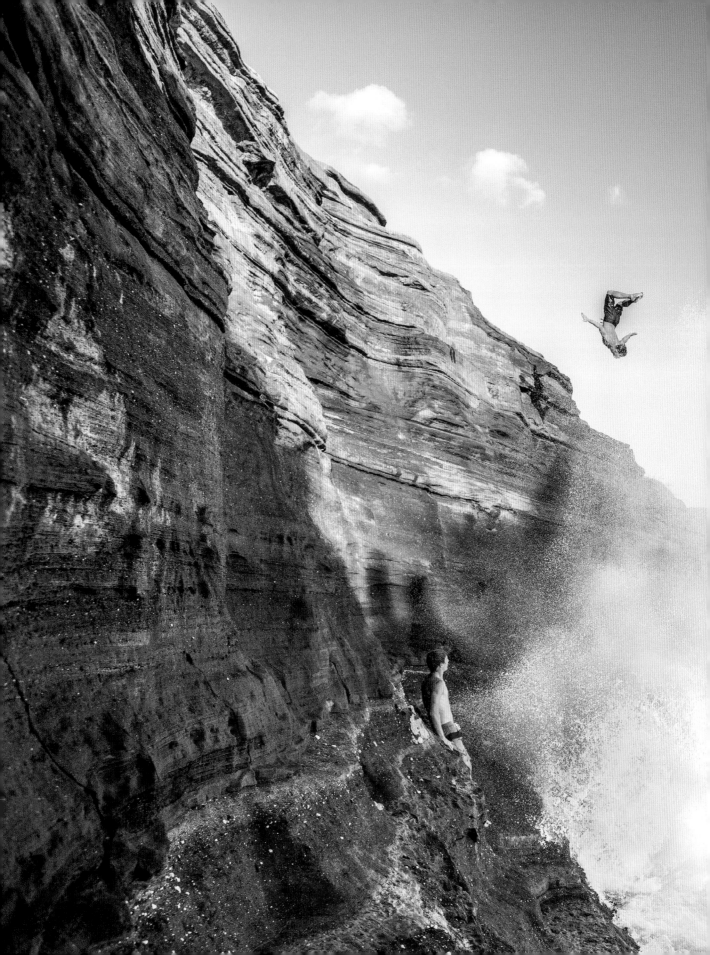

One day in September 2015, the swells were hitting the sixty-five-foot cliff above southeast Oahu's Spitting Cave at a near-perfect ninety-degree angle, creating an especially intense exchange of water and air. "You'd see the entire cave sucked dry, then it would explode out," says photographer Ryan Moss, who stood halfway down the face to capture his friend, professional cliff diver Dan Worden, doing a gainer flip. Worden had to time his dives perfectly to avoid getting pulled into the cave. "There are consequences, as you can imagine," says Moss, who splits his time between Hawaii and California, "but Dan is at peace with what he's doing."

To get this shot of British BASE jumper Chris Bevins nose-diving off 460-foot Thaiwand Wall, near Railay, Thailand, Patrick Orton had to climb four pitches up a 5.11 route called Circus Oz. "I wanted to be directly below Chris when he jumped," says the Bozeman, Montana, photographer. Orton, who was dangling from a bolt by his climbing harness, snapped seventeen frames in the thirty seconds it took Bevins to reach the beach. Rapelling took Orton half an hour. "Chris was sipping a margarita at the bar when I got down," he says.

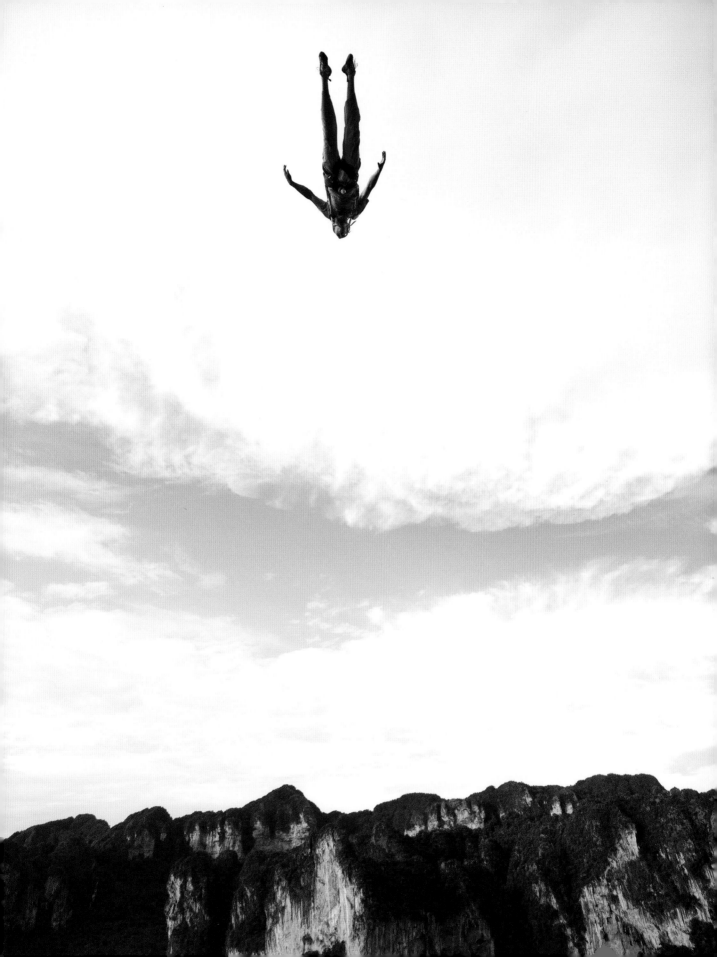

Before launching from a 10,500-foot ridge on Mardi Himal, in Nepal's Annapurna Range, California photographer Cody Tuttle handed the camera to his wife, Cherise. On the anniversary of the country's devastating April 2015 earthquake, the two planned to paraglide on a thermal updraft that would carry them to fifteen thousand feet, and Cherise wanted to capture Cody near Fishtail, considered a sacred peak and therefore inaccessible to climbers. "Getting into position was tricky, but I knew it would be spectacular up there," Cherise says. "Then all it really took was a gust of rising air."

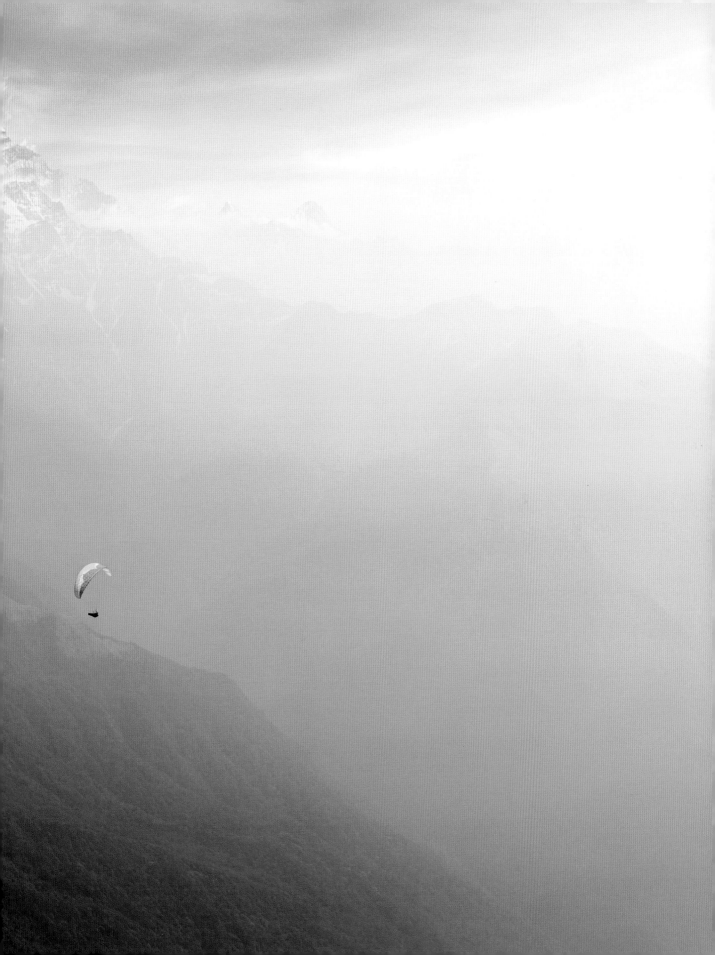

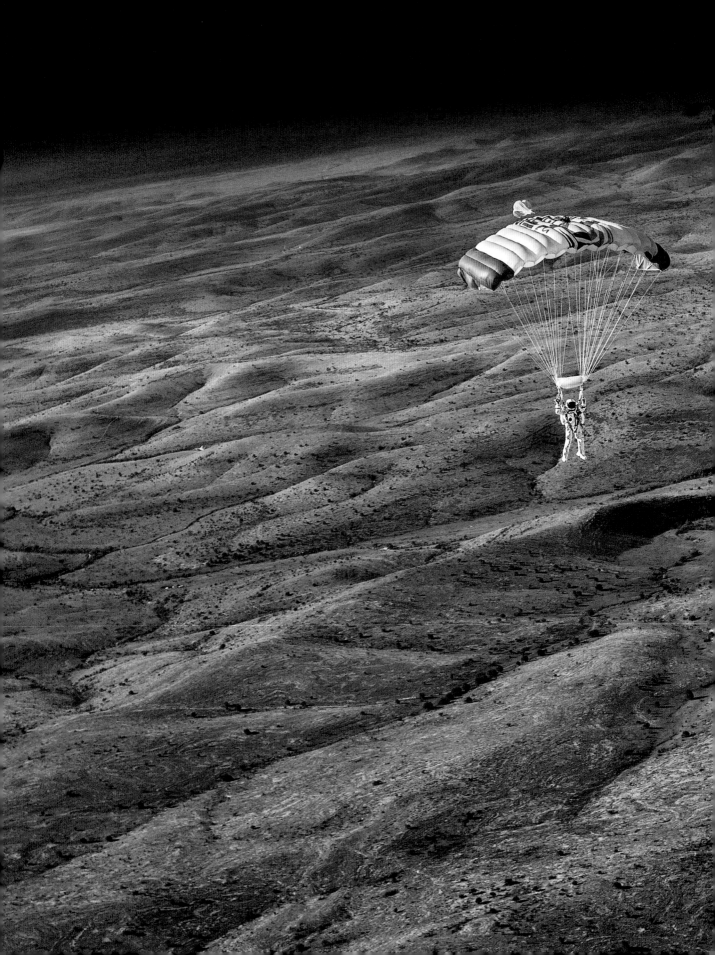

While thirteen million live-television viewers sat on the edge of their seats watching Felix Baumgartner attempt the highest free fall in history in 2012, there was at least one man who was certain the twenty-four-mile drop would be a success. "It was very intense, but I had no doubt," says Balazs Gardi, one of a small group of photographers who embedded with the Red Bull Stratos team for the entire project. "It was extremely well-rehearsed." Gardi shot this image of the stuntman's second test jump, from 97,145 feet, above the New Mexico desert. Despite Baumgartner's extraordinary level of preparation, Gardi was struck by the nerve it took to go through with it all: "It was a privilege to see him stand out there and make that leap of faith."

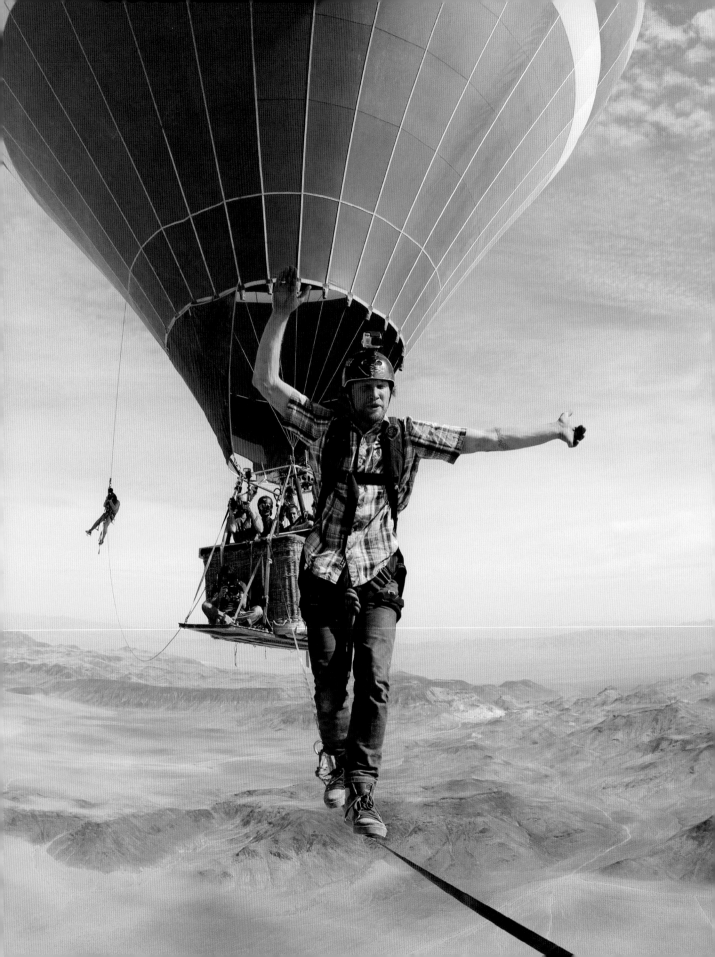

Trask Bradbury worked as an industrial rigger for fifteen years, but he never had a project as interesting as this one: suspending a slackline between two hot-air balloons so "Sketchy" Andy Lewis, of 2012 Super Bowl halftime-show fame, could walk between them. "The first time we tried it, the weather was too dicey to set up the line," says the Colorado Springs photographer, who captured this shot in February 2014 some four thousand feet above a dry lake bed outside Las Vegas. "But by the second go-round, the conditions were flaw-less. We spent the whole day up there while Andy and his team traversed back and forth."

During a trip to Namibia's NamibRand Nature Reserve in March 2014, Theo Allofs was hoping to take a few bird's-eye shots of the area's wildlife from a powered paraglider six hundred feet above the ground when he noticed these fairy circles. While some scientists believe they're etched into the landscape by desert termites, the photographer's vantage gave them an expressionistic appeal. "The patterns were so otherworldly," says Allofs, who lives in Santa Fe. "I felt like I was shooting a fifteen-mile abstract painting."

Matt Irving had been working out of a temporary base camp on Baffin Island's frozen Sam Ford Fjord, in Canada, for more than a week when he learned that the helicopter scheduled for this shoot had been canceled. "Something about bad weather," says the Salt Lake City photographer. "We had to improvise." With the help of BASE jumpers Tim Dutton, Jesse Hall, and J. T. Holmes, Irving scouted this 2,200-foot cliff and captured the three in mid-leap from a nearby ledge. "I was only a few steps from a pretty terrifying drop, but it wasn't until we brought the video director up later that week and made him harness in that I realized I probably should have been strapped in, too."

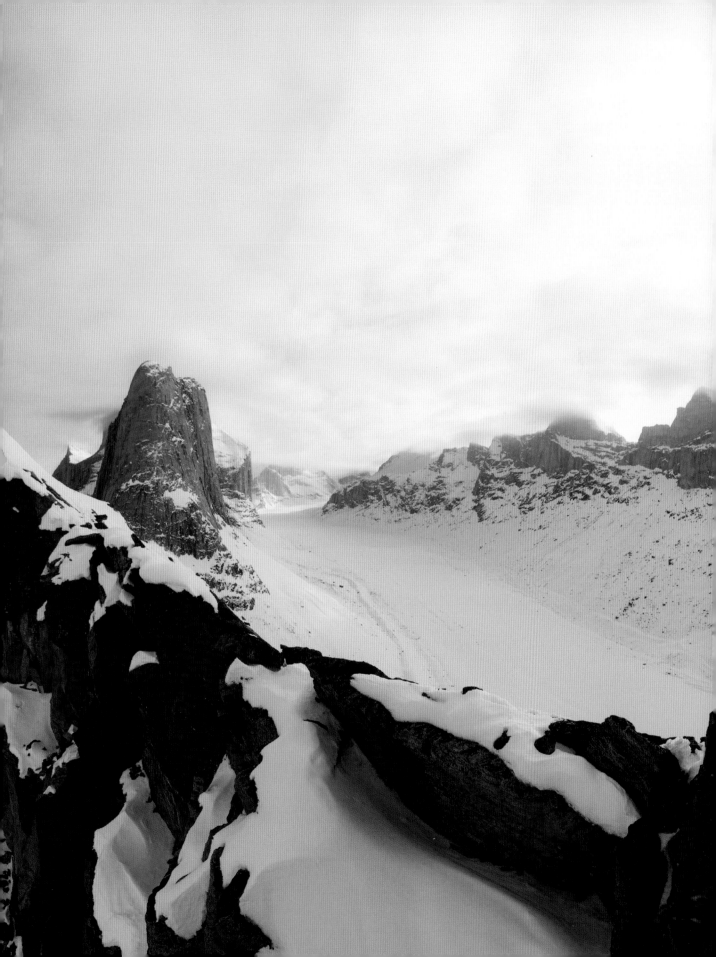

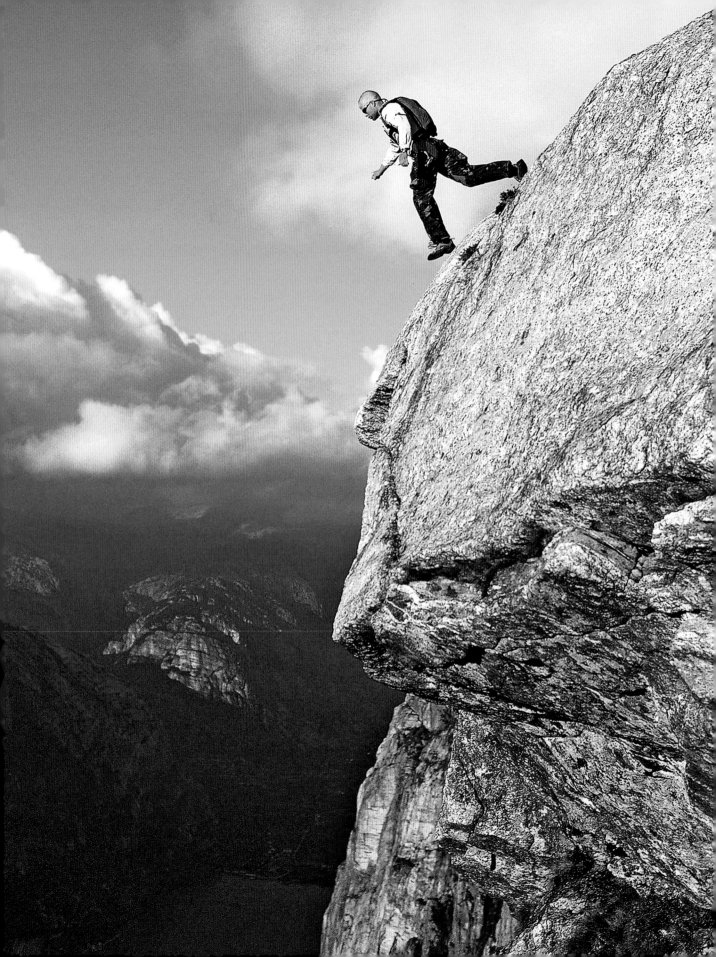

"Most photos are of the thing that is happening—this one is of what is about to happen," says Jonas Paulsson of this shot from a BASE jumping sequence he shot in Norway in 1999. The Stockholm-based photographer was balancing on a small ledge, using a fixed rope to lean out over the three-thousand-foot drop into Lyse Fjord. "This is a popular spot for jumps, but it's also popular with regular tourists," he says. "So these guys would radio to the boat captains and stop the boats in the fjord if someone was about to jump—they didn't want to have any accidents and create a bad vibe about the sport."

Florida might be known for its humidity, but in May 2009 the state's brushlands were desert dry when lightning strikes ignited wildfires near the Palm Beach suburb of Indiantown. Matthew Ratajczak, who was covering the fires for a local paper, captured this reconnaissance plane flying into the billowing smoke of an unnamed blaze. "The firefighters monitored that fire for a week," says the photographer, who shot thousands of images over three days. This one, taken from the yard of a church firefighters were protecting, is his favorite. "I love how the plane is dwarfed by the massive plume," says Ratajczak.

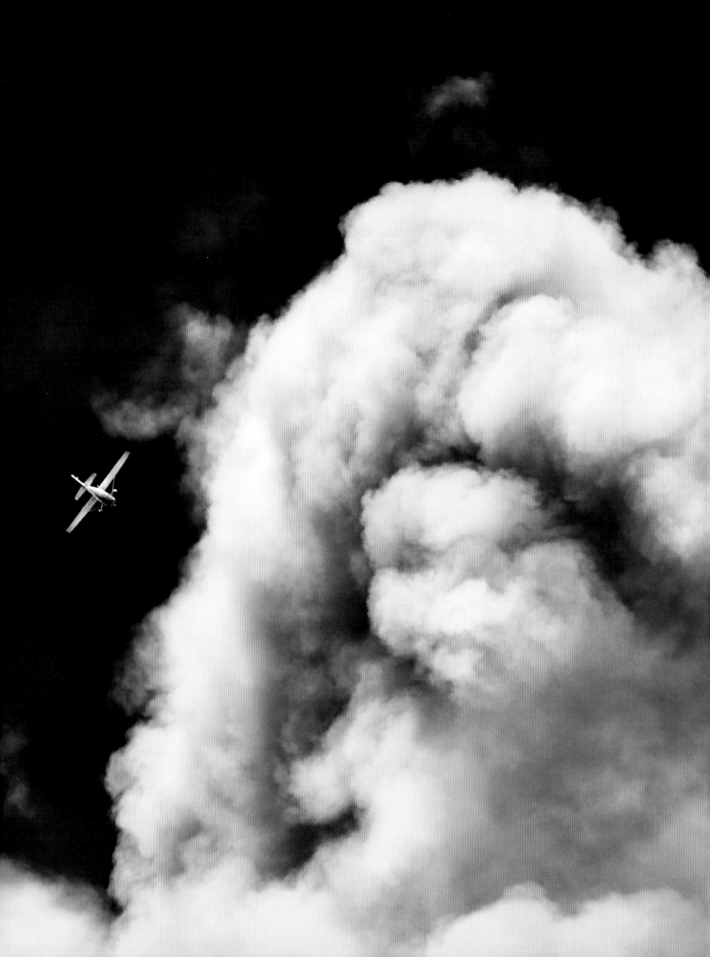

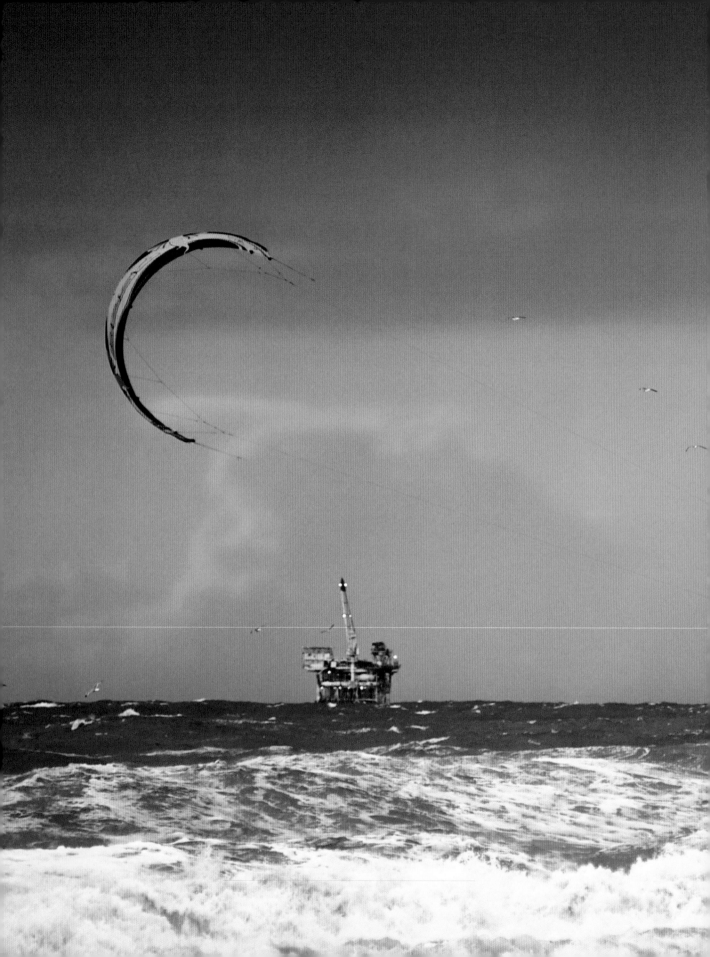

I was sure it was someone flying one from the beach," says Los Angeles–based David Zentz, who photographed this kite surfer from L.A.'s Huntington Beach in January 2010 moments before an approaching storm hit the area. "I couldn't believe there was someone actually out in the water." The setting sun was illuminating the kite perfectly; the off-shore oil rigs were merely happenstance. "My initial focus was the foreground," says Zentz, "but after the Deepwater Horizon disaster that spring, the background took on a whole different relevance."

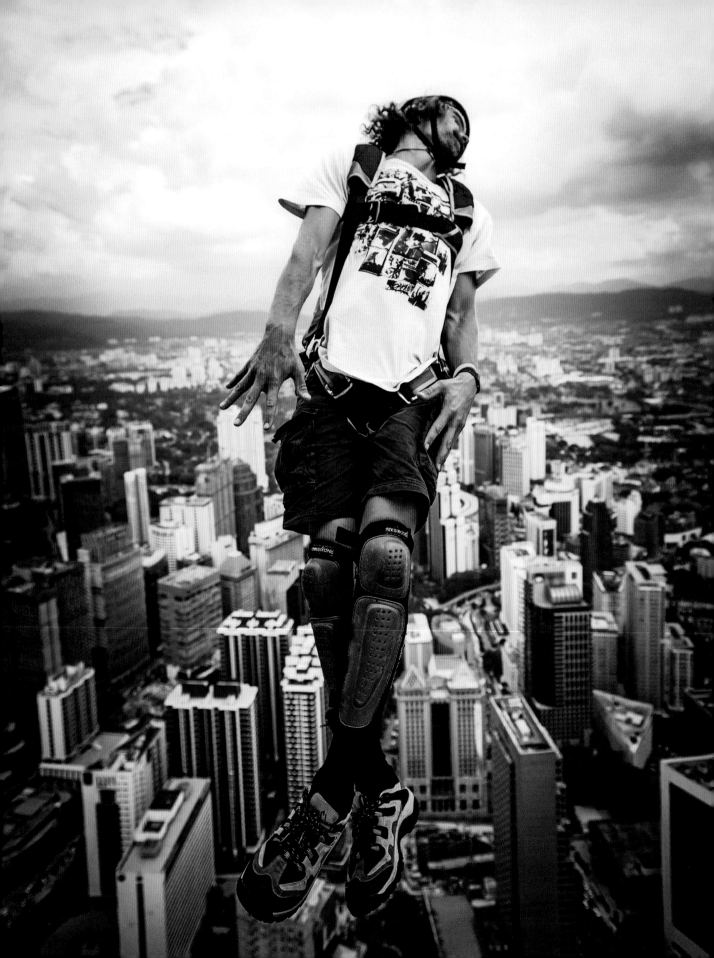

In September 2012, when 92 BASE jumpers gathered in Kuala Lumpur, Malaysia, for the annual KL Tower International, Scotty Rogers made sure he was among them. "I wanted the access," says the Moab, Utah, shooter, who signed up to jump. While other photographers had to be tethered to a 1,100-foot platform near the top of the skyscraper, Rogers was able to move about freely. Shortly after getting this shot of barrel-rolling New Zealander Malachi Templeton, Rogers himself launched off the platform. "I didn't try anything quite so elaborate," he says. "Just a six-second fall."

A few days before breaking her own record for the longest slackline walk by a woman, Faith Dickey met up with fellow professional highliner "Sketchy" Andy Lewis in Moab, Utah, and spent an afternoon traversing between the Witch and the Warlock, two towers in Hell Roaring Canyon. Photographer J. R. Racine captured this image as they were roughly midway through the crossings. "My goal was to get my butt kicked on a big, difficult line," Dickey says, "and this was the perfect warm-up." Later, as temperatures neared one hundred degrees, Dickey, who lives in Austin, Texas, crossed a 350-footer nearby—on her twenty-sixth try.

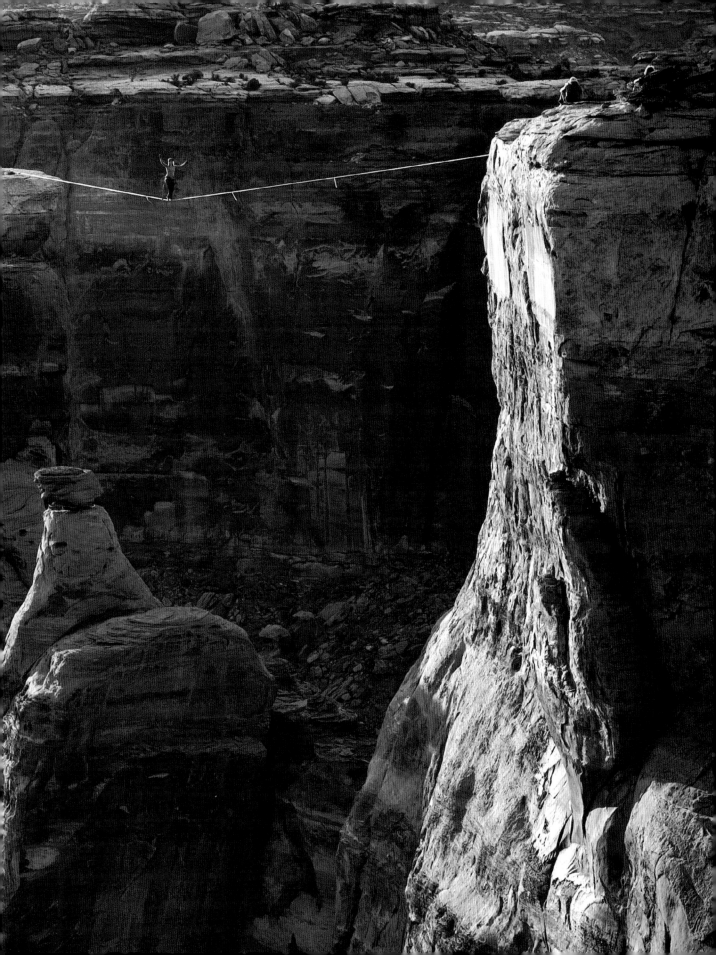

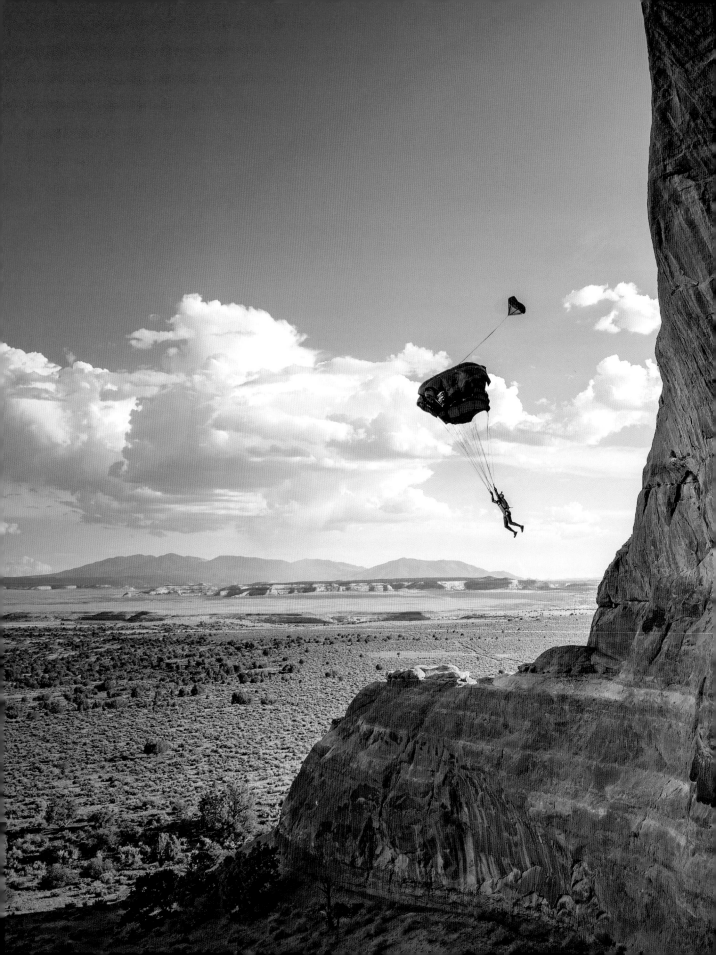

To get this shot of Kevin Chirico BASE jumping from the top of Looking Glass Rock in Moab, Utah, in July 2013, Scotty Rogers stashed his camera at the bottom of the rocks, made the first jump, and rushed to capture Chirico from inside a nearby sandstone arch. "At just 127 feet, this is one of the lowest BASE jumps in the area, which makes for a very technical and immediate deployment," says the photographer, who lives in Moab. "A lot of people climb and rappel here, but I find that a parachute descent is much faster."

Six months out of the year, Cheyne Lempe lives in Yosemite Valley, California, where he was eager to take a group of friends to a favorite spot behind Middle Cathedral Rock. There he captured Colin Harkins slacklining above a pool along Bridalveil Creek. "It's one of Yosemite's hidden gems," says Lempe, who pulled himself across a rope he'd tied to two giant pine trees, fifty feet above the pool, after leading the group on a three-hour hike. "They'd started wondering aloud if it was worth it, but as soon as we got there they were totally stoked."

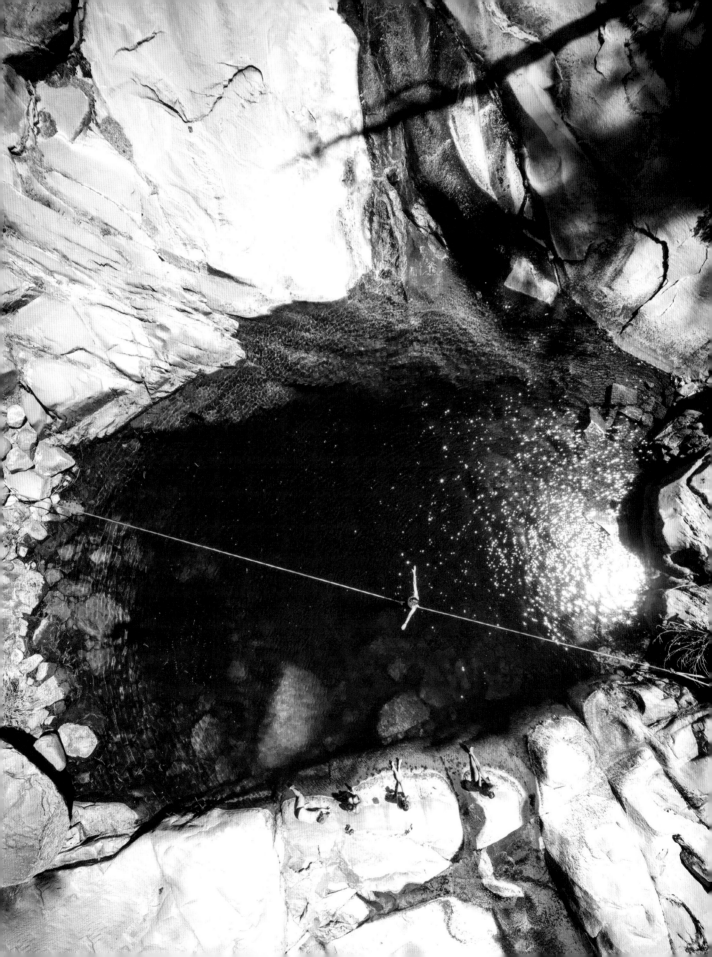

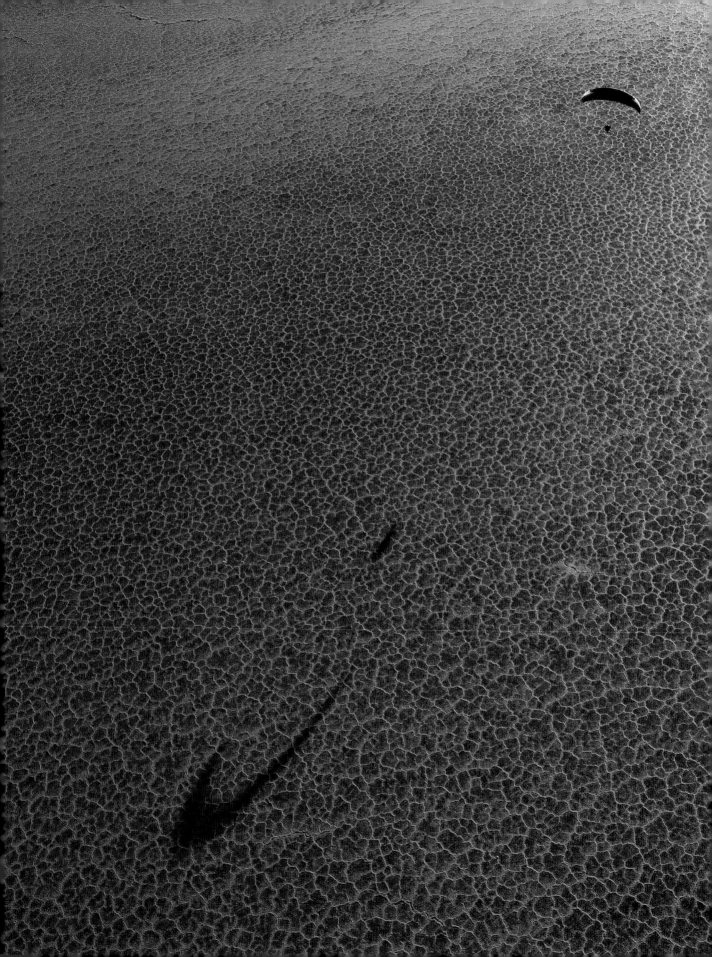

In October 2014, during a three-day expedition to the Bonneville Salt Flats, Krystle Wright took this shot of Utah's Shane Denherder one hundred feet in the air, paragliding with a powered motor at thirty miles per hour. Wright first encountered the flats while driving through western Utah a couple years earlier. "Ever since then, I've been fascinated by the changing textures and colors of the salt ponds," says the nomadic Australian. "It's a photographer's dream."

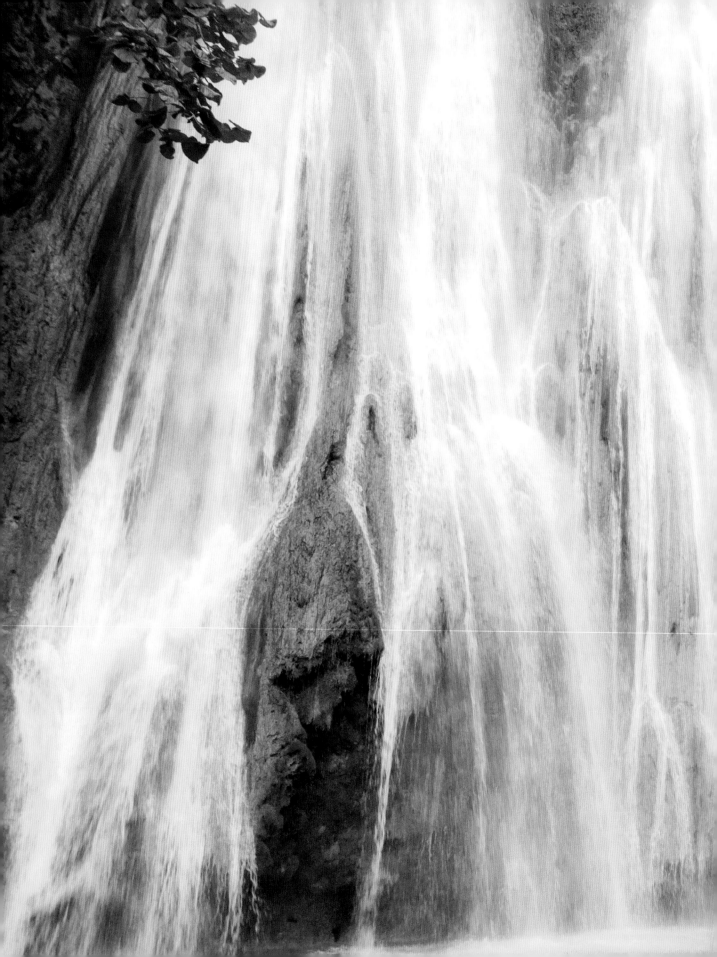

"I was a believer in that saying, 'You've seen one waterfall, you've seen them all'—so I sort of cringed when people kept telling us we had to see this fall called El Limon," says photographer Steve Ogle, who had ventured to the Dominican Republic's lightly visited Samana Peninsula in 2010 in search of new adventures. It was a couple locals who finally convinced him to make the trip to the falls, offering to guide him on horseback. "It was about a twenty-minute ride and there was this beautiful blue pool, and no other tourists," says Ogle. "One of the guys starts scrambling up the cliff ledge, then just launches it. And I will say, it's still probably the nicest easy-to-get-to waterfall I've ever been to."

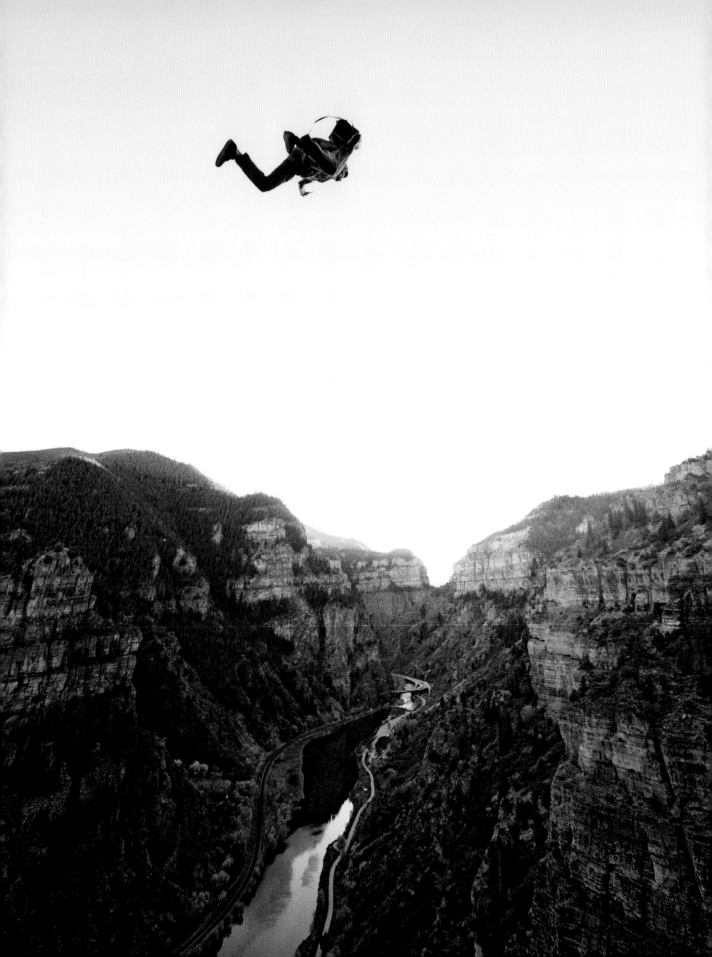

Elliott Bernhagen, of Sandpoint, Idaho, was in western Colorado in October 2014 to capture the area's exploding fall colors. In Glenwood Springs, he met Conor Ward, whose favorite after-work activity is BASE jumping at Glenwood Canyon. After a half-hour hike to the cliff one evening, the photographer rappelled one hundred feet to capture Ward after his launch. "There was a loud rush as he took off, then I caught him isolated above the horizon," says Bernhagen. "When we got to the bottom, he had a big smile on his face."

David Burnett crouched next to the start house of the Utah Olympic Park jump ramp to capture this image of Kyrgyzstan's Dimitry Chvykov in the finals of the 120-meter event at the 2002 Winter Olympics. Unable to see the landings, Burnett relied on the crowd to learn how jumpers fared. "They gasp and then they cheer," he says. "If somebody wipes out, then they really gasp."

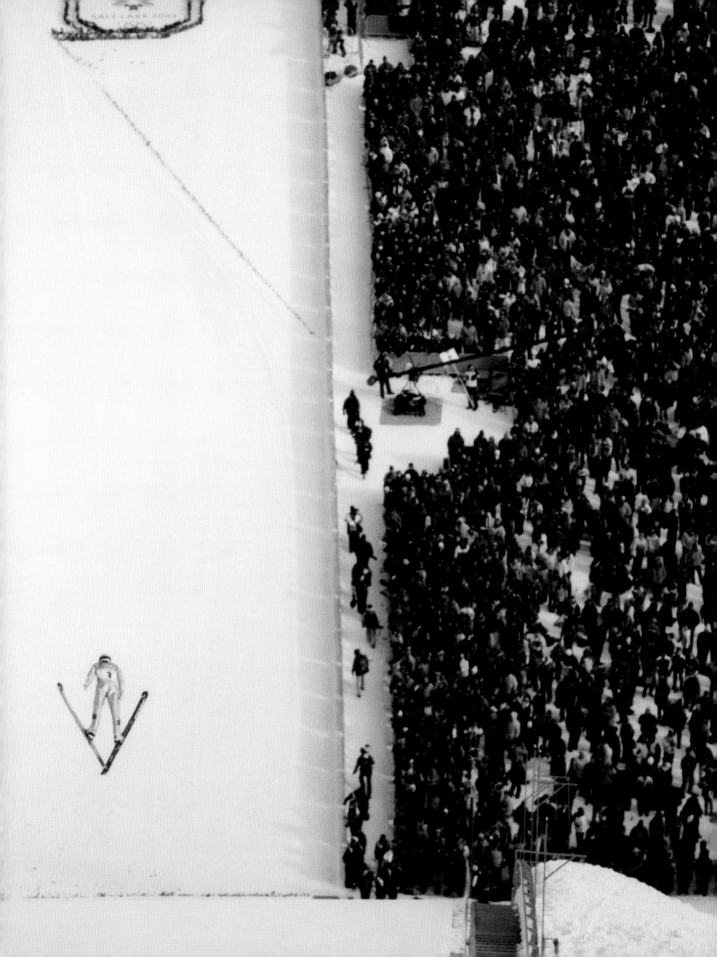

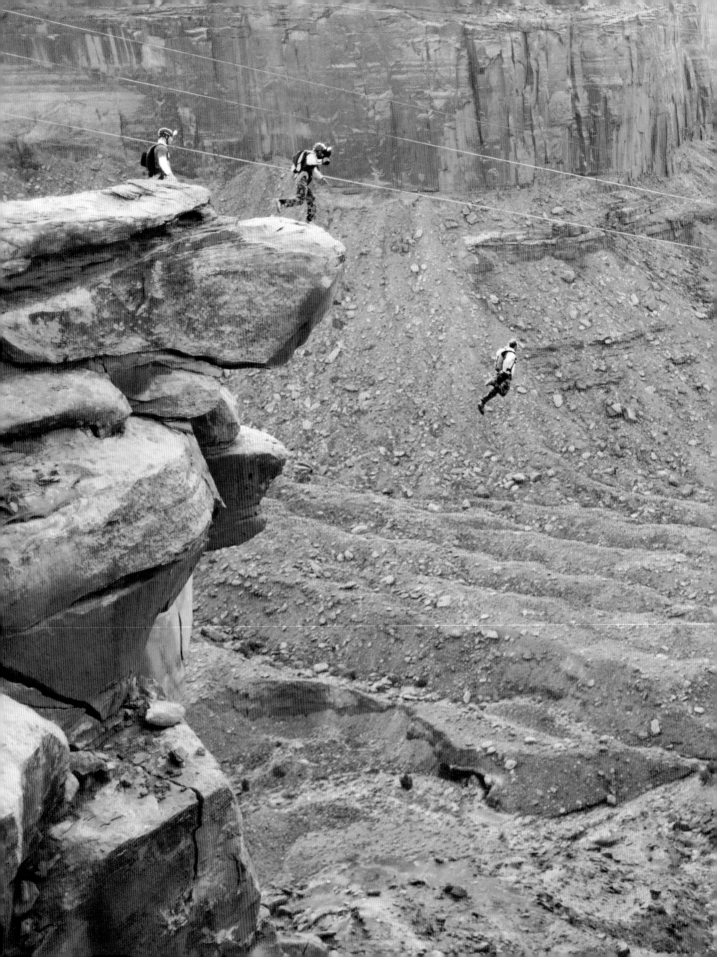

"To say it was organized chaos might be generous—it was more just chaos," says Forest Woodward of the surreal scene he encountered in the Moab desert on Thanksgiving 2015. "One guy was out on this five-hundred-foot-long slackline, there were drum circles, campfires, people cooking. Then, just as I was snapping this photo, these BASE jumpers hucked off into the melee." The "fruit bowl," as it's known, is the site of an annual—and totally illegal—gathering of people with an unhealthy relationship with heights, who build a giant spider web high above the Utah desert. The Ashville, North Carolina–based photographer says it reminded him of a high-stakes music festival. "It required a Tyrolean traverse just to get onto the net," he recalls. "But once you made it, you had your stage."

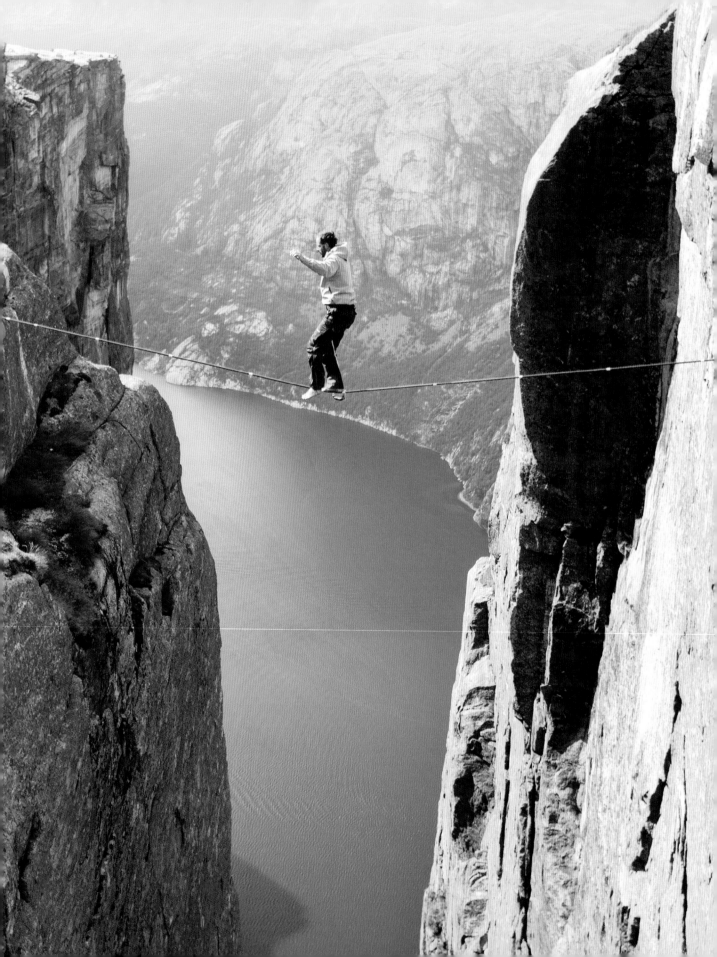

In what was probably the highest slackline stunt ever when he did it, Christian Schou, of Oslo, crosses a three-thousand-foot chasm at Kjerag, in southwestern Norway, in August 2006. "It's like being very far from home. You have very little to relate to," says Schou of the feeling he had midway across the forty-three-foot-long, one-inch-wide strip of webbing. "It's just terrible to look down." Schou had trouble traversing a similar highline in Yosemite in 2005, which made Swedish photographer Fredrik Schenholm skeptical that he'd pull off this feat. At Kjerag, Schou fell twice (wearing a harness) before composing himself and making it across the gap five times. A thin backup rope was taped beneath the slackline for added safety. "Otherwise, if the line snaps," Schenholm says, "it's finité."

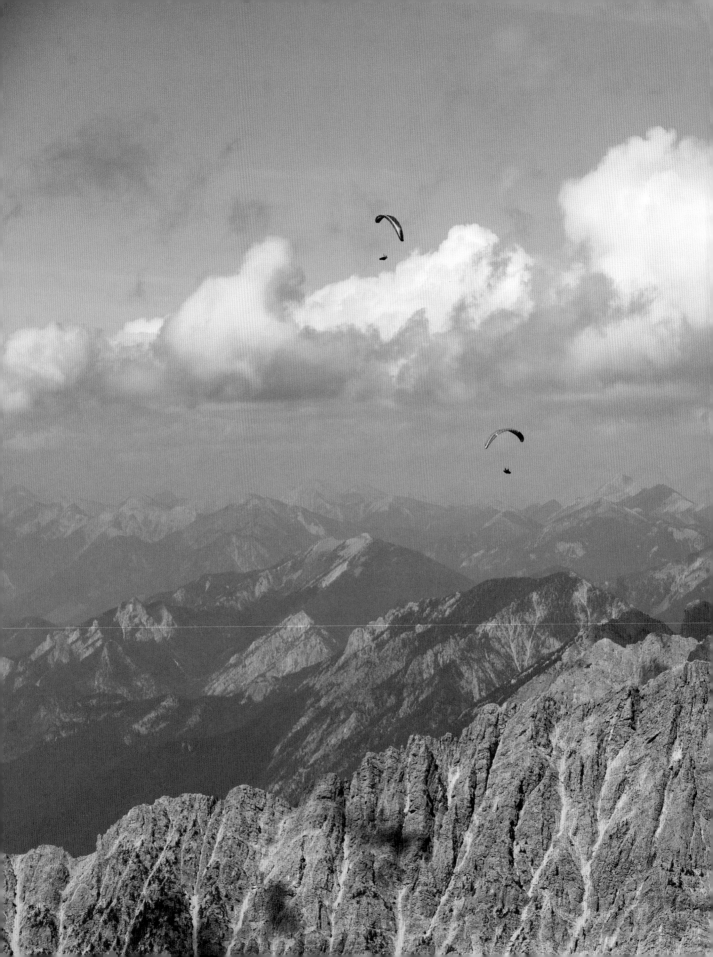

A helicopter afforded Jody MacDonald a front-row seat in 2014 as paragliders Will Gadd and Gavin McClure pulled off one of the most ambitious long-distance trips ever attempted: 385 miles down the spine of the Canadian Rockies. Still, the Sun Valley, Idaho–based photographer wished she'd been even closer. "I would much rather have been flying with them," says MacDonald, who's been paragliding since around 2004 and taught McClure how to fly. She shadowed the two men for the entire month of their journey, but since Gadd has strict rules about how close he'll allow helicopters to get, she always had to keep her distance. "It was great for scale and sense of place," she says. "And that's actually what I love about paragliding itself—accessing these perspectives that you can't get any other way."

On a dry lake bed in Nevada's Black Rock Desert in May 2009, landscape artist Jim Denevan created what's been billed as the largest drawing in the world. It contained more than one thousand circles and, when complete, was wider than Manhattan. San Francisco Bay Area–based photographer Peter Hinson captured the partially finished design, which was composed by dragging chain-link fencing across the dirt, from a single-engine plane. "There were four of us living out of an old touring bus for two weeks," says Denevan. "After it was finished, people flying from London to San Franciso e-mailed saying they saw it perfectly while up in the air." The dot at the near edge of the large inner circle? That's Denevan's bus.

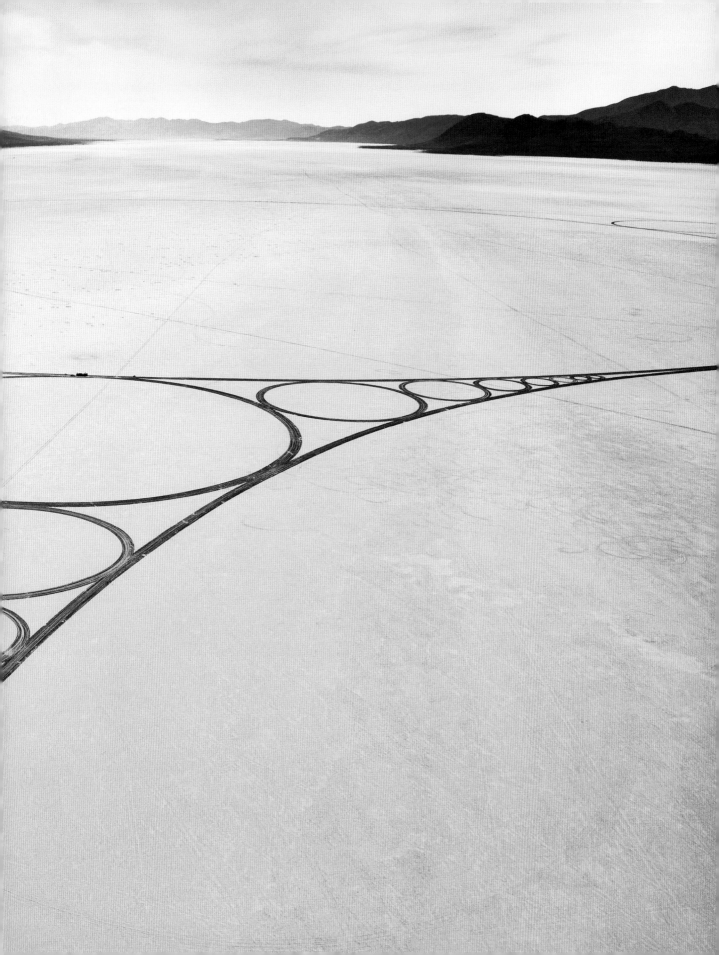

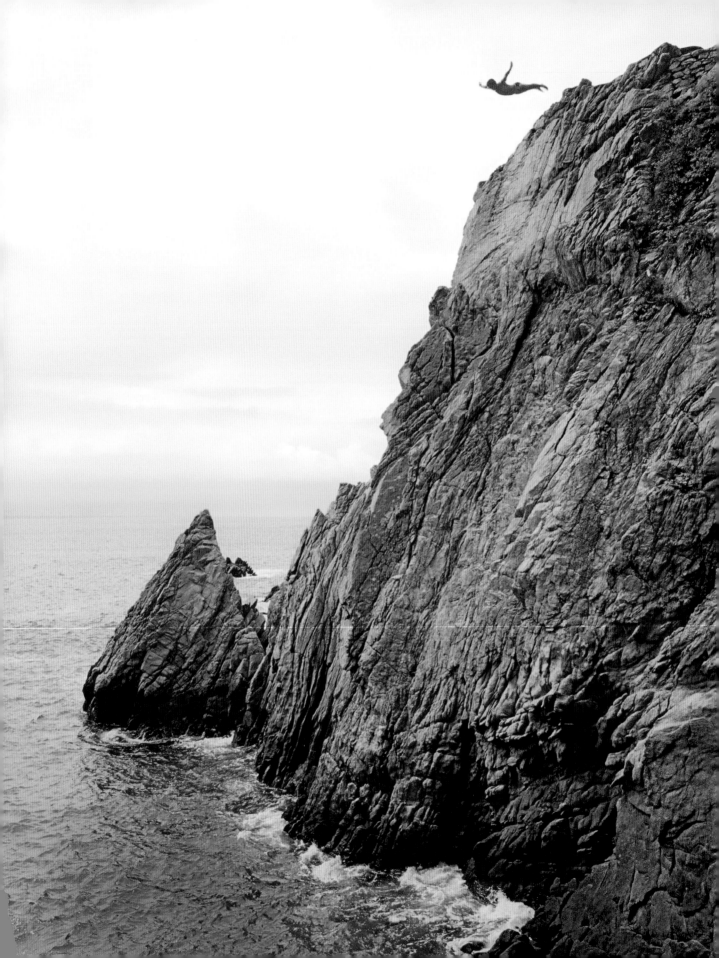

Christian Åslund had been curious about Mexican cliff diving since he saw the 1963 Elvis movie *Fun in Acapulco* as a kid. "The plan was to dive myself," says the photographer, who lives in Stockholm. "But when I saw the local guys doing it, I totally bailed."

"When people see this shot, they're not quite sure what they're looking at," says photographer Blake Gordon. "With the symmetry, it almost looks like a reflection." What they're looking at is the underside of 268-foot-long Sipapu Bridge, in Natural Bridges National Monument, Utah. Gordon, who lives outside Aspen, Colorado, captured the image during a night-photography trip through the Colorado Plateau in January 2008. Natural Bridges proved the perfect spot: In 2007, it was designated the world's first International Dark Sky Park. "The scale of things seems so much bigger at night," says Gordon. "And being out in Canyon Country, alone in winter, with cliffs that span millions of years and drop hundreds of feet, that vastness is magnified even more."

parting shot

May your adventurers be bold, winding, unpredictable, leading to the most amazing views. And may you always take well-composed photos so the rest of us can see what we missed.

photo credits

ii–iii: Jeremy Koreski
vi: Jimmy Chin
x: Uli Wiesmeier
xii: Joey Schusler
xv: Jody MacDonald
xvi: Jimmy Chin
xviii–1: Alex Manelis
2: Jimmy Chin
4–5: Forest Woodward
6: Stephen Alvarez/
 National Geographic Creative
8–9: David Clifford
11: Greg Epperson
12–13: Grant Ordelheide
14: Paris Gore
16–17: Cody Tuttle
18: Ben Moon
20–21: Nicolas Teichrob
23: Jeremiah Watt
24–25: Justin Lewis
26: Brian Mohr
28–29: Jen Judge
30: Michael Schaefer
32–33: Joey Schusler
34: David Clifford
36–37: Sterling Lorence
38: John Wellburn
40: Kyle Dickman
42–43: Darrell Parks
44: Jeff Diener
46–47: Nick Kelley
48: Greg Mionske
50–51: Joey Schusler
52: Steve Ogle
54–55: Kelvin Trautman
56: Brian Bailey
58–59: Jimmy Chin
60: Ian Hylands

62–63: Alex Manelis
64–65: Christian Pondella
66: Jimmy Chin
68–69: Heath Korvola
70: John Norris
72–73: Berthold Steinhalber/
 Redux Pictures
75: Rainer Eder
76–77: Thomas Senf
78: Grant Gunderson
80–81: Mike Schirf
82: Carson Meyer
84–85: Ryan Creary
87: Mark Fisher
88–89: Jimmy Chin
91: Jim Martinello
92–93: Gabe Rogel
94: Grant Gunderson
96–97: Luke Tikkanen
98: Jeremy Bernard
100: Andrew Strain
102–103: Grayson Shaffer
104: Kristoffer Szilas
106–107: Scott Serfas
109: Grayson Shaffer
110–111: Hansi Johnson
112: Mark Fisher
114–115: Jonathan Griffith/
 Alpine Exposure
116: Fredrik Schenholm
118–119: Erik Boomer
121: Blake Jorgenson
122–123: Wiktor Skupinski
124: Ilja Herb
126–127: Ryan Creary
128: Adam Clark
130–131: Chase Jarvis
132–133: Sandy Colhoun